CW00553046

TRADITIONAL CRAFTS AND INDUSTRIES IN EAST ANGLIA

The photographic legacy of Hallam Ashley

TRADITIONAL CRAFTS AND INDUSTRIES IN EAST ANGLIA

The photographic legacy of Hallam Ashley

Edited by Andrew Sargent

ENGLISH HERITAGE

Published by English Heritage, Kemble Drive, Swindon SN2 2GZ
www.english-heritage.org.uk

English Heritage is the Government's statutory advisor on aspects of the historic environment.

First published 2010

ISBN 978 1 850749 68 4
Product code 51192

British Library Cataloguing in Publication Data
A CIP catalogue record for this book is available from the British Library

Edited and brought to publication by Susan Kelleher, English Heritage Publishing
Design by Doug Cheeseman
Printed by DeckersSnoeck, Belgium

~ Contents ~

~ *Acknowledgements* ~

The editor would like to thank the many people who have contributed to this book.

Hallam Ashley's daughters, Kathleen M Davidson and Patricia Ashley, have been very generous with their time and encouragement in supporting this project. Kathleen Davidson also lent a photograph of her father.

Ron Cookson and Luke Bonwick of the Mills Archive Trust have kindly supplied copies of material and provided information relating to Hallam Ashley's interest in windmills. Ken Major, who knew Hallam Ashley, has been most helpful.

Alison Yardy provided information on Englands of Ludham, millwrights. Dr Peter R Crowther, Keeper of Geology and Acting Head of Sciences Division, National Museums Northern Ireland, provided information on Hallam Ashley's geological interests in Northern Ireland.

John H Meredith, Colin Spink, Peter C Wells, Bill Wells and their colleagues at the Road Locomotive Society identified the traction engines on pp 165 & 166.

The editor wishes to acknowledge a particular debt to the valuable oral history studies of East Anglia by Ronald Blythe, George Ewart Evans and Craig Taylor which are listed in the bibliography.

Within English Heritage so many people have contributed to the project in different ways that it is difficult not to miss somebody. Kathryn Morrison allowed access to unpublished research for the English Heritage 'Shopping' project. Caroline Craggs undertook research into the Ashley family. The Curation team included Katherine Bryson, Jenny Hodgson (Conservator), Cynthia Howell and Irene Peacock. The Cataloguing team included Jennie Anderson, Robert Dickinson, Ruth Grundy and Anne Wiggans, managed by Helen Shalders. The Photographic Services team included Steve Baker, Mike Evans, Liz Fife, Rachel Gale, Paul Marks, Jon Proudman, Amanda Rowan, Robert Tims and Shaun Watts, managed by Ian Savage. Anna Eavis provided encouragement.

~ *Hallam Ashley* ~

A personal reminiscence

My father, Hallam Ashley, came from an established photographic background – his grandfather was the first professional photographer in Retford, Nottinghamshire, and founded the family photographic and picture framing business at 31 Grove Street in 1852. When Hallam was approaching his 18th birthday he set off to volunteer for the RAF but when he arrived at the camp there was a telegram to say that his father had died, and so the young Hallam returned home to take over the family firm. (His younger brother Ernest later became a newspaper editor and author, writing under the name of Francis Vivian.) The business was sold in 1921 and my father went out into the wide world with his camera and his expertise as a photographer.

As a young man Hallam hoped to combine geology with photography as a career and geology remained a lifelong interest. The Ulster Museum in Belfast has a small rock containing the imprint of a reptile's foot (*Chirotherium Iomasi*) from the Triassic period, the only evidence of its kind in Ireland, which Hallam discovered at Scrabo Hill, County Down, in the 1930s.

By this time my father was working for Binns Scholastic Photographers of Blackpool. This suited him very well – lots of travelling, open air and the opportunity to photograph anything that took his fancy on the way, including geology. His area of responsibility stretched in a band from East Anglia to Donegal in Northern Ireland and it was in Northern Ireland that he met his first wife, May McKelvey. They were married in 1929 and set up home on the outskirts of Norwich, where I was born.

Imagine a warm summer's day about 1934 and my father has been persuaded to take little Kathleen with him. I remember so well the warmth, the peace, the tranquillity of those quiet country roads banked with cow parsley, scabious and vetch, and the little Austin 7 making scarcely a ripple in the stillness. And then we would draw up outside a little country school, the engine was turned off and the only sound would be the voices of the children floating through the school windows – perhaps chanting a times table or singing some lovely old country song – the most unromantic and yet exciting sounds. And then the bell would ring, and the noise changed to a real hullabaloo of screaming and shouting and laughing and playing. The headmaster would be expecting us, and somehow all these children would be lined up in orderly fashion; and today they would be dressed in their best bibs and tuckers – it was so important not to show the patches and darns of everyday. Some would have gaps in their teeth where milk teeth had fallen out at just the wrong time. And each in turn would stand and have their photograph taken while I stood proudly (but quietly) by. My daddy at work.

A less happy memory. I was out for the day with mum and dad one day when I was about three years' old. As usual, daddy wanted to take some photographs – on this occasion of the windmill carved on a bench end in All Saints' Church, Thornham, Norfolk. The problem, however, was that the bench end was facing away from the light and would reveal no detail (he had no flash light with him). Reflected daylight seemed to be the only answer. After careful thought, the only suitable reflector available was little Kathleen's dress, which was a white smocked dress with a shiny satin lining. I was asked if daddy could borrow my dress for a few minutes! How a child of that age could understand the indignity and indecency of standing in a church in her petticoat I do not know. I can only remember being terribly upset, but finally giving in if I could stay in the porch and not actually go into the church in this terrible state of undress.

In the more settled life in Norwich, my father joined the Norfolk and Norwich Photographic Society and quickly became absorbed in various other activities, always involving photography. He became a close friend of R Rainbird Clarke, the Curator of Norwich Castle Museum, and was much in demand to photograph archaeological sites, excavations and associated objects. Among the items he photographed in the pre- and post-war period were: skeletons *in situ* and diseased or malformed bones for Dr Calvin Wells, a bone specialist; church silver, which in order to light properly was brought home in the boot of his car and photographed in the garage (he progressed to an Austin 7 in about 1931 after a very serious motorbike accident); a fragment of fabric from the Sutton Hoo excavation for Mrs Pretty (Edith Pretty owned the estate on which the famous discovery was made in 1939). I remember my sister and me at the Castle Museum, playing on the floor with gold torques.

During this time my father's photographs were accepted at exhibitions world wide, including Australia, Canada and South America,

earning a box full of gold and silver award certificates. In 1935 he was awarded his FRPS (Fellowship of the Royal Photographic Society) – I remember the day clearly!

Wherever we went – castles, country houses or cottages – Father was always welcomed, and if he had been there before was treated like a long-lost friend. One day as we were driving through the countryside on one of our jaunts in the north of England I noticed a sign pointing to a castle which I had not heard mentioned. Father thought that it might be on his list, so we turned up the drive to this lovely old building. The door was answered by a most charming lady. Father explained who he was and what he was doing, and before we knew it Father, Dorothy (his second wife) and I were inside, drinking tea and discussing the more interesting features of this castle home. The lady did not suggest that we should make an appointment, but straight away showed Father round and asked what he would need. A large reel of cable was produced so that he could use floodlighting where necessary. I think that we made a good team – Father in charge, me holding the lights and moving furniture, and Dorothy chatting with the owner.

To get the right position/angle was important. At an excavation in Arminghall (outside Norwich) he climbed an electricity pylon to get an overhead view. For one of his well-known photographs of the Custom House at Kings Lynn he lay headfirst down the river bank when the tide was out with me holding onto his ankles. On a different level, he photographed otters and birds for Philip Wayre who later founded the Otter Trust. At any time in his travels he could be stopped in his tracks by a mill (wind or water), a fine building or a quarry.

In 1964 an exhibition was mounted at the Norwich Castle Museum entitled, Thirty-five Years of Photographic Recording by Hallam Ashley FRPS. This was a great acknowledgement of the value placed on Father's work.

Kathleen M Davidson (née Ashley)

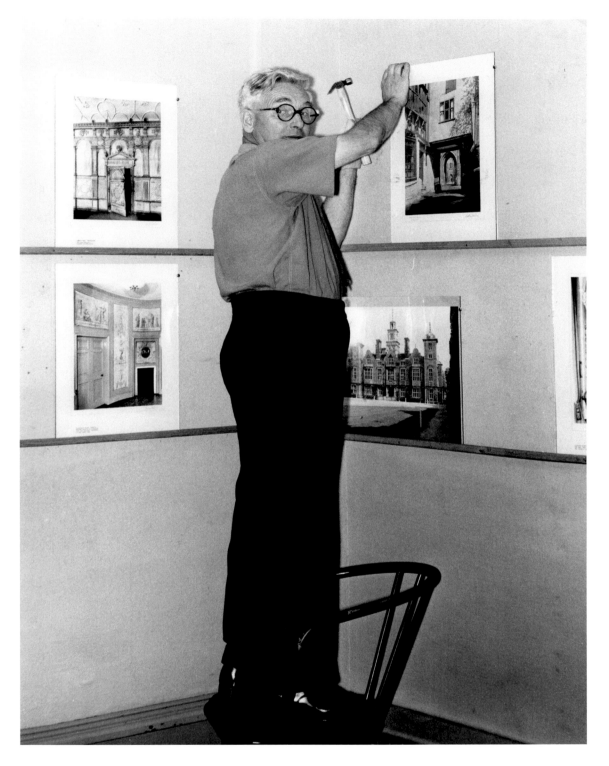

Hallam Ashley hanging prints for his exhibition in Norwich Castle Museum, 4 September 1964.
(Photo N K Harrison, reproduced courtesy of Kathleen Davidson)

~ *Introduction* ~

This book uses the wonderful documentary photography of Hallam Ashley, dating mostly from the 1940s to the 1960s, to explore one of the themes which fascinated him throughout his working life – traditional crafts and industries. It focuses on East Anglia, a region that he grew to love, concentrating mainly on Norfolk and Suffolk but also reaching out into Essex and the fenlands of Cambridgeshire and Lincolnshire. His photographic legacy shows that he was drawn to threatened or disappearing ways of life, making his work an important source for social history. This book presents only a small selection from the archive of his photography held by the National Monuments Record (NMR) in Swindon.

Hallam Ashley FRPS (1900–87)

Hallam Ashley was born on 9 July 1900 into a photographic family, as both his father and grandfather were photographers. John Ashley, his grandfather, established a photographic and picture-framing business at 31 Grove Street, Retford, Nottinghamshire. It was first listed in a trade directory of 1862, though in his advertising John claimed to have started in 1852. In 1904 Hallam's father, Arthur E Ashley, bought out the business, moving from Retford to new premises in Outram Street, Sutton-in-Ashfield in about 1912. He continued to run the business until his death in 1918.

Hallam inherited the family firm on his father's death but he sold up in 1921 and went freelance. This decision may be explained by a letter dated 6 August 1949 in which he wrote that his daughter Kathleen's tastes 'are like mine in the respect that she is more interested in art of any kind than in commerce. I can't see her taking kindly to an ordinary business office any more than I did at about her age.'

Hallam then took a series of photographic jobs around the country. He worked for a firm which processed films, which he found monotonous. For one or two summers at Ilfracombe, Devon, he photographed holidaymakers arriving by charabanc – rushing to get the snaps developed and printed in time for their return. It was whilst working in Essex and staying in the village of Finchingfield that his landlord, Mr Arthur, suggested that he take up schools' photography and recommended him to Binns Scholastic Photographers of Blackpool. This was ideal for Hallam as it gave him the chance to travel around the country and he would take photographs of anything that caught his eye. At first his area of work was fairly limited as he had to travel by bicycle, later replaced by a motorbike and sidecar. Gradually he became responsible for the whole of East Anglia and a band across England – Lincolnshire, Nottinghamshire, Derbyshire, Lancashire and including Northern Ireland. It was in Northern Ireland that he met his first wife, May McKelvey. They were married in 1929 and set up home at 40 Ashtree Road, New Costessey, on the outskirts of Norwich.

As a young man Hallam had hoped to make a career combining a keen interest in geology with photography. He continued to photograph geological features throughout his life, and in 1935 he was pleased to be invited to mount an exhibition of his geological work for the annual meeting of the British Association for the Advancement of Science in Norwich.

A lifelong interest in mills developed after

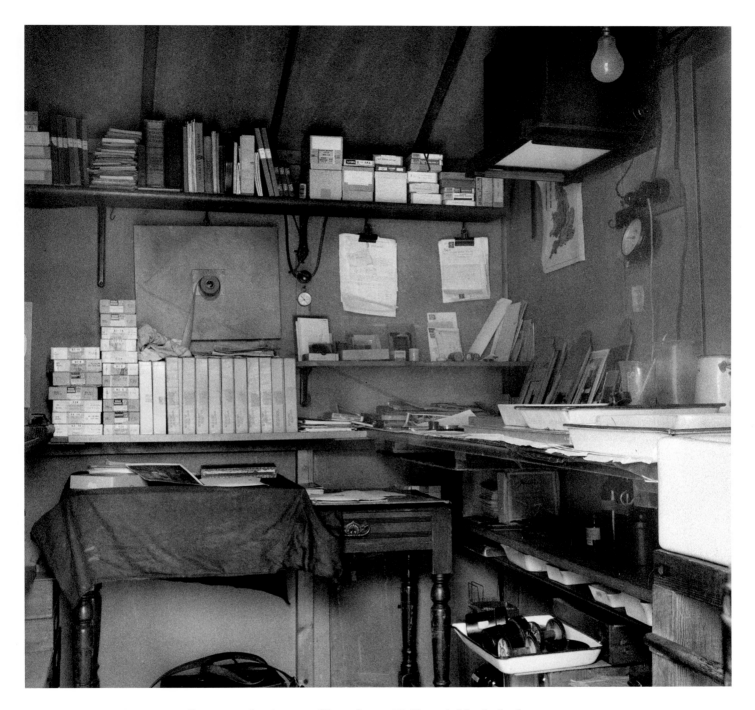

meeting Rex Wailes, an authority on mills and milling, in 1926. As a result he took many photographs of mills for Rex Wailes and later for the Society for the Protection of Ancient Buildings (SPAB). As his interest developed, he published an article in 1936 in the *British Journal of Photography* promoting the value of, and outlining the technical challenges of, record photography of windmills, while in 1948 he

Hallam Ashley's dark room
40 Ashtree Road, New Costessey, Norfolk, May 1954. [AA98/11864]

contributed to an important SPAB exhibition on windmills in art at the Victoria & Albert Museum (SPAB 1951, 71–2).

Throughout the 1930s school photography

remained his mainstay, especially as by now he had a wife and two young daughters to provide for. At the same time he became a close friend of the then Curator of Norwich Castle Museum, R Rainbird Clarke, and was soon photographing archaeological sites, excavations and associated objects for the Museum and for an ever widening field of experts. During this period his photographs were accepted at exhibitions world wide, including Australia, Canada and South America, winning numerous gold and silver award certificates.

Despite his age, Hallam volunteered for the RAF during the Second World War. He was posted to the Photographic Section, and although he did not fly he admitted to learning a lot from this experience. A few weeks before the end of the war his wife died, so that on demob he had to re-establish his photographic business while bringing up two daughters on his own. In 1951 he married Dorothy Baines of Ipswich who was a photographer in her own right and a great help to him.

It was soon after the war that he met Jimmy Hoseason, which gave rise to one of his bread and butter jobs for the next 40 years – photographing Hoseason's boats and holiday bungalows for their catalogue. His letterhead listed the services he offered: picture copying, book illustrations, catalogue illustrations, exhibition photographs, lantern slides (later changed to colour slides).

In 1946 he wrote on Rex Wailes's recommendation to introduce himself to the National Buildings Record (NBR, a forerunner of the English Heritage National Monuments

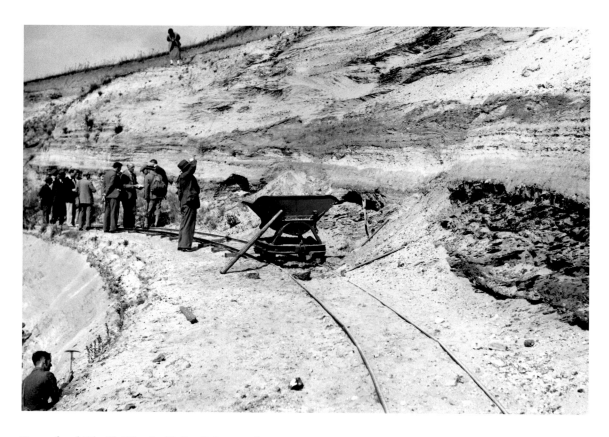

Bramford Chalk Pit, Suffolk, 8 September 1935
British Association members during the Norwich conference on an excursion to study the Bramford Chalk Pit. [OP00143]

Record), soon finding himself on friendly terms with Cecil Farthing, the Deputy Director. This proved to be the start of a new career as he freelanced for the NBR. In 1947 he began to sell the NBR individual prints 'on approval'. Two years later he received his first commission from the NBR, to take 750 photographs of historic buildings in East Anglia, supplying both prints and negatives. The following year he asked for his quota to be increased to 1,000. In a letter dated 29 March 1949 he listed the cameras he proposed to use for a forthcoming commission in Southwold which Cecil Farthing planned as a training exercise in architectural appreciation:

Sanderson 5½" x 3½" with 7" and wide angle lenses;
homemade ½ plate for wide angle work;
Rolleicord 2¼" square roll film for small detail work and exteriors if a rising front was not needed.

Also in the late 1940s he met Monica Dance, Secretary of the SPAB, and her husband Harry. They established a close working relationship and remained among his closest friends. This was another important contact as he received many commissions from the SPAB. Over the years he became deeply involved in the recording of historic buildings, and in 1956 was heavily involved in an exhibition for the Royal Institute of British Architects' visit to Norwich entitled 'East Anglian Buildings'. From the early 1970s his letterhead described him as a 'photographer of buildings', reflecting the significance of his work for the NBR and SPAB.

He continued to carry out archaeological photography, for which the Norwich Castle Museum remained one of his major clients. In 1964 he was honoured with an exhibition at the Museum entitled 'Thirty-five Years of Photographic Recording by Hallam Ashley FRPS'. A reviewer noted that his work fell naturally into three themes: geology, historic buildings and East Anglian landscapes (Harrison 1964).

A fourth could be added: traditional crafts.

Hallam Ashley maintained a number of regular commissions. His photographs have illustrated a large number of magazines and books, including *Pevsner's Buildings of England* series. He took postcard views, produced a booklet on his adopted county of Norfolk (Ashley 1951), and exhibited his work widely. He also taught photography at the Norwich College of Further Education for a number of years, and was in demand as a lecturer – from the Women's Institute to the SPAB. In these ways he built a freelance career doing what he loved best and in the process developed his reputation. He was elected to an FRPS (Fellowship of the Royal Photographic Society) in 1935 and continued photographing until 1983. He died on the 24 October 1987.

East Anglia

East Anglia is a major character in this book. The name conjures up a strong popular image of wide horizons, vast skies and extensive areas of wetland: Hallam Ashley described it as 'an area in which the land, the sea and the sky are happily intermingled' (1951, 1). The geology is mostly either clay or sand and gravel, with a coastal fringe of river estuaries, dunes, mud flats, salt marshes and tidal creeks. Relief is low and large areas appear flat or gently undulating. Much of the region is dominated by arable cultivation with some woodland, and pasture in the valleys. Hallam Ashley was very conscious of the roles of geology and climate, as well as the impact of human activity, in shaping this landscape that he loved.

The buildings reflect the landscape and underlying geology. There are only small outcrops of useable building stone in the region and it was expensive to import quality stone. There was, however, plenty of timber, and this was widely used for vernacular buildings. Many of the more substantial buildings used the flint cobbles which can be picked up in large quantities from the fields in the clay areas and from the beaches. With no suitable stone for slates,

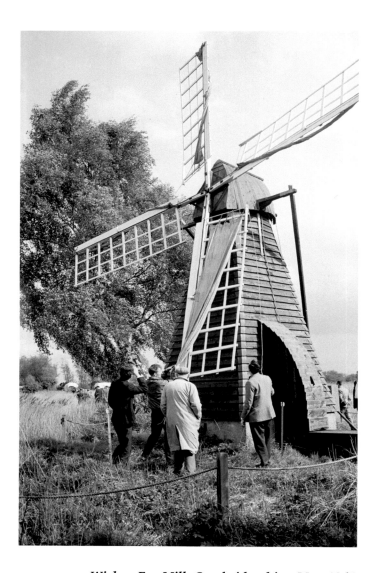

Wicken Fen Mill, Cambridgeshire, May 1968
*Wicken Fen is a surviving fragment of the
natural wetland habitat that once covered
the fens before they were drained, and is an
important nature reserve. One of the last
surviving pumping mills on the Fens is now
ironically used to keep Wicken Fen wet for
nature conservation. Without it, the peat
would dry out and shrink. [MF98/00829/08]*

many roofs, including churches, were traditionally thatched. From the 19th century the use of bricks and tiles has masked this trait, though even most of these were made from local clays.

To the north-west, the region was separated historically from the rest of Britain by the expanse of the Fens. This extensive area of fen and marsh was drained from the 17th century to exploit its agricultural potential. Rivers were canalised and drains dug. Hundreds of windmills were built to pump water; they have all now been superseded by motorised pumps.

The other extensive area of wetland is the Broads, on the river systems of the Bure and Ant, Yare and Waveney in eastern Norfolk. These areas of open water are mostly man-made, the flooded remains of a peat-digging industry which flourished from the medieval period until the 19th century. Water was carefully managed by a series of pumping mills in order to maintain the productive grazing marshes of the river valleys. Today the Broads are enjoyed by many as a paradise for boating holidays, and windmills, often derelict, remain part of the holiday memory for many visitors.

Crafts and Industries

Hallam Ashley's photographs are full of interest and life. They are also important historical documents as he was working at a time of rapid change in the countryside, so many of the activities he routinely witnessed have now either declined or altered beyond recognition. His photographs, mostly spanning the period from the Second World War to the 1960s, caught traditional crafts and industries and rural life at the very point of change, creating an invaluable record.

In this book his photographs of various trades and crafts are grouped under their broader heads – agriculture, fishing, food and drink, quarrying, building trades, industry, retail, transport, and a range of traditional

crafts. Hallam Ashley had a particular interest in mills and milling, and undertook a detailed photographic study of thatching, so these iconic crafts are treated more fully.

The Suffolk village was described by George Ewart Evans as a 'tight community' (Evans 1985, 155), self-reliant if not completely self-sufficient, and this was equally true throughout East Anglia. Historically, crafts and trades were organised on a local scale. Each region would have its own complement of craftsmen to serve its basic requirements, though some raw materials had to be imported and specialist craftsmen travelled more widely or supplied markets further afield. Craft lore was passed from father to son, master to apprentice, often perpetuating local styles and variants, and some craftsmen were proud to develop their own 'signatures'.

Many traditional crafts and industries throughout the country served, or were directly dependent upon, agriculture, while fishing occupied a similarly influential position in coastal communities. Until recently, rural society depended on the productivity of the land, so that activities as diverse as the building trades, retail, furniture-making and transport – and even the rural doctor and vicar – were ultimately tied to the economics of farming. Only a few small-scale industries were free from its shackle, such as brick making which largely served the growing towns, and that most unusual of East Anglian industries, the manufacture of gun flints, which exported most of its output.

Changing crafts

Agriculture, traditionally the bedrock and economic driving force for the countryside, has suffered many changes of fortune. The crafts and trades which served rural communities had constantly to adapt to new technologies and requirements, but usually the rate of change was so slow as to be imperceptible. Throughout the 19th century the steady migration from the countryside to the industrial

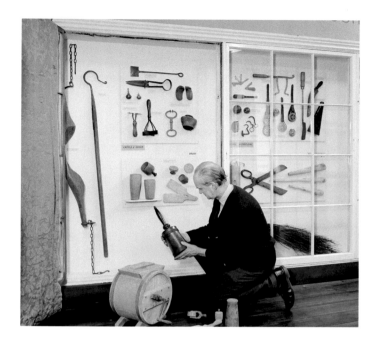

Norwich Castle Museum, Norfolk, 1965–75
A curator arranges a display in the crafts room. These traditional working tools have become curiosities, nostalgia. Hallam Ashley photographed for the Norwich Castle Museum. [AA99/04451]

towns must have had an effect on the vibrancy of rural life in general. By the mid-19th century the range of craftsmen in most villages had declined as the tailor, boot maker and furniture maker withdrew to towns with their larger markets, leaving behind just the 'core' rural crafts – smith, carpenter, wheelwright, miller and thatcher.

The prolonged agricultural depression from 1870, the widespread depression of the 1920s and 1930s, and competition from industrially produced and imported goods, left many aspects of rural life struggling to survive. The rural craftsman continued to make functional goods in an increasingly price-sensitive market in which improved transport led to heightened competition. Even as late as 1944, Michael Powell and Emeric Pressburger's film, *A Canterbury Tale*, while no doubt being deliberately

nostalgic, could still present a very traditional picture of rural life and agriculture in contrast with the mechanisation of modern warfare.

People left the land in huge numbers as agriculture was transformed in the decade after the Second World War, finally sounding a death knell for many crafts and trades and for rural society as it was then structured. The 1901 census recorded over 1,100,000 people employed in agriculture (which probably underestimated seasonal and casual labour), while today the figure is nearer 200,000. One of the major factors in this change was the wholesale adoption of mechanisation on the land and the consequent demise of the working horse. Although first steam power and then the internal combustion engine had been applied to farming since the early 19th century, it was the introduction of new models of tractor during and immediately after the Second World War which brought about a sudden change – almost a revolution – in farming. When the end came, it was rapid. In 1914 there were almost 900,000 working horses on farms; by 1950 there were still 300,000; by 1960 they had become rare. In those post-war years, the traditional crafts which for so long had supported the agricultural economy almost died out; the blacksmith/farrier and saddler found their livelihoods slashed, while the carpenter no longer had wagons to maintain.

Recording a revolution

George Ewart Evans, who moved to Suffolk in the 1950s, was one of those who noticed this change with regret: 'After living at Blaxhall, a small Suffolk village, for some years after the last war [Second World War] I realized that we were witnessing the end of the old farming. One fact made this apparent: during the eight years I lived there nearly all the farm horses disappeared from the land, and their places were taken by the tractor' (Evans 1969, 31). In the 1950s and 1960s Evans (1958, 1974, 1985) began deliberately to record the oral history and folk life of East Anglia before it

was irrevocably lost, starting with his own village of Blaxhall: 'At present, old people in this countryside are survivors from another era. They belong essentially to a culture that has extended in unbroken line since at least the early Middle Ages' (Evans 1958, 13–14). That assessment of continuity may be romanticised, given the huge disruptions caused to farming by enclosure, the agricultural revolution and industrialisation. However, his interviewees could remember the final years of Victoria's reign and could recount the lore passed down from their parents and grandparents.

A similar documentary account of life in the fictitiously named Suffolk village of Akenfield (based chiefly on Charsfield) was recorded in 1966–7 by Ronald Blythe (1969). This important book is as much a picture of rural life as it was in the 1960s as a record of a lost past. Recently Craig Thomas (2006) returned to Akenfield to bring Ronald Blythe's study up to date, and in so doing has presented a fascinating account of ongoing change in the countryside.

Hallam Ashley was travelling East Anglia with his camera at the same time that both Evans and Blythe were interviewing their sources. Where they recorded passing traditions with the printed word, he captured them on film. He was conscious of this hard reality: it is certain that he was increasingly aware that milling was a 'dying industry' and he saw photography as having a vital role in recording what remained (Ashley 1936, 546).

Revival

The countryside has reinvented itself in order to survive. Many East Anglian villages have now become dormitories for urban workers who have escaped from the city, or else picturesque retirement locations. Elsewhere the new rural industry is tourism, no longer important just around the coastal fringe and the Broads, seeking out picturesque locations and recreational activities.

In the same way, many of the traditional crafts which almost died out in the mid-20th

century are now being revived to serve new markets. Tourism and commuters are bringing new money to rural communities. Craftsmen often appeal to the 'art' market. The blacksmith now makes ornamental ironwork for holiday homes; thatching is once again in demand; mills are restored and produce organic flour, and may offer a model for sustainable energy. Traditional crafts are adaptable and are demonstrating that they will continue in new forms. Agriculture and the fishing industry are also seeking new ways to survive.

The Hallam Ashley Collection

After Hallam Ashley's death in 1987, the bulk of his collection of negatives was given to the National Monuments Record (NMR) with which he had had such a long association. Together with photography commissioned by the NBR (a predecessor of the NMR), there is a total holding of over 19,000 items. Although this material spans much of England, from Cornwall to Northumberland, 80 per cent is of East Anglia. Hallam Ashley's interests in landscapes, mills and geology are well represented, as is his building recording work for the NBR, and many of his photographs show people going about their daily routines.

The NMR, the public archive of English Heritage, is the largest publicly accessible archive in Britain dedicated to the historic environment, with an unparalleled collection of images, old and new. The collection comprises more than 10 million photographs and other archive items (including measured drawings and survey reports) relating to England's architecture and archaeology. It continues to accept major collections of national importance and is a repository for material created by English Heritage's staff photographers. The collection may be consulted at the National Monuments Record offices in Swindon (telephone 01793 414600 for details) and a selection of historic images, including many by Hallam Ashley, is available online at www.english-heritage.org. uk/viewfinder.

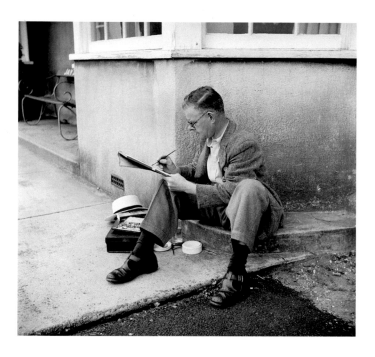

Artist, Aldeburgh, Suffolk, July 1950
In the post-war years, as the economic importance of the traditional ways declined, East Anglia began to be appreciated for its picturesque qualities. This amateur artist, sketching the Moot Hall in Aldeburgh, was in the vanguard of a major new industry – tourism. [AA98/12113]

~ *Agriculture* ~

Farming was the dominant industry in rural areas until the mid-20th century and provided the economic basis for the whole of society. From the 18th century a mixed agricultural regime developed in East Anglia based on arable cultivation with cattle on the heavier clays and sheep on the poorer soils.

Traditional farming depended upon the muscle power of horses and people to carry out the many processes and tasks. Harvest in particular required a large seasonal labour force, and the children were often taken out of school at this time to help. Throughout the 19th and 20th centuries mechanisation increased, gradually improving efficiency and reducing the amount of labour required – but the horse remained the main unit of power until the Second World War. It was only after the war that the effects of mechanisation, government policy and a healthy economy set farming back on its feet, ushering in a time of huge changes in the countryside. This was precisely the time when Hallam Ashley was photographing.

Other crops which have gained in commercial importance since the late 19th century as agriculture sought to diversify include potatoes, vegetables, sugar beet and fruit. Market gardening expanded rapidly in the early 20th century, which together with poultry farming provided an economic option for smallholdings which could no longer compete with the large arable producers. These alternative crops benefited from improvements in transport and the canning industry.

Very different is bulb and flower growing, for which the Cambridgeshire and Lincolnshire fens, especially the area around Spalding, have been renowned since the late 19th century. Another example of diversification in a period of agricultural depression, it was made possible by the railways which provided rapid transport to London. The first bulb grower listed in a Lincolnshire directory was Mrs Elizabeth Quincey of Fulney, Spalding, described in 1885 as a Wholesale Fruiterer and Bulb Grower. The industry expanded considerably in the years following the First World War, particularly with the production of cut flowers; in 1933 about 6,000 tons of flowers left Spalding in the season. In 1958 the famous Tulip Parade in Spalding was established and became a focus for an important tourist industry.

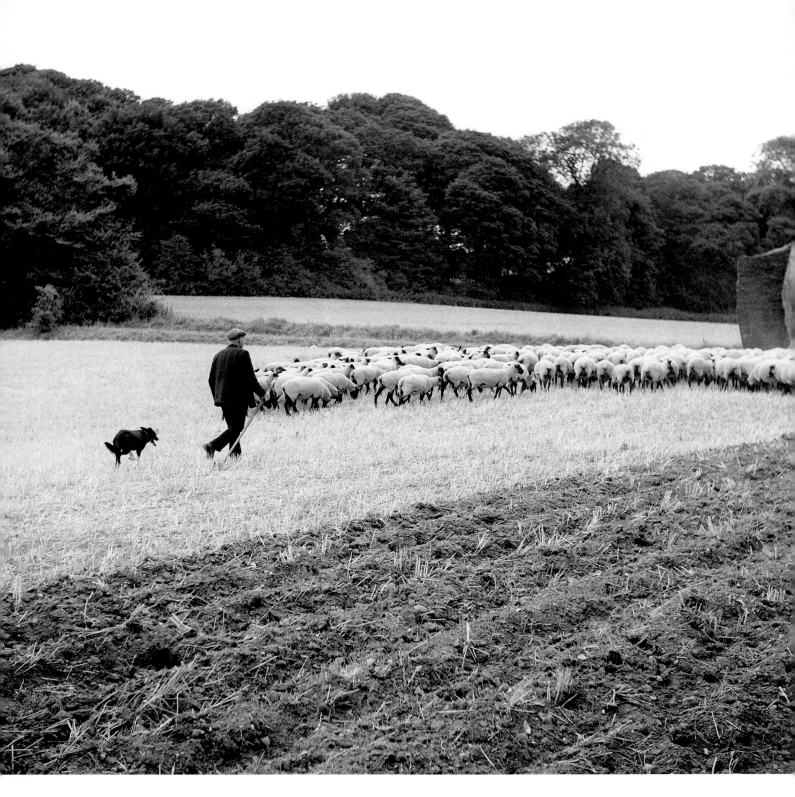

Shepherd, near Glandford, Norfolk, September 1953
A shepherd and his dog move a flock of sheep to graze on the stubble left after the harvest. This had been a traditional practice since the late Middle Ages as the manure that sheep provided was a vital resource for cereal cultivation in many areas. At the end of the 18th century as much as three-quarters of the country carried sheep at various times of the year, including a considerable percentage of arable land which relied on their manure to maintain fertility. [AA98/11249]

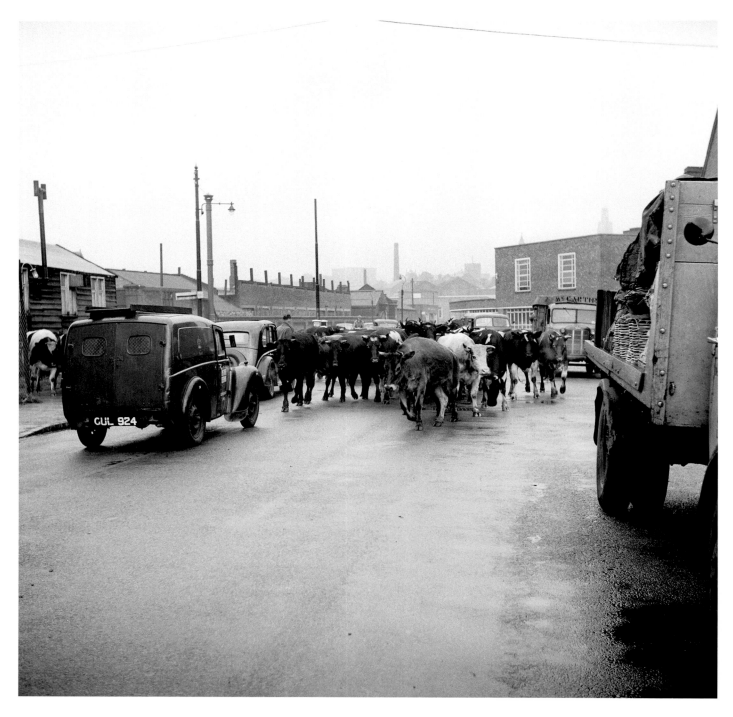

Cattle, Heigham Street, Norwich, Norfolk, May 1954
Traffic has to give way as a herd of cattle is driven through the streets of Norwich to the railway station. Traditionally, cattle were driven many miles to market in the towns or fairs, but the development of the railway network brought an end to this centuries-old, long-distance droving trade as cattle only had to be herded to the nearest station to continue their journey. In its turn, road transport has replaced the railways, and now livestock are never seen in town streets. [AA98/11670]

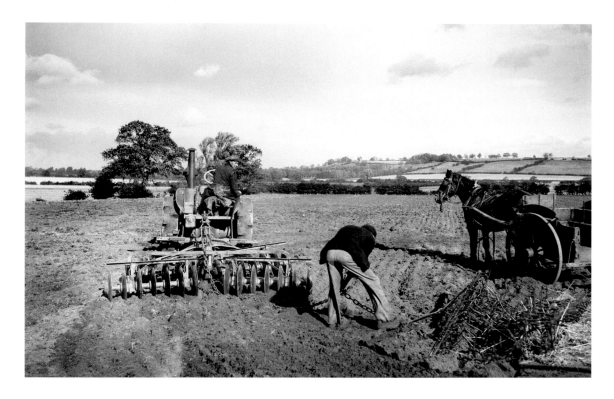

Harrowing, near Honington, Lincolnshire, October 1940
Hallam Ashley recorded the final eclipse of the farm horse by the tractor. Investment and effi-
ciency considerations and the need to change working practices meant that take-up was slow; in
the 1930s the number of tractors on farms had risen to 50,000 compared with 600,000 horses. The
need for efficient food production during the Second World War gave the tractor impetus, though
working horses were still a common sight until the end of the 1950s. Here a chain harrow is at-
tached behind a disc harrow to prepare a fine tilth suitable for sowing seed. [AA98/09683]

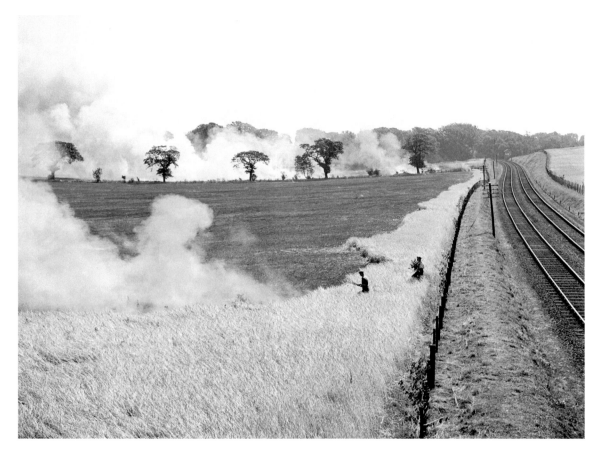

Field fire, near Postwick, Norfolk, August 1949
The loss of a crop though fire, whether accidental or set deliberately, has always been a risk. The barley field in this photograph lies beside a railway and trackside fires were a particular hazard in the days of steam when a spark from a locomotive in a dry summer might be enough to ruin a farmer's livelihood. Under the Railway Fires Act of 1905 liability for damage to agricultural land was limited to £100. [AA98/11587]

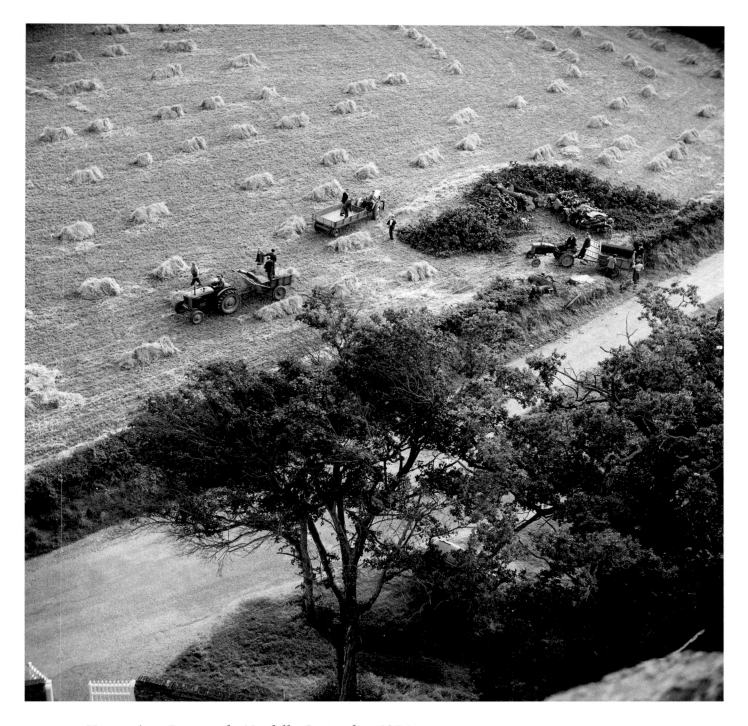

Harvesting, Ranworth, Norfolk, September 1954
This familiar farming scene was captured from the vantage of Ranworth church tower. Despite increasing mechanisation, agriculture was still a labour-intensive industry in the 1950s requiring considerable seasonal employment. Here at least 15 men are employed in gathering in the harvest. [AA98/14729]

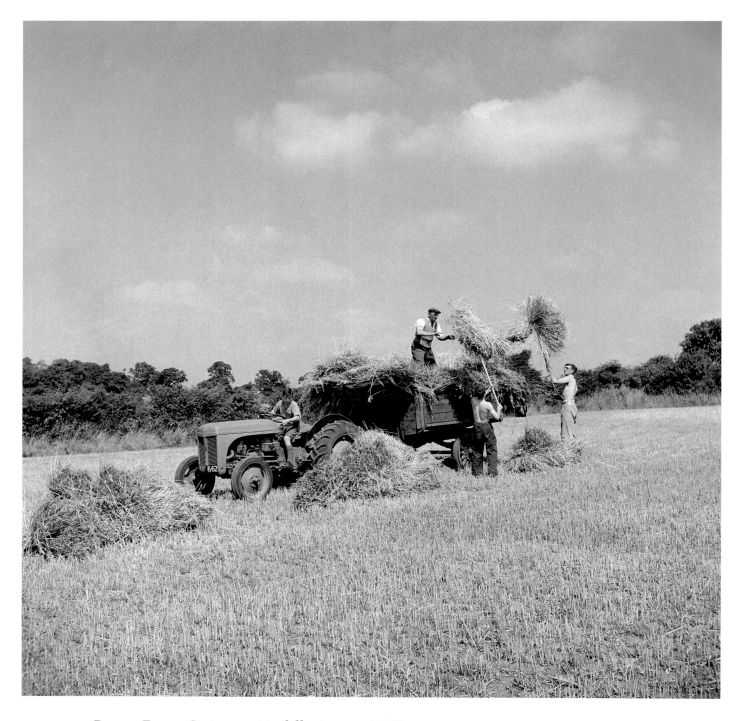

Rogers Farm, Costessey, Norfolk, August 1953
Two men with pitchforks load straw onto a trailer in much the same way that it had been done for centuries. The novelty was that the trailer was now pulled by a tractor rather than a horse. An hour was generally allowed to feed, groom and harness horses for work each morning, and this process had to be repeated each evening. By contrast, at the close of the day's work a tractor can be parked and left. [AA98/16219]

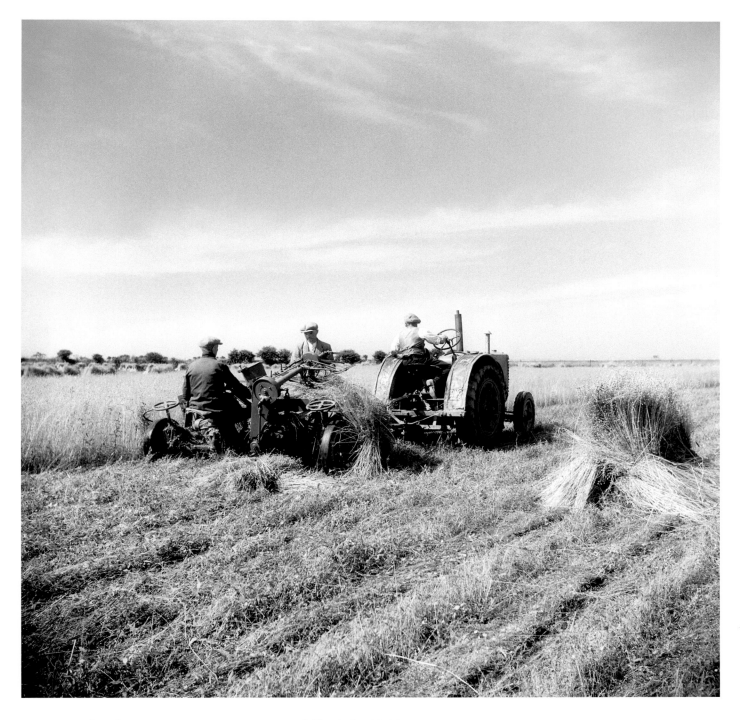

Flax harvest, near Knapton, Norfolk, July 1946
Flax has been cultivated in England since the pre-Roman period. Its stems are the raw material for linen while its seeds are crushed to make linseed oil. This flax-pulling machine, in operation at Mr May's farm, takes two men to operate and a third to drive the tractor. A fourth is presumably employed in stacking the stooks. [AA98/09093]

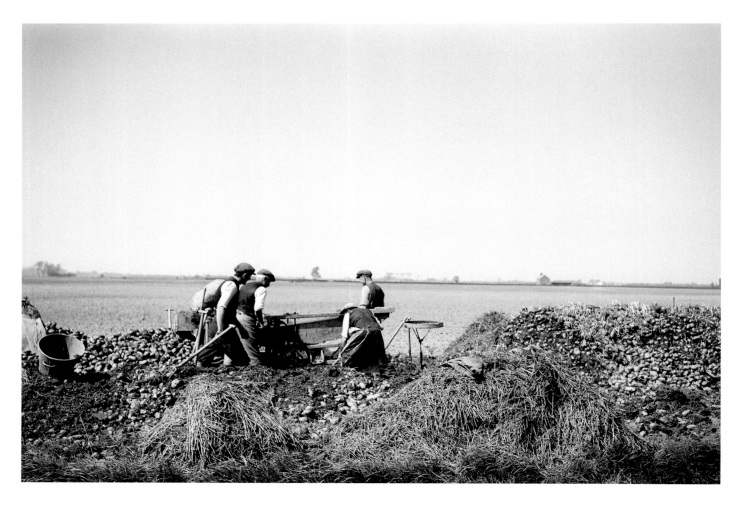

Potato riddling, Marshland St James, Norfolk, May 1940
At the start of the 20th century a quarter of the acreage of the Fens was used for potatoes. After harvesting, main crop potatoes were stored in 'clamps' at the edge of the fields and protected from rain and frost with a covering of straw and soil. As they were needed throughout the winter and spring, the clamp would be opened and the potatoes dug out with a special potato shovel and 'riddled' – that is, sized and graded through a series of sieves and inspected for damage or disease – and then bagged. In this wartime photograph, several labourers are employed in riddling the potatoes. [AA98/09647]

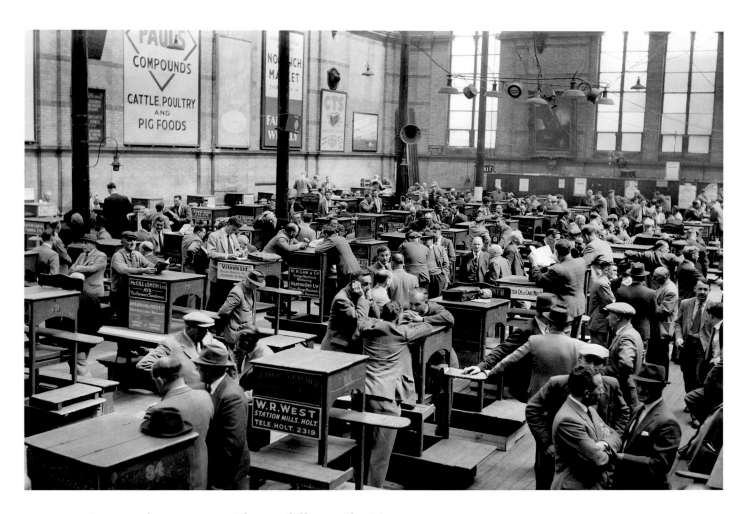

Corn Exchange, Norwich, Norfolk, April 1960
The commercial sale of produce is an essential part of the business of farming. The Norwich Corn Exchange was built in 1859–61 by T D Barry. Designed as a place for farmers and dealers to strike their bargains, the Exchange also seems to have been a venue for socialising and gossip. It was demolished soon after Hallam Ashley's visit. [AA98/11332]

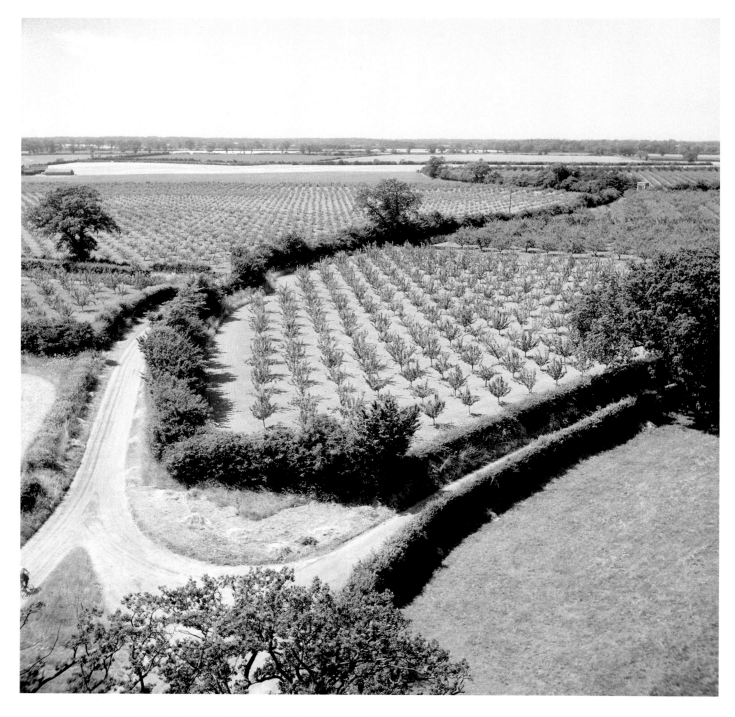

Fruit farm, Ranworth, Norfolk, July 1955
In common with other aspects of agriculture in England, fruit farming has changed considerably since the post-war years. Orchards such as this one at Ranworth are becoming less common. Malcolm Peck, an orchard foreman in Akenfield, Suffolk, notes a change from apples and pears to soft fruit: 'I think in years to come the English apple will be gone. So far this year we've cut down five acres of them... . The ones we've cut down this year are trees that were put in in 1956' (Taylor 2006, 12, 14). [AA98/14771]

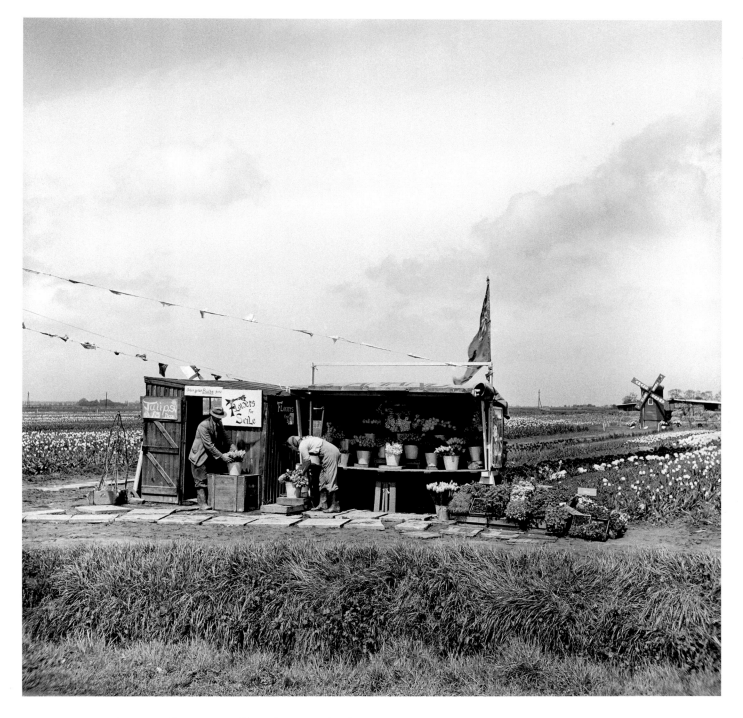

Roadside stall, near Holbeach, Lincolnshire, May 1951
From a small start in the 1880s with just a handful of growers cultivating bulbs on a few acres, the industry rapidly expanded until there were about 6,000 acres of bulbs in the Spalding area alone by the 1950s. After the Second World War, people were hungry for colour and flowers were not rationed! By 1951 the tulip fields were becoming a major springtime tourist attraction and this was given focus in 1958 with the founding of the annual Tulip Parade in Spalding. Stalls selling cut flowers and bulbs, such as the one shown here, sprang up to tap the passing market. The small windmill in the background is presumably just part of the window dressing. [AA98/09477]

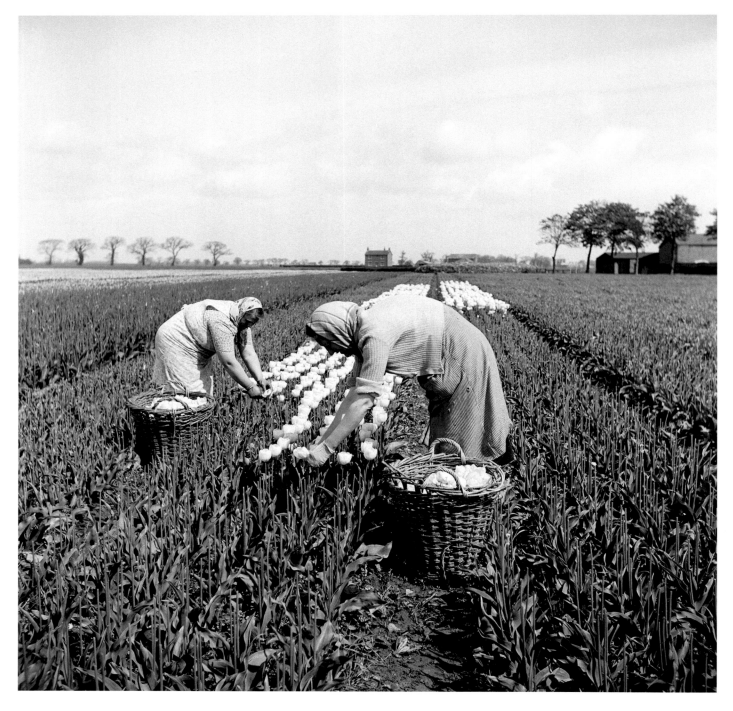

Tulip field, near Fulney, Lincolnshire, May 1951
By the 1950s bulbs rather than cut flowers had become the main crop in the Spalding area. These women are not picking flowers, but removing the flower heads in order to encourage the plants to put their growth into the bulbs rather than seeds. [AA98/09310]

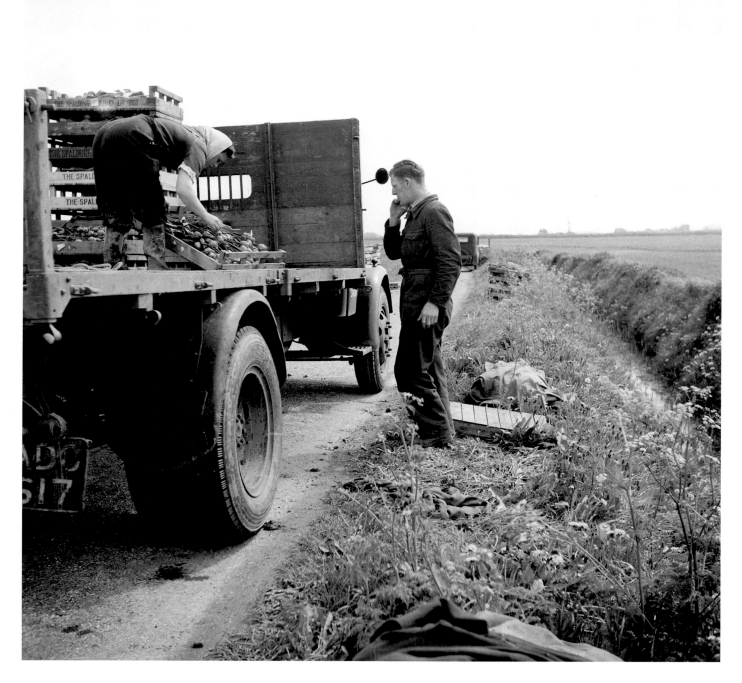

Loading tulips, near Spalding, Lincolnshire, May 1951
Crates of cut tulips are loaded onto a lorry while the flat tulip fields stretch away into the distance. While bulb production was the main concern of most growers by this date, there was still a significant market for cut flowers. [AA98/16119]

Gardener, Abbey Gardens, Bury St Edmunds, Suffolk

Most countrymen cultivated their own cottage gardens as allotments. A few were more serious about horticulture and went into service as gardeners for grand houses. Many Victorian and Edwardian country houses employed a large garden staff with a rigid apprentice system which provided training and a career structure. (In the early 20th century the Rothschilds employed over 50 gardeners at Waddesdon Manor, Buckinghamshire, but that was exceptional.) By the time Hallam Ashley was photographing, few estates could afford to maintain a lavish garden establishment, but the public parks, like Abbey Gardens, offered similar opportunities and training. [AA98/07503]

~ *Fishing* ~

Fishing has long been a major industry which supported many towns and villages around the East Anglian coast. In the larger ports, such as Great Yarmouth and Lowestoft, this industry was very profitable. A key economic target was the herring, a migratory fish which can be caught off East Anglia in October and November. In the 19th century the 'herring girls' from the east coast of Scotland followed the shoals as they migrated southwards, and were expert at gutting fish. Volumes were high: a skilled team of three women could gut and pack 21,000 herring in a 10-hour shift. Herring would either be packed in brine for transport to wholesale markets in London or smoked to make kippers. Elsewhere around the coast crabs and lobsters were caught, and shellfish such as cockles and whelks were gathered.

The Domesday Book records many fisheries in the Cambridgeshire fens. These would probably have been eel fisheries. Eels were plentiful throughout the Fens and were caught by the thousand; they provided a valuable dietary component for many fenland communities.

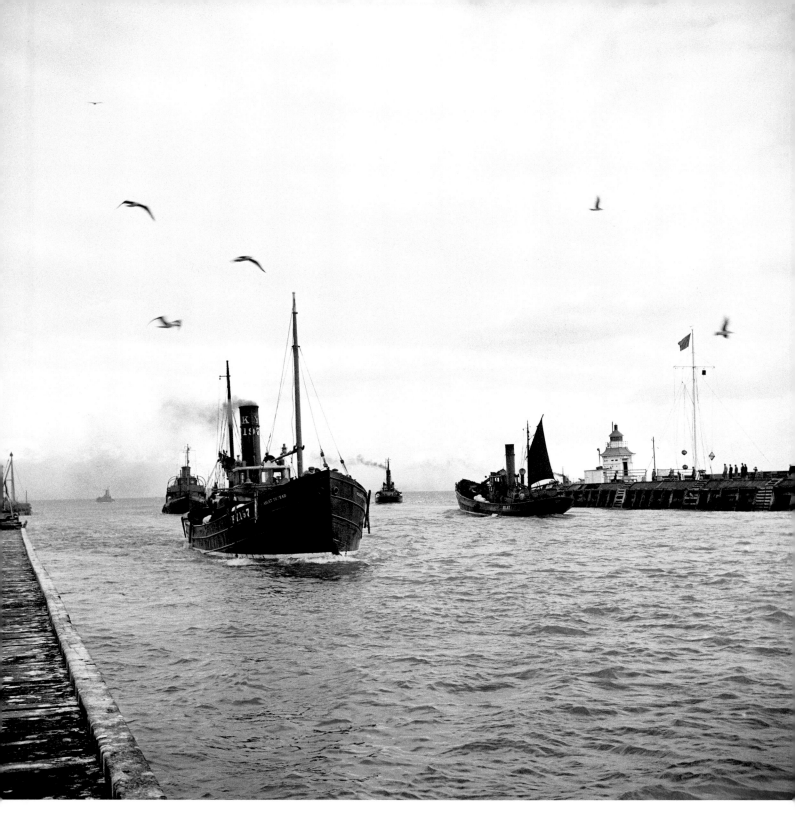

Great Yarmouth, Norfolk, November 1947
Great Yarmouth was a major fishing port and a base for the herring fleet – the fleet sailed for the last time in 1955. In this photograph fishing boats are seen entering and leaving the safe anchorage provided by the mouth of the River Yare. [AA98/10882]

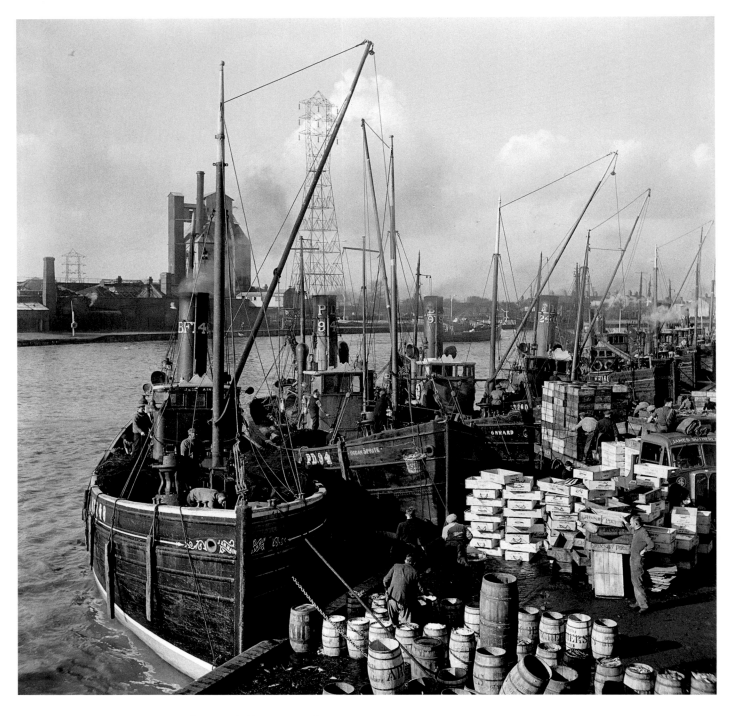

Great Yarmouth, Norfolk, November 1947
Fishing boats are moored at a wharf on the River Yare. Empty barrels and fish-boxes are stacked on the quayside ready for the herrings, while a lorry delivers a load of boxes to the fishing boat *Onward*. [AA98/10885]

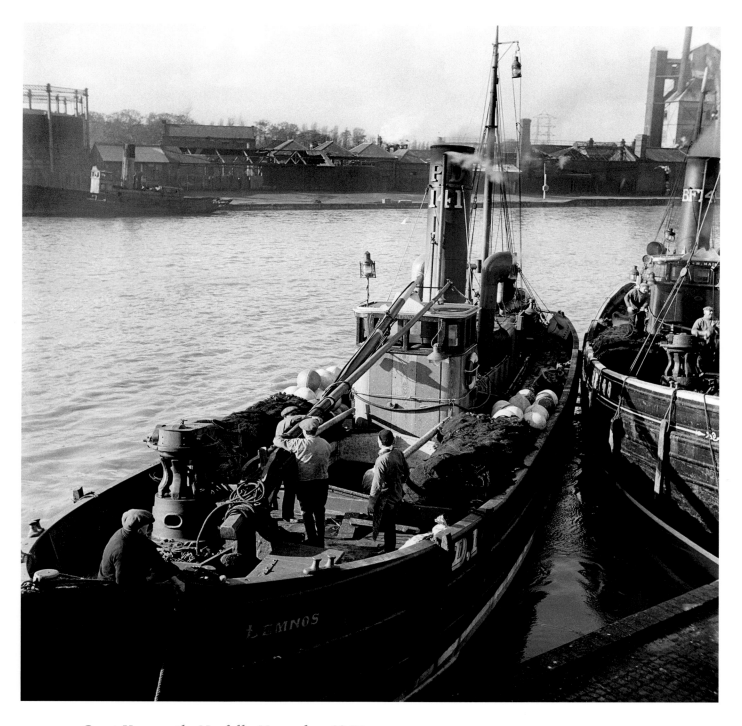

Great Yarmouth, Norfolk, November 1947
A detailed view of a fishing boat shows the drift nets and buoys stacked in readiness on the deck.
[AA98/10884]

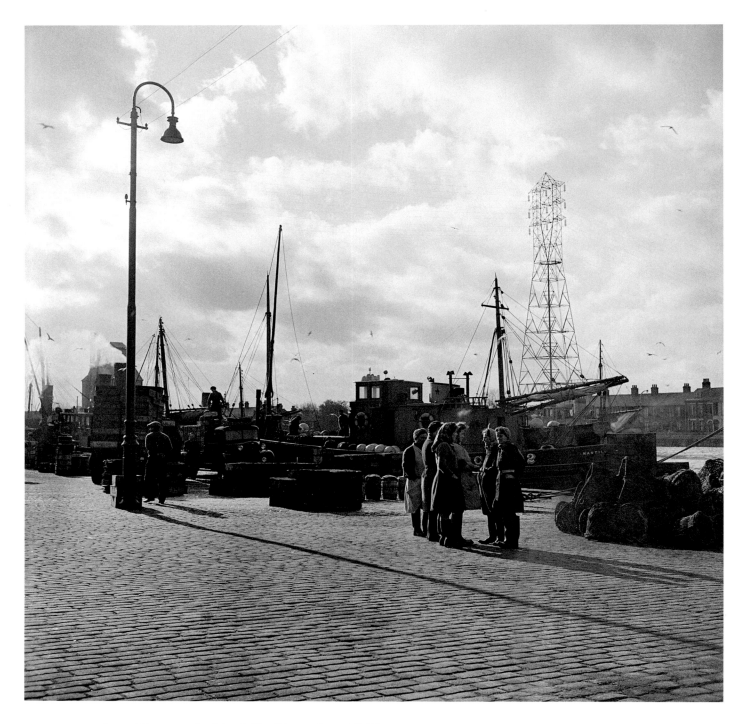

Great Yarmouth, Norfolk, November 1947
The group of women on the harbour are possibly 'herring girls' from the east coast of Scotland.
The herring trade began to decline in the 1930s due to increased competition from a wider
range of tinned foods, but the 'herring girls' continued to find work into the early post-war years.
[AA98/17150]

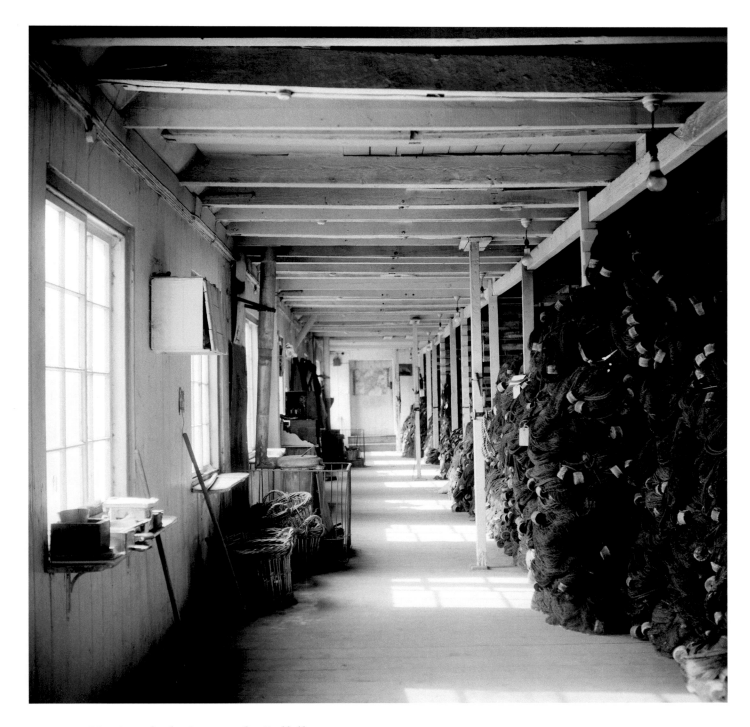

Netting sheds, Lowestoft, Suffolk
Fishing nets were an essential tool for the fisherman and required considerable maintenance. Traditionally, net-making was a cottage industry, but factory-made cotton nets replaced the heavier hemp or linen in the 1860s. After each fishing trip, nets had to be laid out to dry and any tears mended; they also had to be washed regularly using a solution made of oak or birch bark to reduce damage from sea salt. They were then stored in special netting sheds like this one. [AA98/12838]

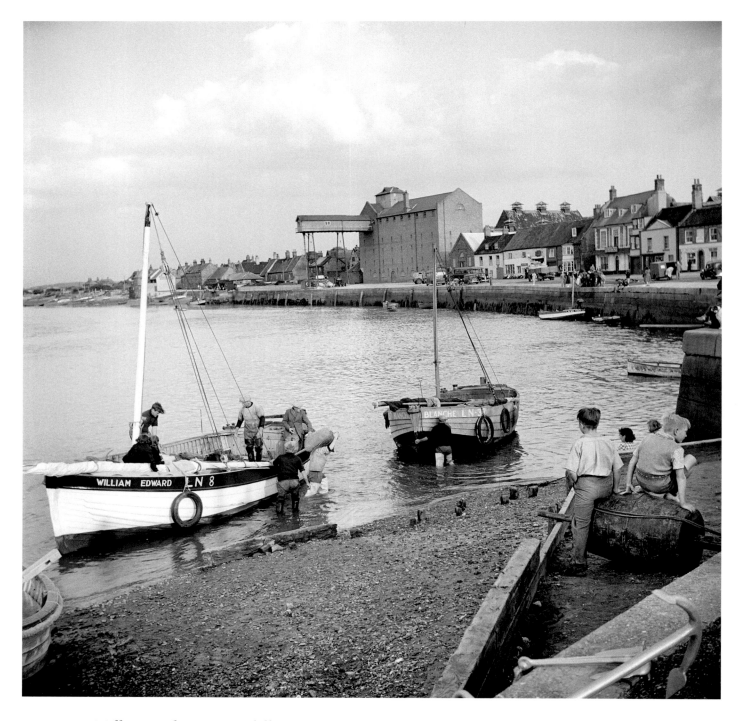

Wells next the Sea, Norfolk, August 1949
An inshore fishing boat, the *William Edward*, unloads cockles at Wells next the Sea, watched by an appreciative audience. [AA98/14631]

Aldeburgh, Suffolk, May 1950
Inshore fishing boats are drawn up on the shingle beach at Aldeburgh. Further along the beach a lifeboat is kept in readiness – a perpetual reminder of the dangers of making a living from the sea. The North Watch Tower and Lifeboat Station can be seen in the distance. [AA98/09409]

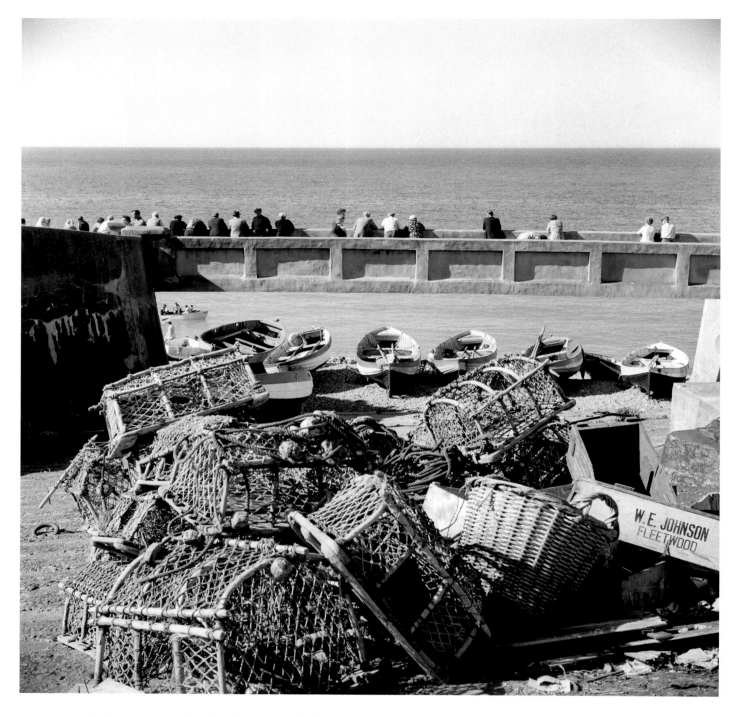

Lobster pots, Sheringham, Norfolk, 1959
In the mid-19th century over a hundred small boats operated out of Sheringham, one of many small fishing settlements on the north Norfolk coast. Following the arrival of the railway in 1887, lobsters caught in Sheringham could be on sale in London the same day. Improved transport links also allowed the town to develop as a seaside resort and, although the amount of fishing has declined, it is still renowned for its lobsters. [AA98/18178]

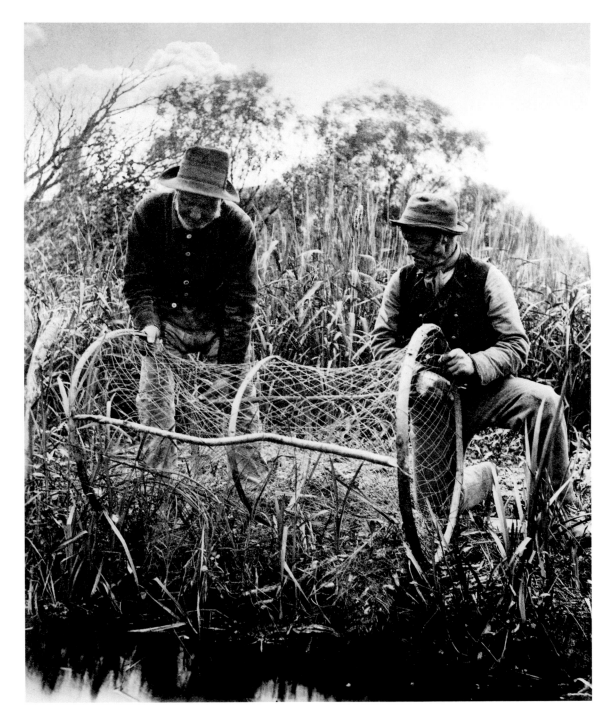

An eel net

Eels were a major food in East Anglia and were available in huge quantities. Domesday Book records that fisheries in Littleport and Stuntney, Cambridgeshire, paid the Abbot of Ely 17,000 and 24,000 eels respectively, while in Wisbech, Cambridgeshire, 20 fishermen paid a total of 31,760 eels to various overlords. In this old photograph copied by Hallam Ashley, two men are showing off an eel trap beside a waterway. [BB99/05551]

~ *Food and drink* ~

Following directly from agriculture, and essential for the life of the community, food processing covers a range of activities that often had their origins as domestic tasks carried out by individual households to meet their needs but which evolved into crafts in their own right. The staple foods of most village people were produced locally. Bread was a basic foodstuff for working people well into the 20th century and so milling (*see* p 56) and baking were fundamental activities. Few households could afford either a bread oven or the fuel to heat it, so one or two specialist bakers emerged to serve the needs of each community. Fish was a major component of the diet in coastal areas while meat, when eaten at all, was often bacon from your own pig. Cheese was another staple which could either be made at home or purchased locally. Fruit and vegetables were produced on villagers' allotments or received as payment in kind.

Malting and brewing were small-scale local industries dependent upon local agriculture. Weak beer was important as a safe drink – William Cobbett, the early 19th-century political writer, estimated that a family used on average two quarts of beer a day in winter and up to five quarts in the height of summer (Cobbett 1826, para 25). Brewing was once carried out in nearly every village home and inn, but in Blaxhall, at least, domestic brewing died out with the First World War (Evans 1958, 60). Over the last 150 years brewing and malting have developed on an industrial scale.

Keeping food fresh and preserving it to extend the season were major concerns, and traditional recipes for bottling and pickling would be passed down from generation to generation. Milk was easier to transport and store if it was converted into cheese or butter, though it might be sold fresh in a local town. Only with the coming of the railways was it possible for advantageously located dairying areas to exploit the demand of urban centres for fresh milk. For fishermen, most of the catch could be gutted, salted and packed in barrels to be shipped to market, but other traditional methods of preservation, such as smoking herring to make kippers or bloaters, were important.

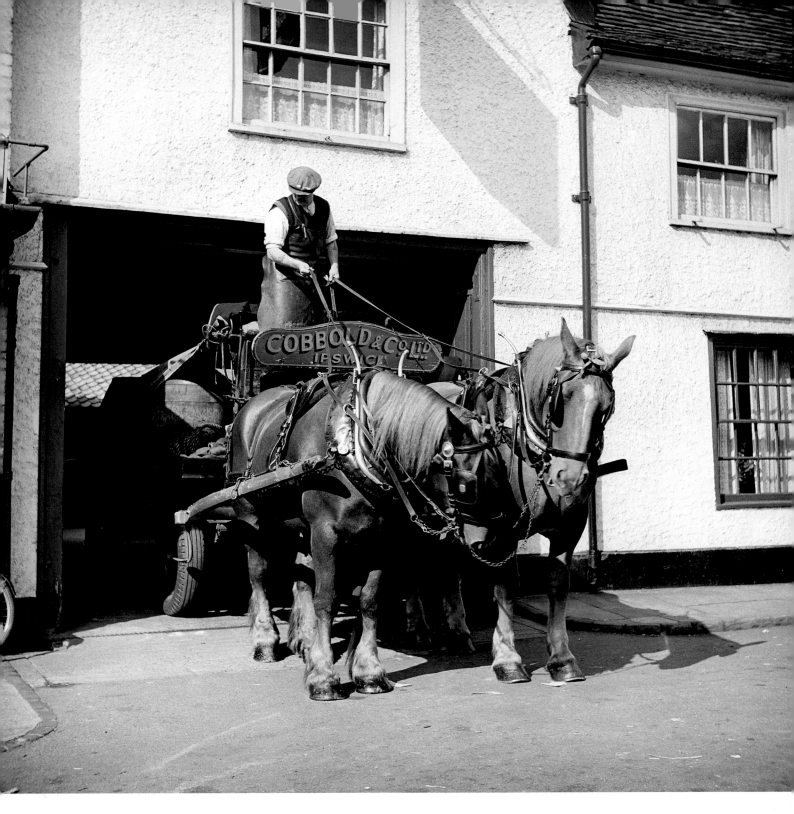

*Brewer's dray, Saracen's Head, St Margaret's Green, Ipswich, Suffolk,
September 1950*
Brewers were often local firms supplying public houses within a small radius. Drays were well-adapted working vehicles and two horses could pull 10 or 12 barrels. Brewers have remained among the most loyal supporters of horse-drawn transport and today some firms still use drays for promotional purposes. [AA98/12167]

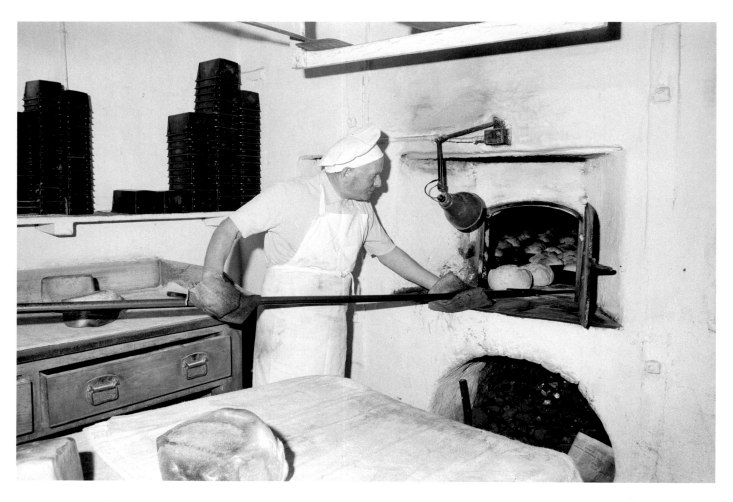

Bakery, William Street, Norwich, Norfolk, October 1968
From the Middle Ages until the 20th century most households depended on a local baker for their daily bread. W R Busey, Baker and Grocer, baked on the premises using a traditional dome-shaped brick oven with a rake hole beneath. In this photograph the baker removes the loaves from the oven using a wooden shovel or 'peel'. [MF98/01550/08]

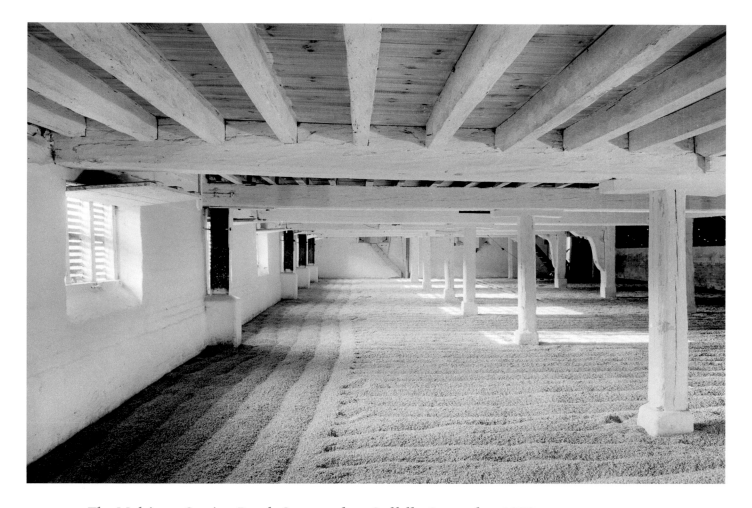

The Maltings, Station Road, Stowmarket, Suffolk, September 1970
Malting is the first process in the making of beer. Grain, usually barley, is first soaked in water in large tanks or 'steeps' and then spread at a depth of about 30cm (1ft) over the malthouse floors. This encourages germination which causes the starch cells to break down and produce a sugar called maltose. When the grain starts to sprout it is transferred to a kiln where it is heated to halt germination – it is then known as malt. Once nearly every town and village in England had a traditional floor maltings like this one: today fewer than 10 are still in use. [MF98/01576/08]

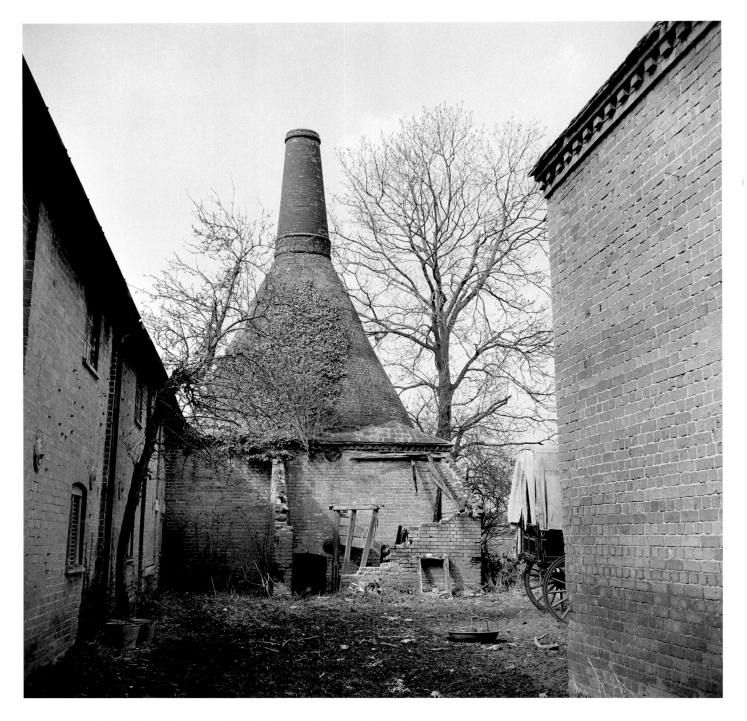

Barley kiln, Mill House, Kersey, Suffolk, April 1958
Traditional malthouses are usually long, rectangular buildings of several storeys. The small windows are shuttered for ventilation control, and there is usually a kiln or kilns with distinctive pyramidal or conical roofs at one end of the complex. This malting was attached to the water mill at Kersey, though the kiln looks quite derelict in this photograph. [AA98/12722]

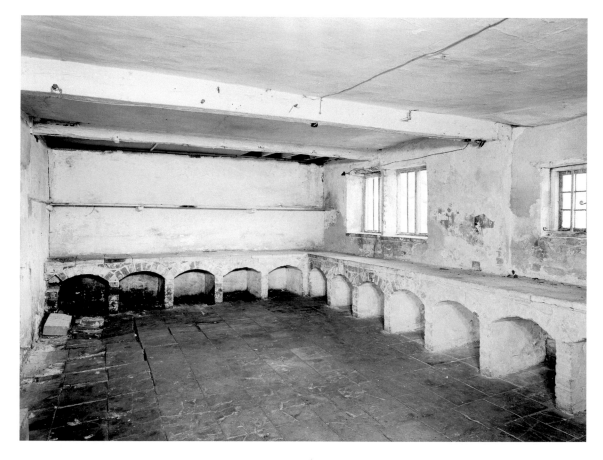

Brewhouse, Ashby Hall, Ashby St Mary, Norfolk, May 1960
Public houses frequently brewed their own beer. Before reliable sources of drinking water were available, many country houses also brewed their own beer as the normal drink for their large staff. By the late 19th century, however, the ready availability of cheap beer and other bottled drinks led most country houses to stop their private brewing activities. This brewhouse at Ashby Hall does not appear to have been used for a long time. [BB98/27256]

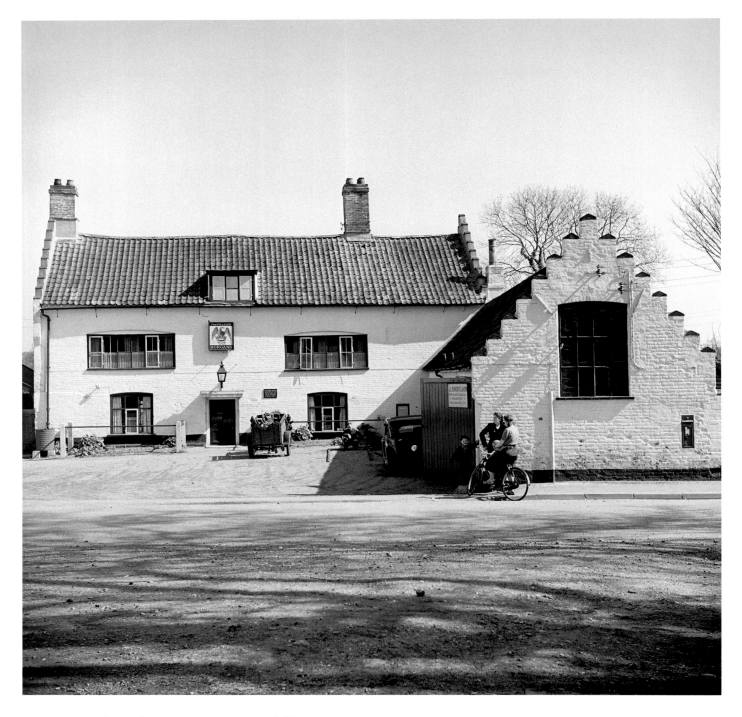

The Falcon, Costessey, Norfolk, May 1950
This country pub encapsulates the history of the brewing industry. In the 19th century the land-
lords brewed their own beer; in 1918 the pub was bought by Morgans of Norwich which was
itself acquired by two local rivals, Bullard's and Steward & Patteson. They in turn were swal-
lowed up in 1966 by the major national company Watney Mann. The Falcon closed the same year.
[AA98/14922]

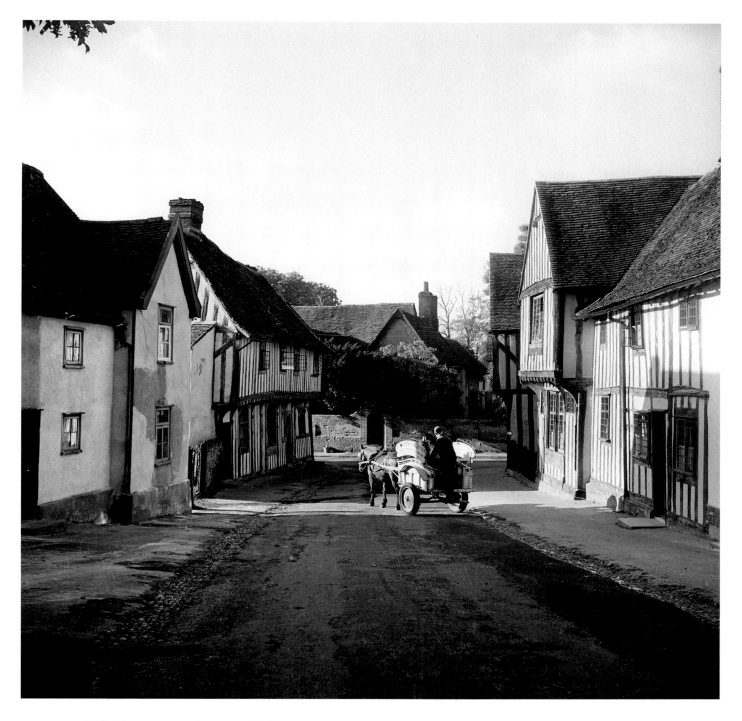

Milk float, Lavenham, Suffolk
In the early morning sunlight, a horse-drawn milk float makes its slow way from door to door down a street of half-timbered houses. The daily delivery became a British tradition, now in decline. [AA98/09366]

Lowestoft, Suffolk, September 1968
Herrings (known colloquially as 'the silver darlings') were an important industry in Lowestoft. The fish were often cured by smoking to turn them into kippers, and this man was the owner of the last kippering smokehouse in Lowestoft. [AA98/16381]

~ Milling ~

The grinding of cereals into flour is a basic process in the conversion of raw agricultural produce into food. For many centuries, the mill was an essential part of the village economy, particularly in corn-growing areas – the 3,000 settlements mentioned in Domesday Book (compiled in 1088) had an average of almost two mills each. Milling remained mainly a small-scale industrial process until the late 19th century, serving the local area and drawing upon the produce of local agriculture.

A mill represents a considerable capital investment, and until the Industrial Revolution was at the forefront of technology. The miller, responsible for processing cereal into flour, was a person of substance in the local community – though he is credited with a reputation for dishonesty in Chaucer's *Canterbury Tales!* The mill was not simply a machine: skill was required to maintain the right consistency of flour, and to prevent the wind from running away with the sails and causing damage. A related craftsman was the millwright, the specialist who built and maintained mills and their equipment.

From the later 19th century, windmills increasingly lost their sails and were powered instead by steam, which was more reliable than wind as a source of energy: the absence of sails in an old photograph does not necessarily imply that a mill was redundant. The introduction of the roller mill in the 1880s made milling corn on an industrial scale possible, and a few big firms had risen to dominance by 1914. This led to a rapid decline in the use of wind and watermills for grain and many went out of use, though others staggered on for another 40 years.

In addition to milling flour, water mills in particular have been used to power industrial processes and windmills have been used to grind many non-foodstuffs such as animal feed, linseed oil and chalk. One very significant use for windmills in East Anglia was to drive water pumps for land drainage and reclamation, making the windmill almost synonymous with this area. However, from the mid-19th century they were increasingly replaced by pumping engines and many drainage mills became derelict, though wind-powered drainage mills were still being built on the Broads until the start of the 20th century.

Windmills are picturesque landscape features and have often attracted the attention of artists. Water mills also have their admirers. In the last 50 years many mills have been saved and are managed by local preservation trusts, while an increasing market for organic flour is providing a financial lifeline for others.

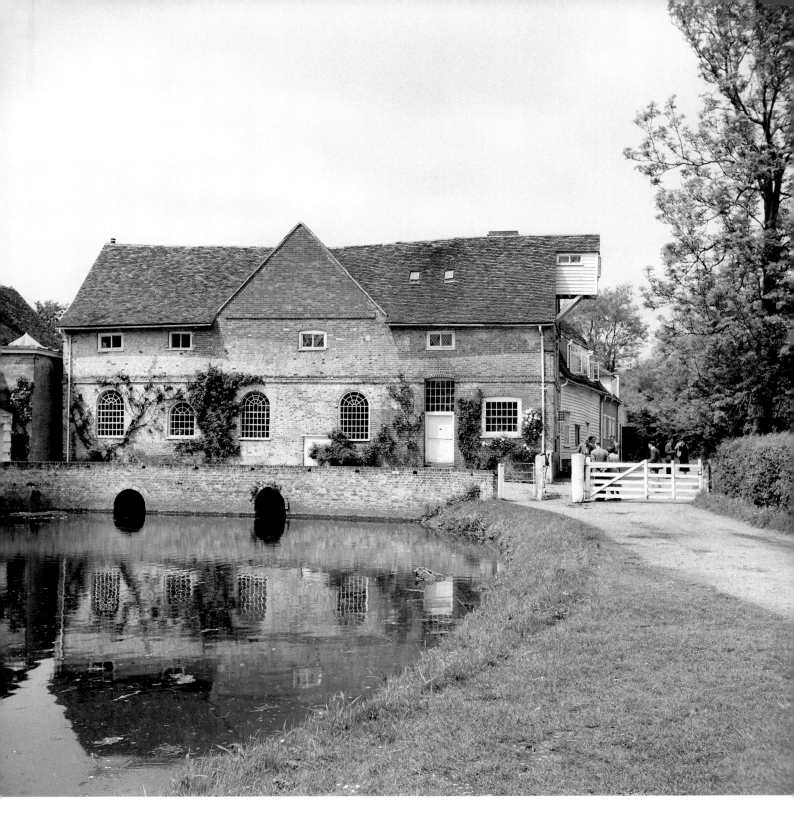

Flatford Mill, East Bergholt, Suffolk, May 1954

The earliest type of mill in England was the water mill. They were known to the Romans and, following a short hiatus, were present again from the Saxon period. They are technologically complex, demanding a level of engineering skill to ensure a reliable water supply. Flatford Mill is a late example, built in the 17th century, and made famous by the artist John Constable's painting *Flatford Mill* (1817). [AA98/11813]

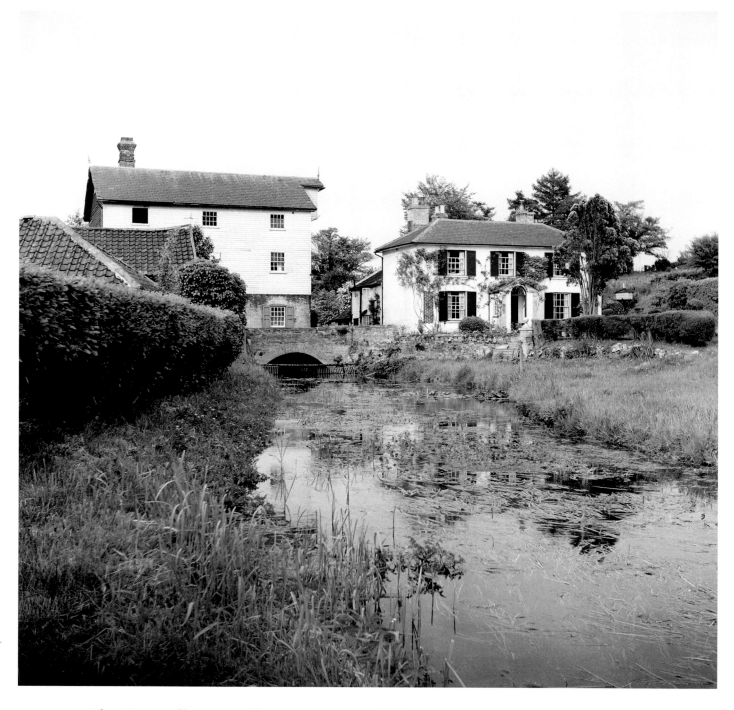

The Watermill, Watermill Lane, Hoxne, Suffolk, June 1954
This corn mill and neighbouring miller's house on the River Waveney make a charming composition which could almost have come from a tourist guide. The mill, with its weatherboarded upper storeys, dates from 1846 and the house is of a similar date. The view, taken from upstream of the mill, shows the headrace which channels water from the main stream to power the mill wheel, after which it is returned to the river. [AA98/10014]

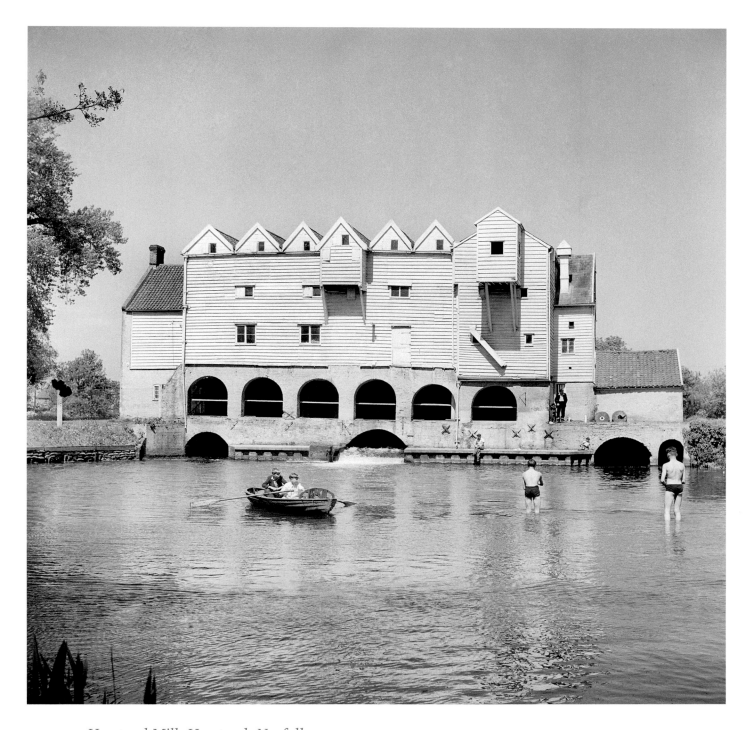

Horstead Mill, Horstead, Norfolk
This late 18th-century weatherboarded corn mill on the River Bure is powered by two water wheels; it appears to be on a larger and more commercial scale than the previous two examples. The pool below the mill seems to be a favourite spot for fishing, swimming and boating despite dangerous currents. The mill was gutted by fire in 1963 and is now a ruin. [AA98/11271]

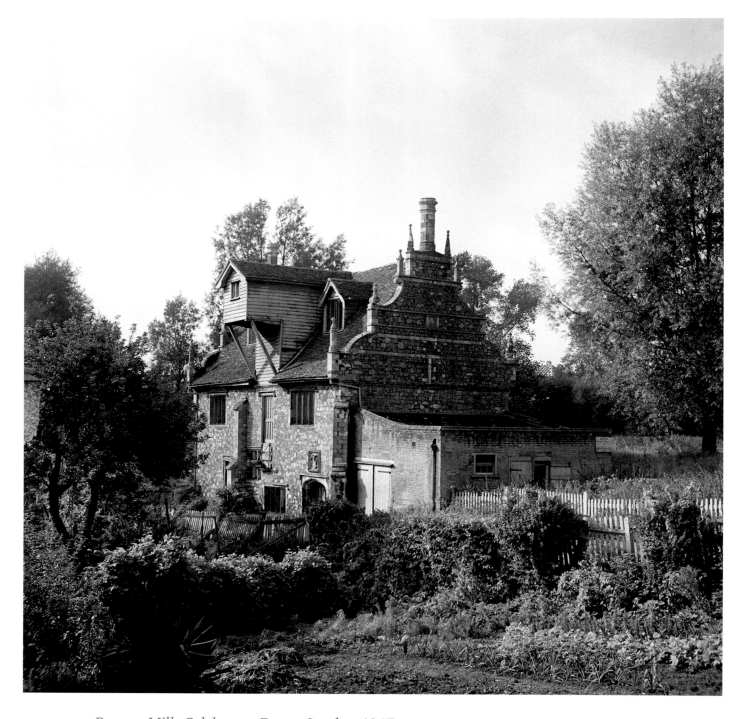

Bourne Mill, Colchester, Essex, October 1947
This ornate building on the banks of the River Colne has a more varied history than most mills. It was erected in 1591 as a fishing lodge by Sir Thomas Lucas, reusing stone and architectural fragments from nearby St John's Abbey which had been demolished following the Dissolution of the Monasteries. In the 19th century it was converted into a fulling mill, powered from a mill pond to the rear. In 1833 it was again converted, this time into a flour mill, and the weatherboarded hoist loft was added. [AA98/17146]

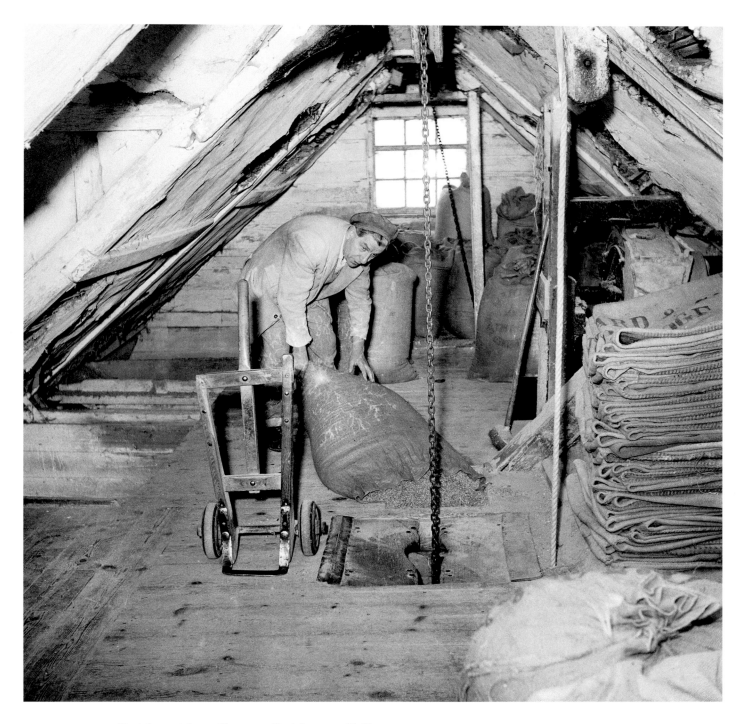

Woodbridge Tide Mill, Woodbridge, Suffolk, May 1954
A rare type of mill in Britain, the tide mill makes use of the large tidal range around the British coast. The incoming tide fills a pond, and as the tide ebbs the water is released in a controlled manner to drive a wheel – in other respects a tide mill is similar to any other water mill. This mill at Woodbridge is thought to have been the last working tide mill in England and was still in use when it was photographed by Hallam Ashley. It finally ceased working in 1957. [AA98/11837]

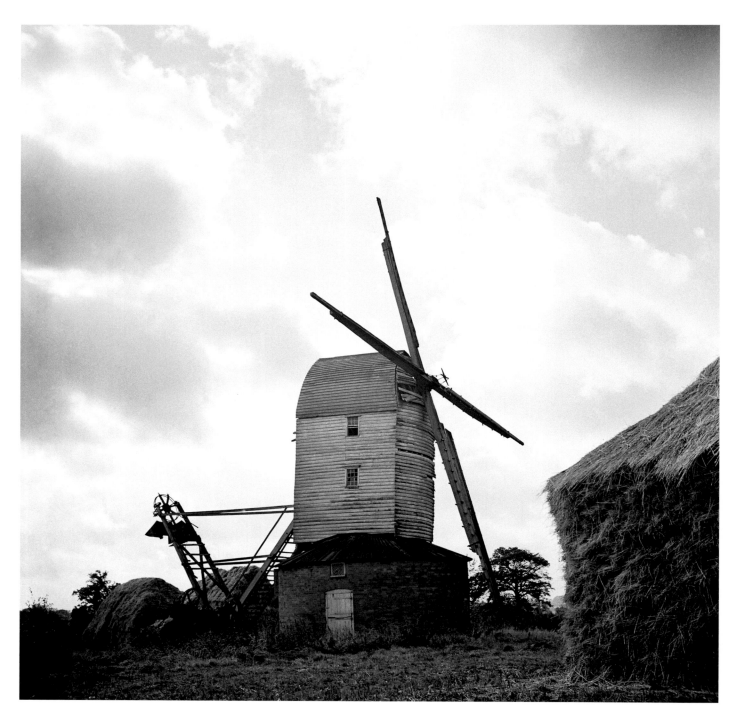

Post mill at Thornham Magna, Suffolk, 1950
Introduced in the 12th century, post mills were the earliest form of windmill in England. The timber-framed body of the post mill is carried on a central upright post around which it can rotate through 360 degrees. A fantail at the rear of the mill automatically turns it into the wind. By the 18th century the timber trestle supporting the mill was often encased within a roundhouse, as here. Windmills declined in the later 19th century as a result of the introduction of industrial-scale milling technology, though many continued in use well into the 20th century. The post mill at Thornham Magna seems to have become derelict by the time of this photograph. [AA98/07336]

Drinkstone Smock Mill, Drinkstone, Suffolk, June 1951
Smock mills were probably introduced into England in the late 16th century. They consisted of a timber-framed tower surmounted by a cap which carried the sails and could rotate on top of the tower to face the wind. One of their advantages was that they were more robust than the earlier post mills. Drinkstone Smock Mill has lost its sails, but a post mill with sails can be seen beyond it. [AA98/07095]

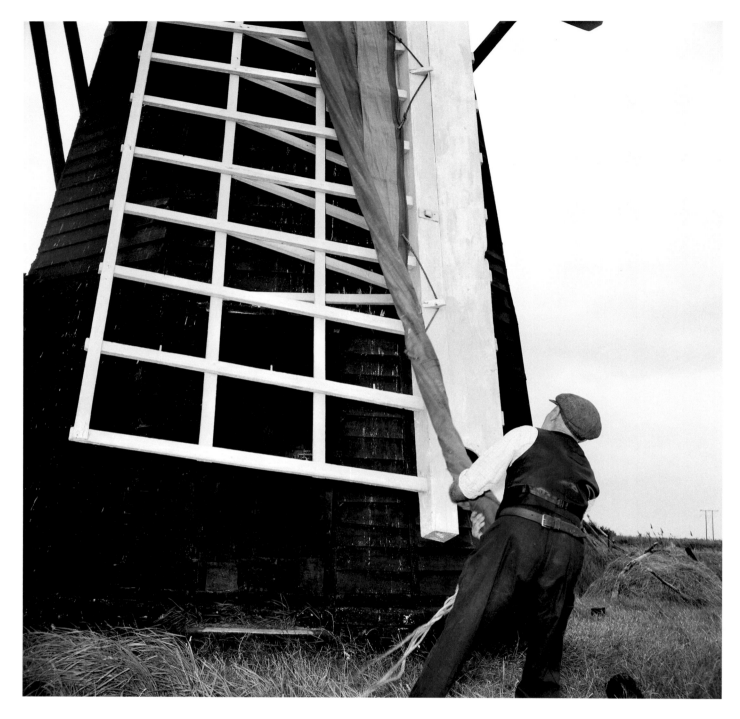

Drainage mill, Herringfleet, Suffolk, July 1959
The basic sail is a frame to which either a cloth or shutters are fitted to catch the wind. Here the miller is 'clothing' his sail – adjusting the amount of cloth covering the sail according to the wind conditions both to ensure the appropriate level of power, and to prevent the mill mechanism from over-speeding and being damaged by strong winds. Herringfleet mill was built in the 1820s. [AA98/09904]

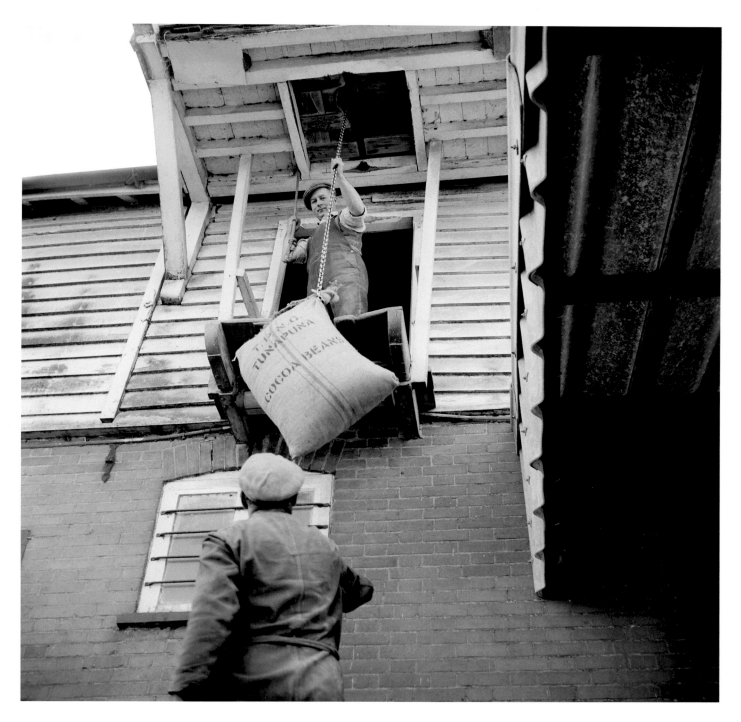

Elsing Mill, Elsing, Norfolk, May 1967

Gravity helps to move the grain through the milling mechanism. Sacks of cereals are hoisted to the top floor where they can be loaded into the hopper – although this sack claims to contain cocoa beans! This water mill was established as a paper mill in 1809 but rebuilt in 1854 as a corn mill. It was later converted for animal feed and finally ceased working in 1970. [AA98/11683]

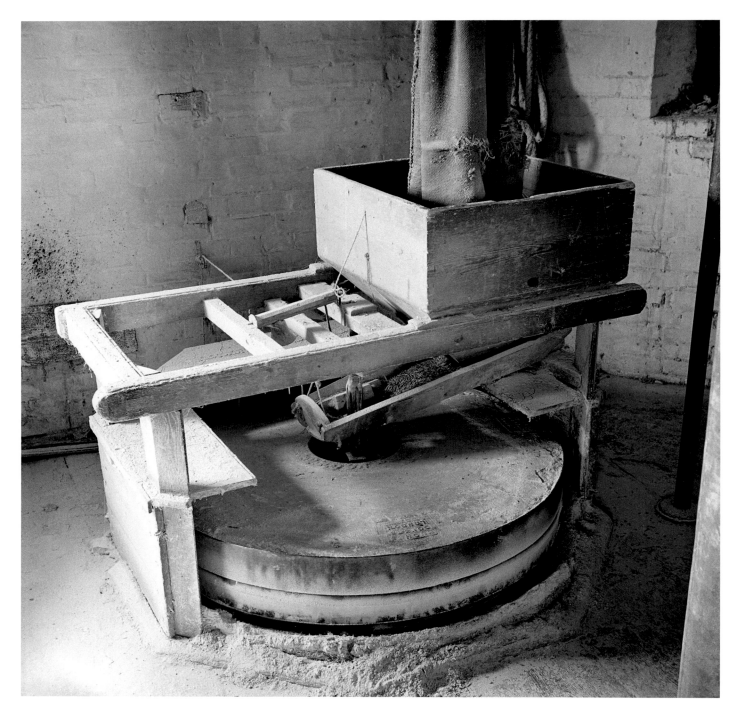

Downfield Mill, Soham, Cambridgeshire, May 1948
This is a good illustration of how a mill grinds cereals. The grain from a bin on the top floor is fed down through the mill by gravity passing down a spout into the hopper over a pair of stones. A 'shoe' (or chute) feeds it from the hopper into the eye in the centre of the runner. As corn is ground between the rotating stones, meal/flour is pushed out at the side and passes down another spout into the meal bin. In this picture part of the skirting around the stones has been removed to give a clear view of the mechanism. [AA98/15988]

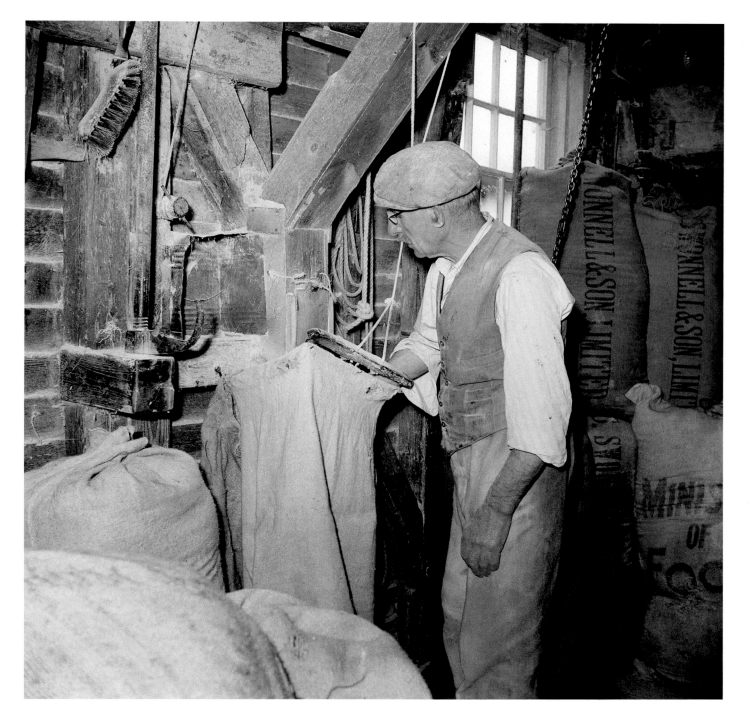

Friston Windmill, Friston, Suffolk, September 1953
The miller, Mr Wright, watches as flour comes down the spout from the millstones above and fills a sack. Behind him a sack is stencilled 'Ministry of Food' – a reminder that the control of food production and rationing lasted for several years following the end of the Second World War. [AA98/13435]

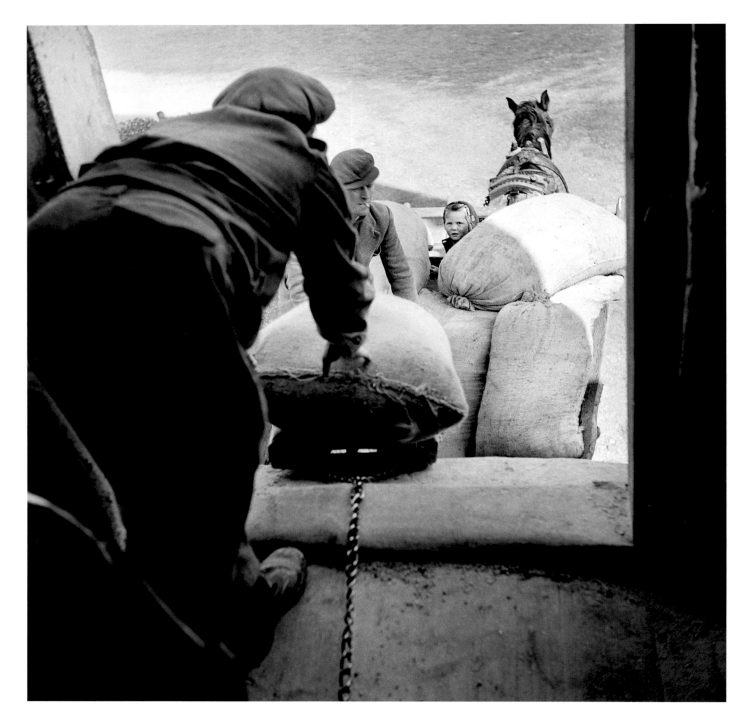

Billingford Mill, Billingford, Norfolk, April 1950
This tower mill (similar in form to a smock mill, but built of brick or stone and so more substantial) was built in 1859–60 and ceased working 100 years later. The miller at the time of this photograph was Arthur Daines who carried on working the mill until it closed in 1959. Here sacks of meal or flour are being loaded down a chute onto a horse-drawn wagon, a reminder of the long survival of traditional practices in many areas of rural life. [AA98/07572]

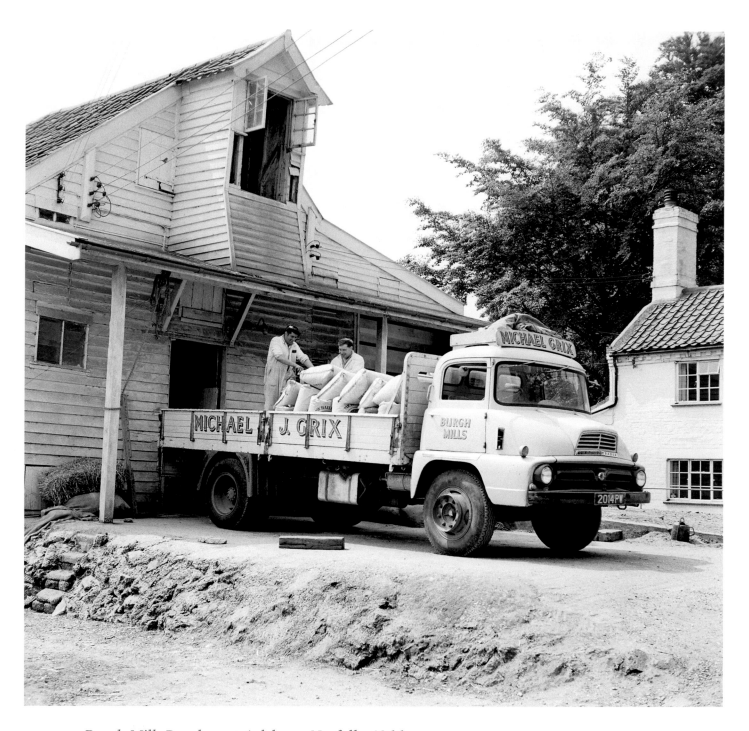

Burgh Mill, Burgh next Aylsham, Norfolk, 1966
This large weatherboarded water-powered corn mill on the River Bure was rebuilt in the late 18th century. In the 1890s the mill owned three wherries which plied up and down the river to the docks at Great Yarmouth. The Grix family bought the mill in the early 20th century and it passed from father to son. In contrast with Billingford Mill, sacks of flour are loaded onto the company's lorry. [AA98/11668]

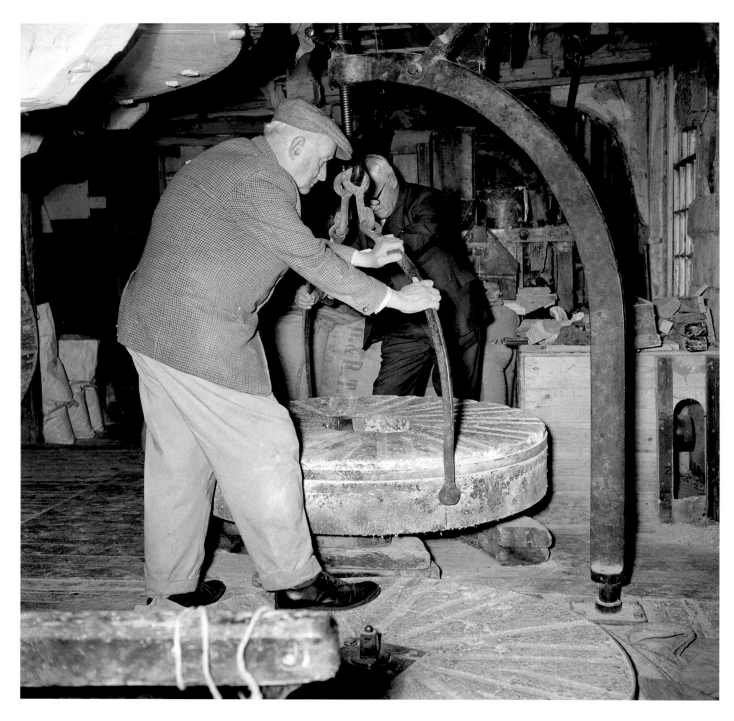

Lifting a stone, Debden Watermill, Wickham Market, Suffolk, October 1967
The upper millstone, known as a 'runner', might weigh up to one ton. Raising it for dressing was a routine task, so most mills were equipped with sturdy lifting apparatus. In this photograph Edward and Robert Rackham lift and turn a runner without difficulty and position it on wooden blocks ready for dressing. In mills which lacked similar lifting gear, this task would require brute force and could be dangerous. [AA98/13162]

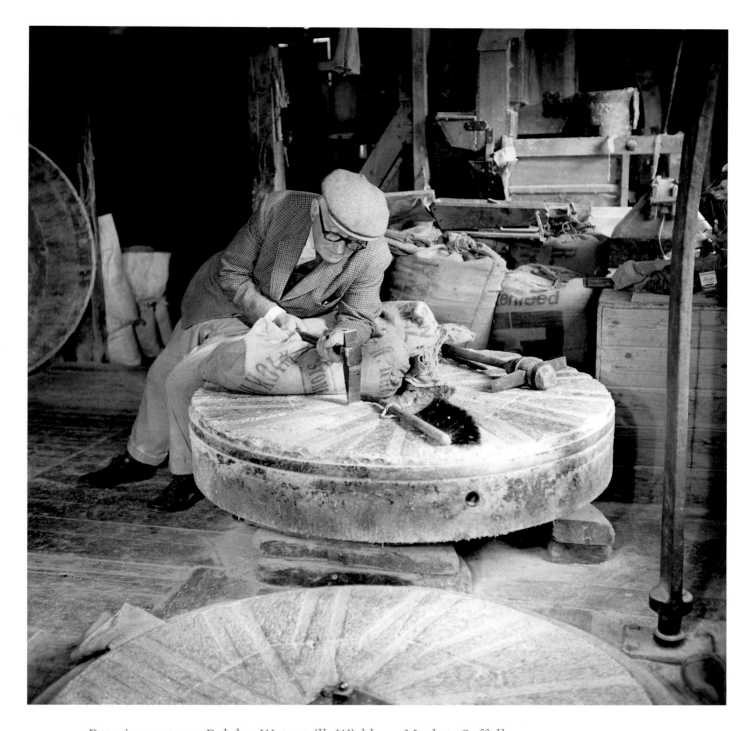

Dressing a stone, Debden Watermill, Wickham Market, Suffolk
The surface of a millstone consists of a pattern of furrows (or grooves), the edges of which must be sharpened – perhaps monthly – in order to grind efficiently. This skilled task is known as 'dressing', and was often carried out by the miller himself or more rarely by a millwright. The upper stone or 'runner' must first be lifted off the lower or 'bedstone' and laid face upwards. Here the miller uses his 'mill bill', a steel pick, to dress a runner. [AA98/15813]

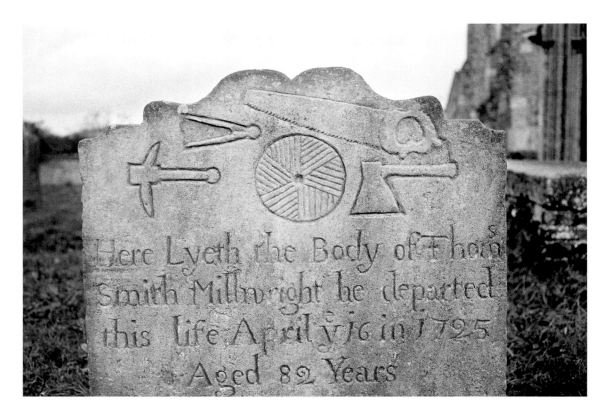

Gravestone, St Mary's churchyard, Wiveton, Norfolk, November 1976
This 18th-century headstone commemorates Thomas Smith, millwright. The tools of his trade are engraved into the stone – a millstone, a mill bill for dressing the millstone, a pair of compasses, a saw and an axe for the carpentry required to build a mill complete with its wooden machinery. That Thomas lived to a ripe old age, together with the fact that his estate could afford a headstone, suggest that the millwright's craft was relatively prosperous. [MF98/00321/29-30]

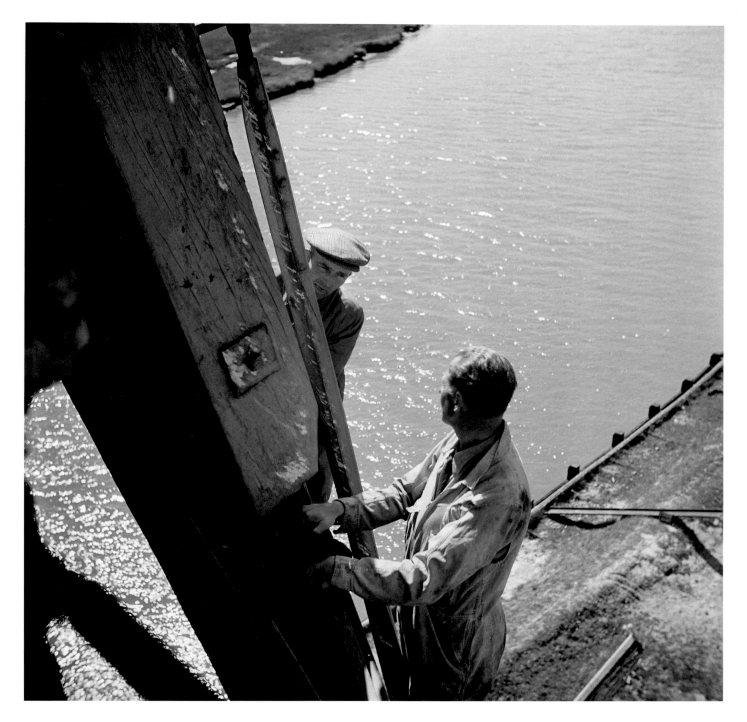

High Mill, Berney Arms, Reedham, Norfolk, May 1948
Rex Wailes (nearest the camera, an expert on the history of mills) and a millwright examine a
sail during the restoration of High Mill. This was a drainage mill, a type of mill which powered a
scoop wheel to raise water from one level to another as part of a land drainage system. This mill
originally had a dual function as it also ground clinker for cement. It has now been restored and
is in the care of English Heritage. [AA98/15997]

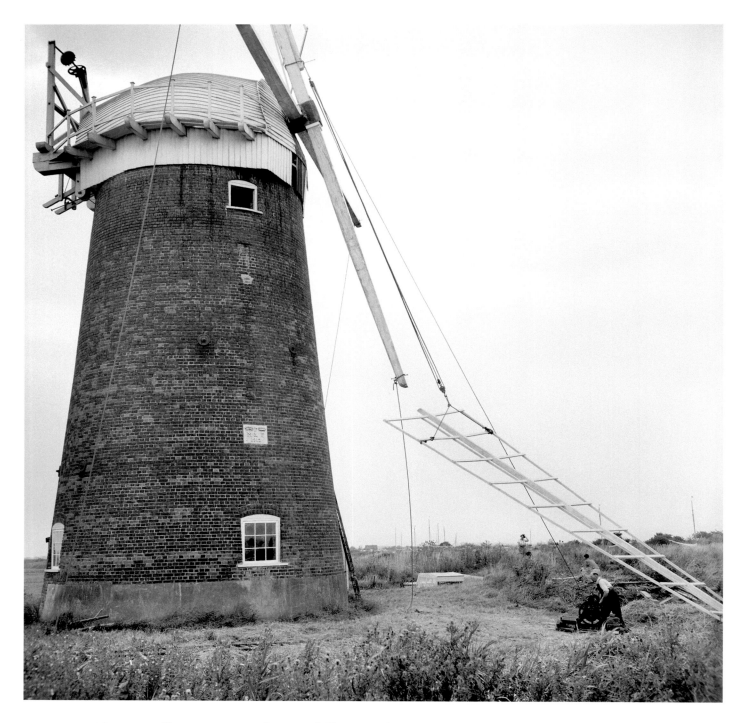

Horsey Mill, Horsey Staithe, Norfolk, 31 July 1961
Horsey drainage mill was rebuilt in 1912 and restored in 1961 following a lightning strike 20 years previously. Here a new set of sails is being raised onto the stocks (the cross-timbers to which the sails are fixed) during restoration. This operation uses a simple technology of ropes and pulleys, with the stocks anchored to prevent them from turning. [AA98/15787]

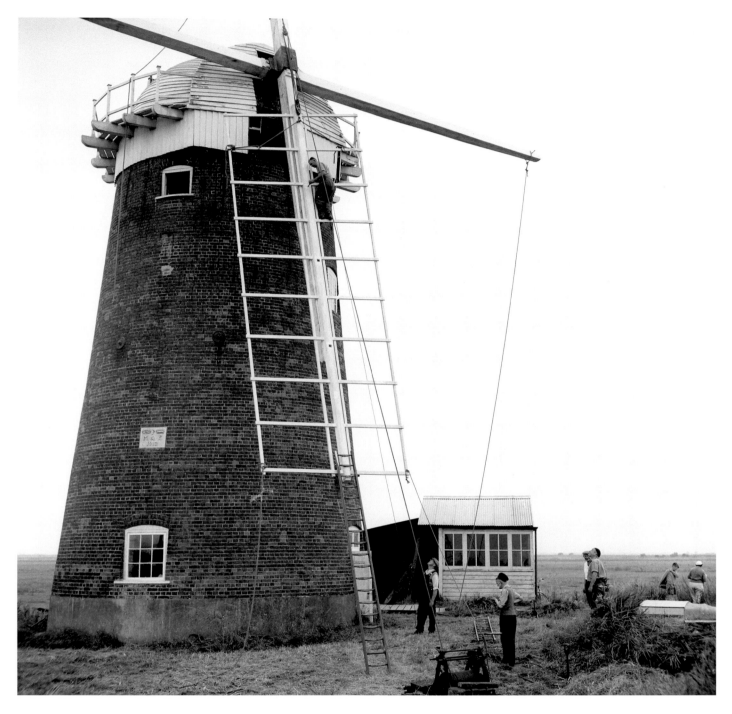

Horsey Mill, Horsey Staithe, Norfolk, 31 July 1961
Once the new sail has been raised into the required position against the stock, a millwright climbs
the sail frame and attaches it to the stock using bolts and straps. This procedure must be repeated
for each sail. [AA98/15851]

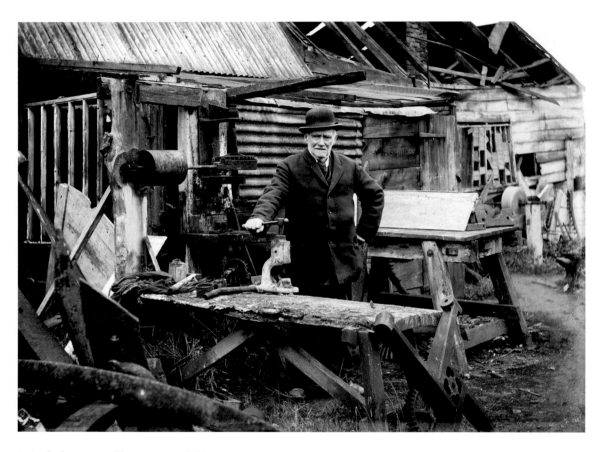

Workshop, Ludham, Norfolk

Edwin William Daniel England, a fourth generation millwright, stands among the work benches of his workshop in Ludham High Street. Such small-scale workshops were always functional environments, and maintenance was soon skimped when business began to dwindle. During the 1930s England's yard became increasingly derelict, as is evident here. Although the mill-building era was over by the 1920s, England's family firm continued to carry out mill-related work until 1939 (and is listed in *Kelly's Directory* for Norfolk 1937), trading as 'executors of Edwin William Daniel England' after his death in 1933. [BB99/05394]

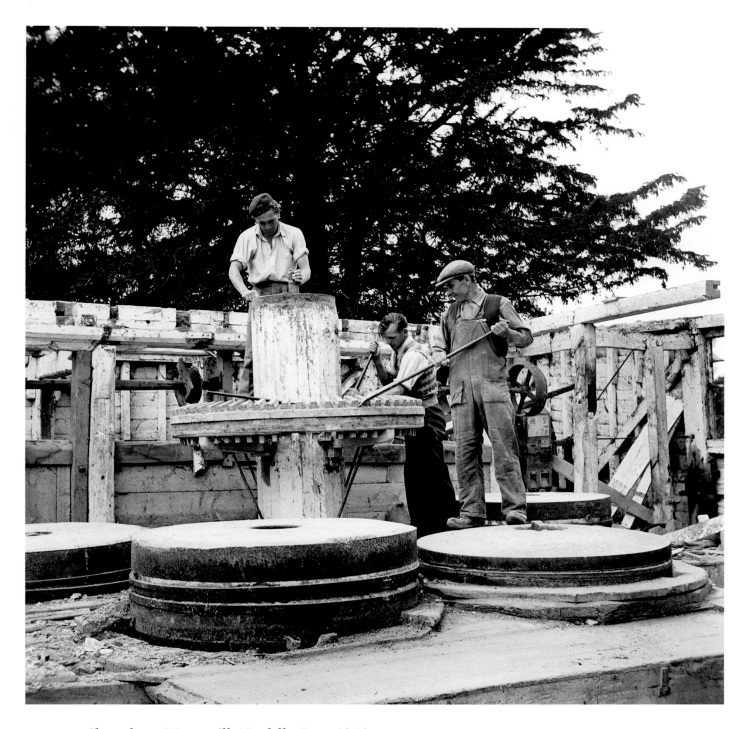

Shotesham Watermill, Norfolk, June 1949
The application of wind and water power for industrial processes declined throughout the 19th century. While its use on a smaller scale for milling corn also decreased, many mills did continue into the 20th century. The traditional, weatherboarded water mill at Shotesham on the River Tas, which was built in the 18th century, typifies this pattern. After years of decline, it finally went out of use in 1947 and was demolished two years later following flood damage. [AA98/07631]

~ *Quarrying* ~

East Anglia has few mineral resources and is poorly endowed with building stone. Hallam Ashley did, however, record a number of quarry sites – no doubt due to his interest in geology.

The only suitable building stone in Norfolk is carstone, a ferruginous sandstone (an outcrop of the Upper and Lower Greensands), which is found in the north-west of the county and used mainly locally. High-quality stone was imported when required, though this was an expensive decision. Flint cobbles from the beaches and fields were a popular alternative. Clunch (or hard chalk) was quarried and used in Cambridgeshire, limestone and ironstone were quarried in Lincolnshire around the fringe of the Fens, and limestone (known as 'Barnack Rag') from Barnack near Peterborough was also widely used in the region during the Middle Ages.

Clay was dug in increasingly large quantities for brick and tile making from the 16th century. In the 20th century, chalk was quarried for cement and lime-burning, while sand was in demand for mortar and for use in the chemical industry.

Quarrying techniques varied according to the nature of the raw material and the size of the quarry. By the time Hallam Ashley was photographing, large excavators and motorised transport had taken over many of the heavy tasks, reducing the workforce hugely – though working methods for skilled craftsmen were still basically traditional.

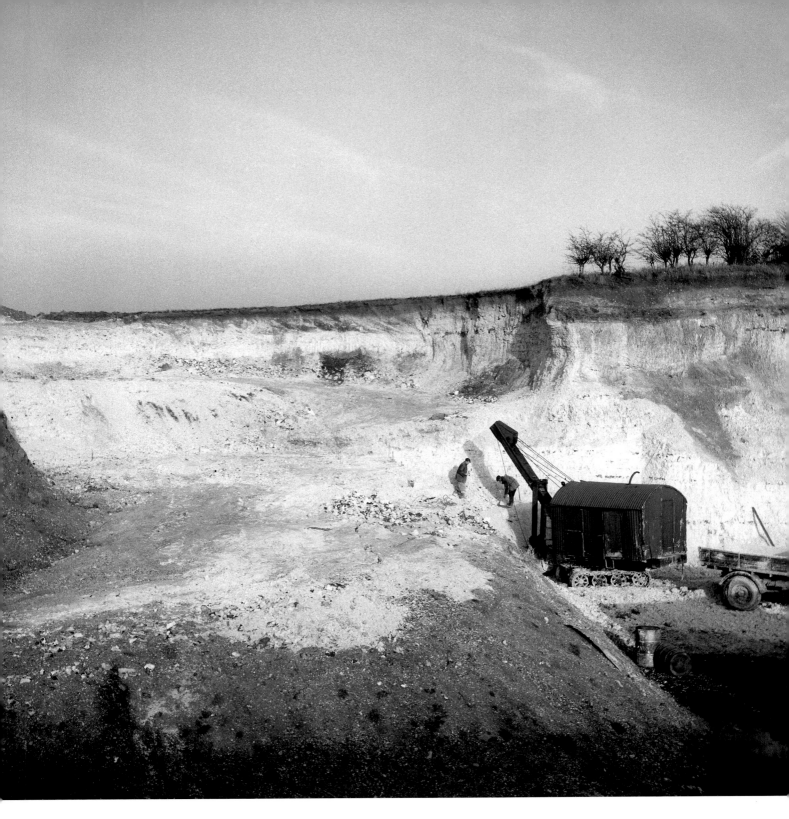

Chalk pit, Caistor St Edmund, Norfolk, December 1954
Here chalk is dug from the quarry face by an excavator on caterpillar tracks and loaded onto a
waiting lorry. [AA98/14740]

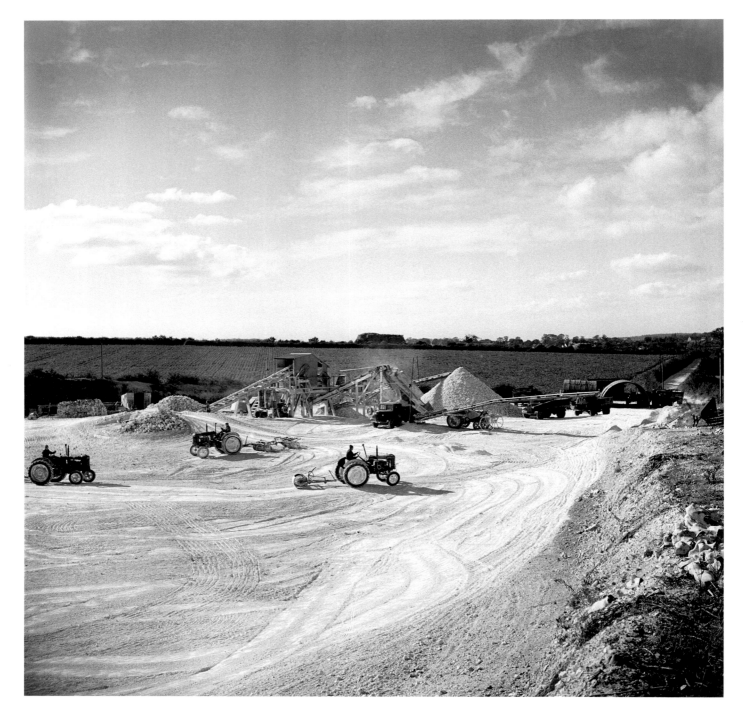

Chalk pit, Newton-by-Castle Acre, Norfolk, October 1946
Chalk was quarried for cement and lime-burning rather than as building stone. It was crushed before being transported: three mounds of crushed chalk can be seen in the middle distance. [AA98/16518]

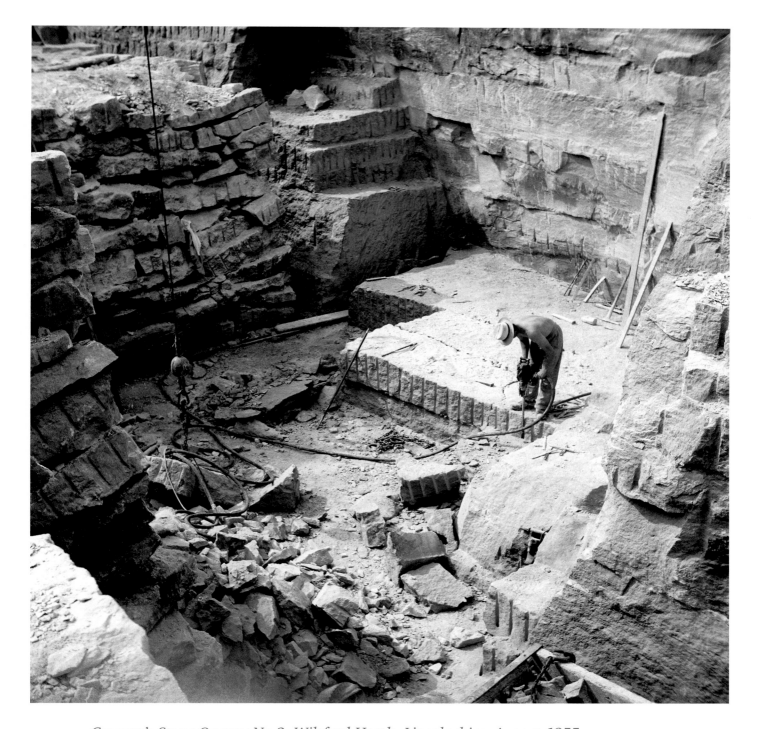

Gregory's Stone Quarry No 2, Wilsford Heath, Lincolnshire, August 1955
Limestone is a sedimentary rock deposited in a marine environment, forming layers which are separated by lines of weakness called bedding planes. Here the layers are horizontal making them valuable for producing regular blocks of stone. It is quarried by drilling a line of holes into a layer and inserting into each a 'plug' (or wedge) between two 'feathers' (or thin plates). The plugs are then driven home using a sledge hammer, and the rock splits along the line. Limestone may either be dressed as building stone or burned for lime. [AA98/14826]

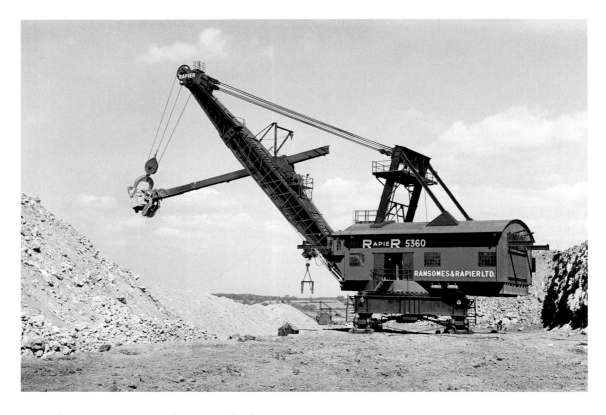

Stainby Quarry, Stainby, Lincolnshire, May 1935
Ironstone forms part of the limestone sequence. Depending on the amount of iron it contains, it was valued either as building stone, when it typically has a brown colouration, or as a source of iron ore. A large excavator was in use at Stainby to strip the overburden from the workable stone, and the waste is heaped up on the left of the picture. [BB99/06536]

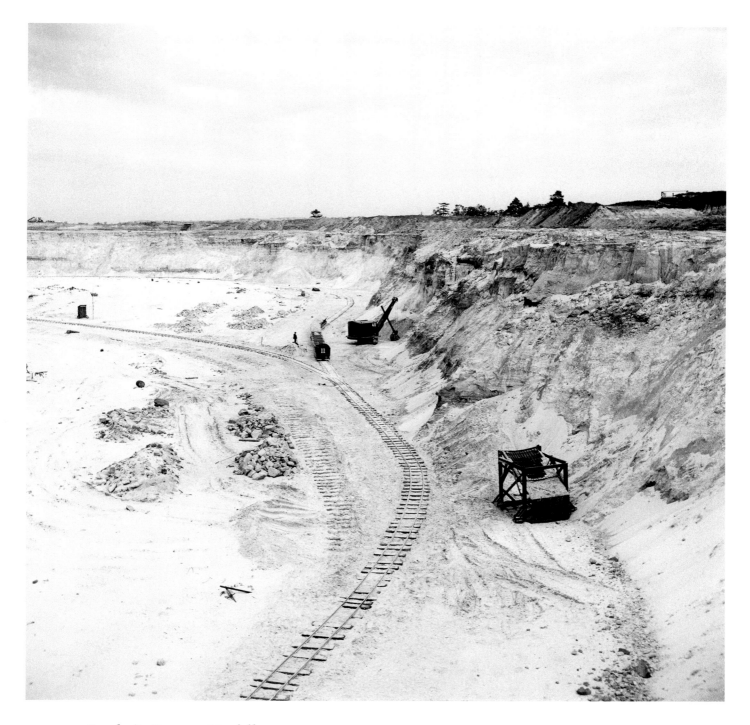

Sand pit, Bawsey, Norfolk

Sand has many uses depending on its quality, for example as foundry sand for metal casting, in glass-making or in mortar. A light railway has been laid to transport sand around this large pit. The track has recently been moved closer to the working face, as testified by the parallel impression of a line of sleepers. While a small excavator loads the wagons, the train driver watches on. The large piece of equipment in the foreground is a 'grizzley', used for grading the sand. Several disused pits in this area have since been flooded to create a country park. [AA98/09738]

~ Building and repair ~

The architecture of a region reflects both local materials and changing fashions. As quality building stone is scarce in East Anglia but wood plentiful, traditional buildings were frequently timber-framed with the spaces filled with panels of wicker, straw and mud (wattle and daub) or brick (known as brick noggin). The exterior was often plastered and this was sometimes decorated further with 'pargetting' – incised or raised patterns made in the plaster. Alternatively, buildings might be weatherboarded externally. Cottages and farm buildings could also be built of cob (clay).

In the Middle Ages many high-status buildings, such as castles and churches, were built in stone which had to be imported to East Anglia. Where this option was too expensive, flint cobbles from the fields and beaches were an important substitute, used both in their own right and for decorative purposes in conjunction with dressed stone (known as 'flushwork'). The specialist skills of masons and stone carvers were rarely found locally, so these craftsmen travelled around the country to each new job. Other travelling specialists include the plumber who leaded the roof; the wood carver who created such details as roof bosses; the stained-glass window maker and the painter (*see* p 124). The skills required to build with the ubiquitous East Anglian flint cobbles – all different shapes and sizes and lacking squared sides and right angles – were more likely to be available locally, as were the carpentry and joinery crafts necessary for all types of buildings.

Brick was increasingly used from the 15th century. At first it tended to be reserved for high-status buildings – country houses such as Oxburgh Hall, Norfolk (built 1482), or churches such as Layer Marney, Essex (built early 16th century). Locally produced cheap brick replaced the timber framing and weatherboarding traditions in the 19th century and was also used extensively in the growing towns. New buildings continue to be built using new materials, requiring new skills and creating new trades.

Vernacular buildings and even some churches were thatched (*see* p 113). In an urban context roofs were more likely to be tiled to minimise the danger of fire. In East Anglia, roofing tile was made of clay rather than slate or stone, and pantiles (a form of clay roofing tile) are a familiar sight in the region.

Buildings always require maintenance and repair, but restoration – an attempt to recreate the original form of a building – is a concept which was introduced by the Victorians and has since been refined. Today many older buildings are restored, reflecting a modern concern with the past. This can sometimes be a drastic process, stripping a building back to its structure and seeking evidence for a faithful reconstruction. More drastic still are demolition and salvage.

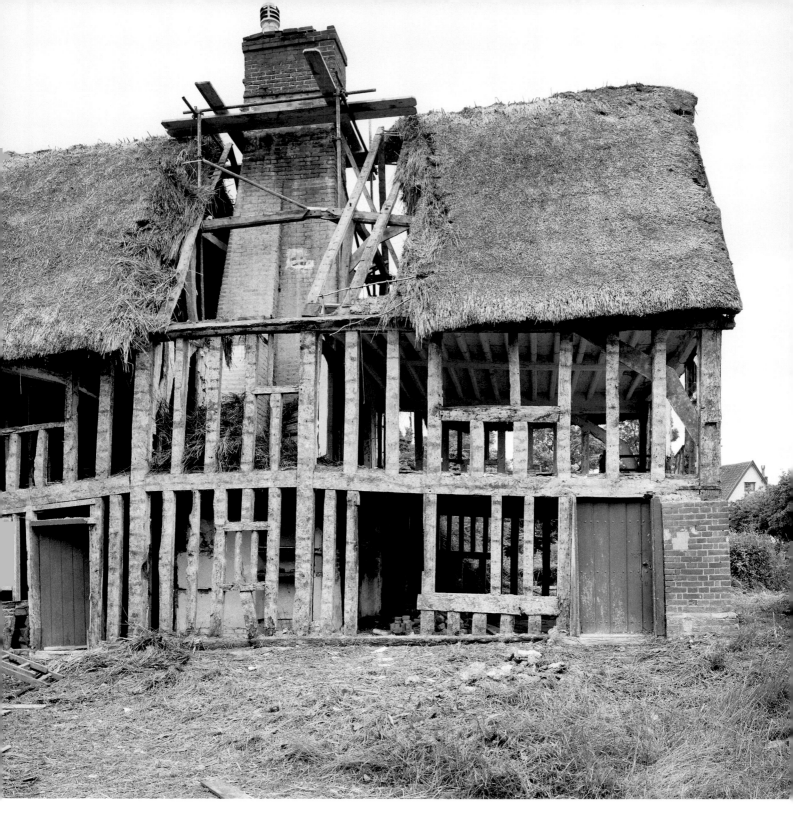

Church Farmhouse, South Elmham St Nicholas, Suffolk, July 1965
In traditional timber-framed buildings only the central chimney stack would be made of fire-proof brick. These buildings often later dropped down the social scale or went out of occupation completely before changing fashion in the mid-20th century rediscovered the beauty of timber framing. This early 16th-century house has been stripped back to reveal its frame prior to a full restoration. [BB98/14520]

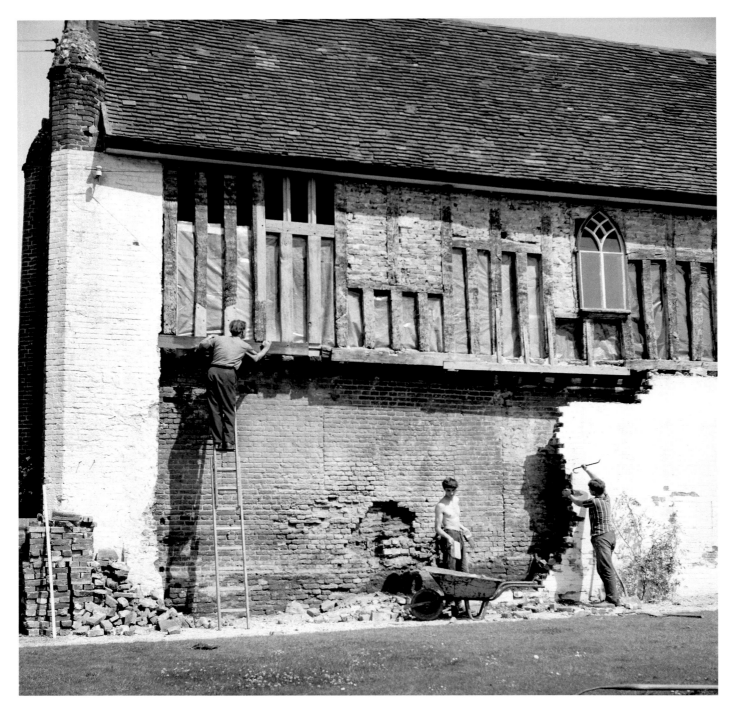

Abbey Farm, Old Buckenham, Norfolk, July 1966
In order to keep in step with changing fashions in the 18th century, this high-quality building was faced in brick thus hiding the original jetty and timber work. In this photograph workmen are removing the functionless outer wall to reveal the 16th-century wall and timber jetty. [AA98/15967]

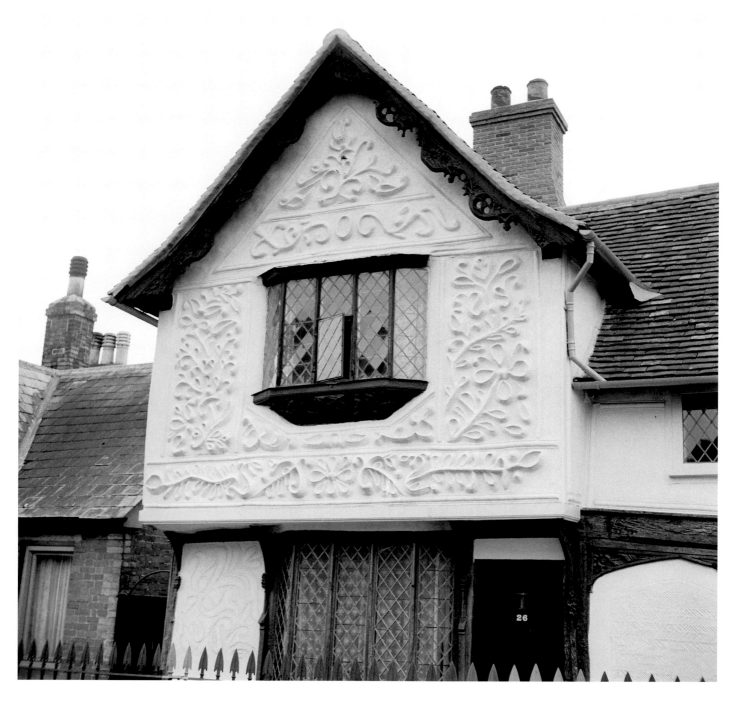

The Ancient House, High Street, Clare, Suffolk, April 1958
Many vernacular buildings were plastered externally in a mixture of lime and sand (often with hair added as a binder) to form a tough, weatherproof surface. During the 16th and 17th centuries this plasterwork became increasingly elaborate and ornamental with raised or recessed patterns. Known as 'pargetting', this craft has its heartland in East Anglia, although examples are known as far afield as Kent, Yorkshire and the West Country. The Ancient House is a particularly fine example of pargetting. [AA98/12764]

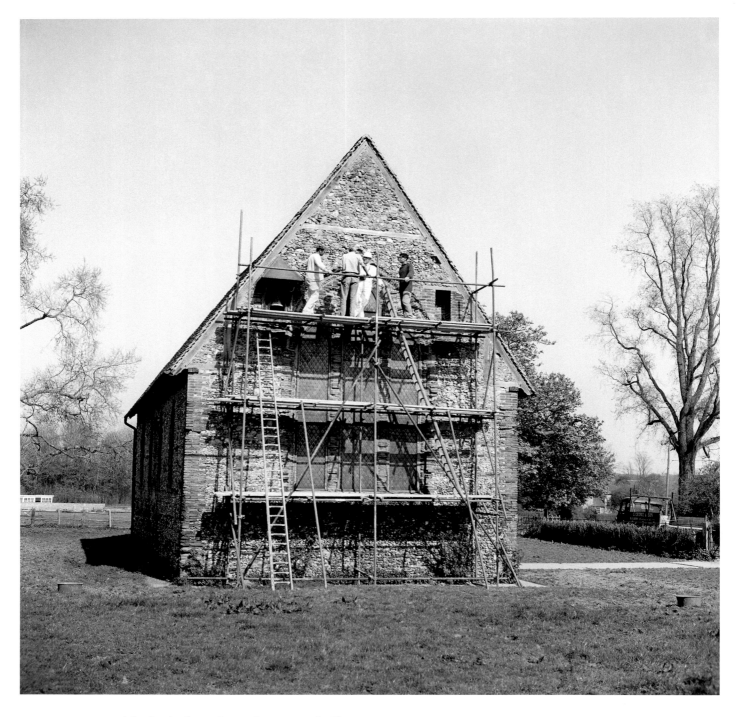

St Nicholas' Chapel, Little Coggeshall, Essex, May 1970
Flint cobbles are often found on East Anglian beaches and fields. This unpromising raw material was mastered by masons and there are many buildings in the region constructed from flint – though key architectural and decorative features sometimes had to made from high-quality imported stone. St Nicholas' Chapel built around 1220 as the gatehouse chapel of Coggeshall Abbey, a Cistercian house founded in 1148, is seen here during restoration. Built largely of flints, it is an early example of the use of brick dressings to give stability at the corners of the building and round the window openings. [AA98/15417]

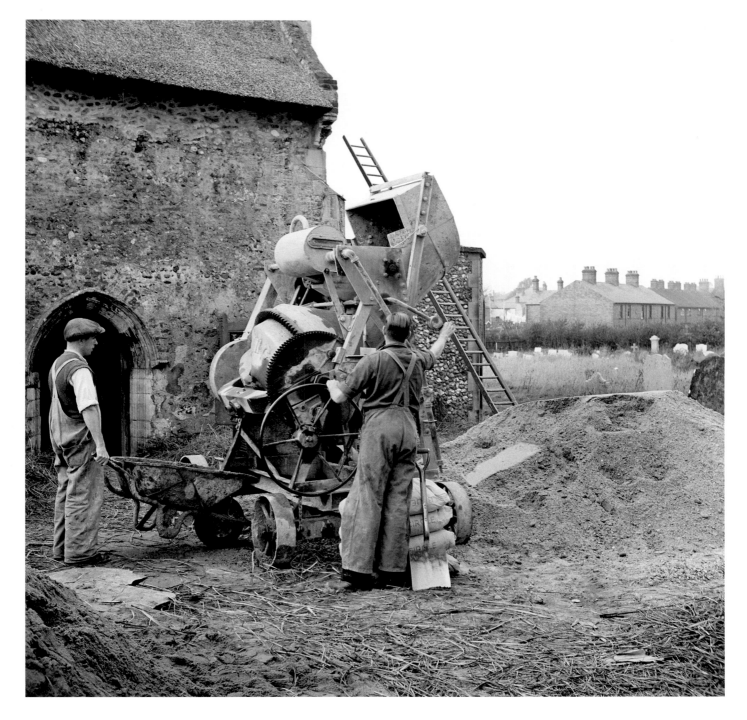

St Margaret & All Saints' Church, Pakefield, Suffolk, October 1949
This 14th-century flint-built church was unlucky to be gutted by a stray incendiary bomb during the Second World War. It was quickly restored, and re-consecrated in 1950. [AA98/14678]

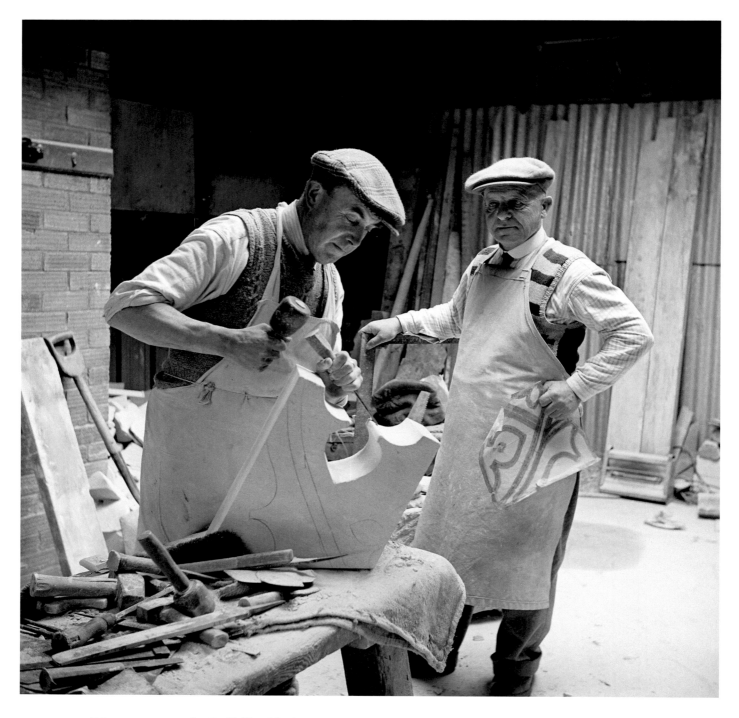

Masons at work, Suffolk, 1949
In the Middle Ages a small army of masons was employed on each church or cathedral building project, and many cathedrals still maintain their own team of specialist masons to repair and renew the ancient fabric. The techniques have changed little over the centuries. Here two masons from Barbers Monumental Masons of Halesworth carve window tracery for a site in Southwold. The older man is holding the paper template for the finished work which has been copied onto the stone block being shaped by the younger mason. His tools are heaped on the bench in front of him. [AA98/14596]

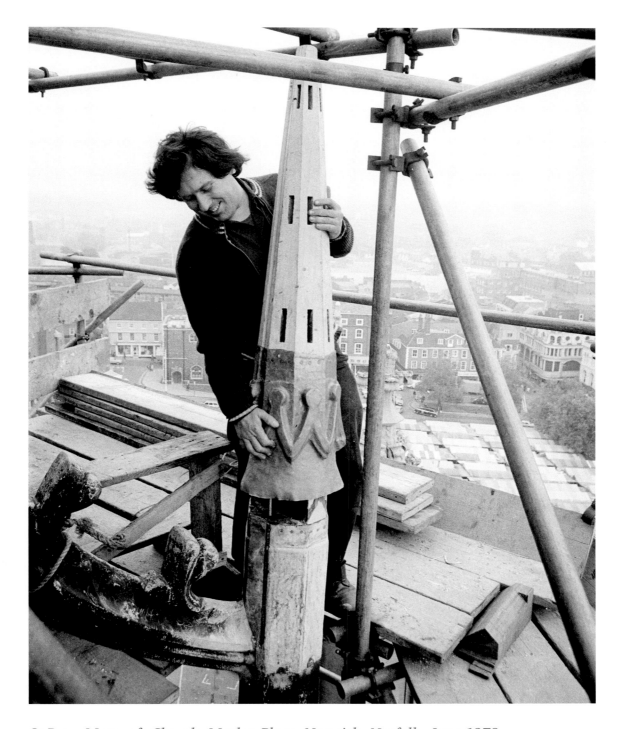

St Peter Mancroft Church, Market Place, Norwich, Norfolk, June 1978
Historic buildings require constant care in order to maintain them in good condition. A programme of work at St Peter Mancroft Church in the late 1970s followed a previous campaign 10 years earlier. The present building dates from 1430, though the short spire with its flying buttresses was added to the tower in 1895. Here the pinnacles around the late 19th-century spire are being repaired. [MF98/01530/26]

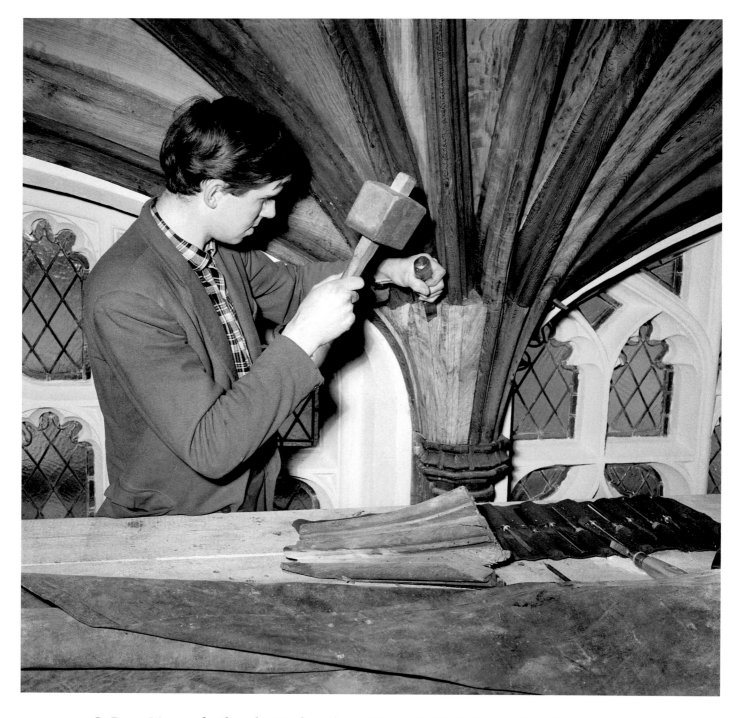

St Peter Mancroft Church, Market Place, Norwich, Norfolk, April 1964
St Peter Mancroft has a wooden ceiling designed to imitate the much heavier and more expensive vaulted stone ceilings which had been common in major buildings for centuries. During the restoration campaign in the 1960s, a new section has had to be inserted at the base of the ribs and is being shaped to fit. [AA98/11080]

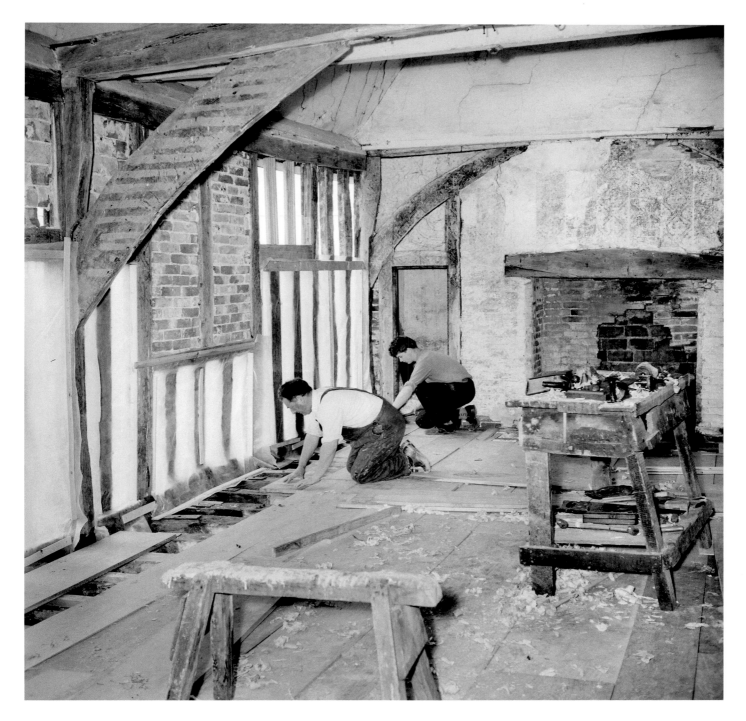

Abbey Farm, Old Buckenham, Norfolk, July 1966
Carpenters make a vital contribution to most buildings and their skills are particularly in demand for timber-framed structures. In 1966 this high-status 16th-century house of mainly timber construction underwent a major restoration. In this photograph the studding and roof braces have been exposed, and carpenters are laying new floorboards. [AA98/11978]

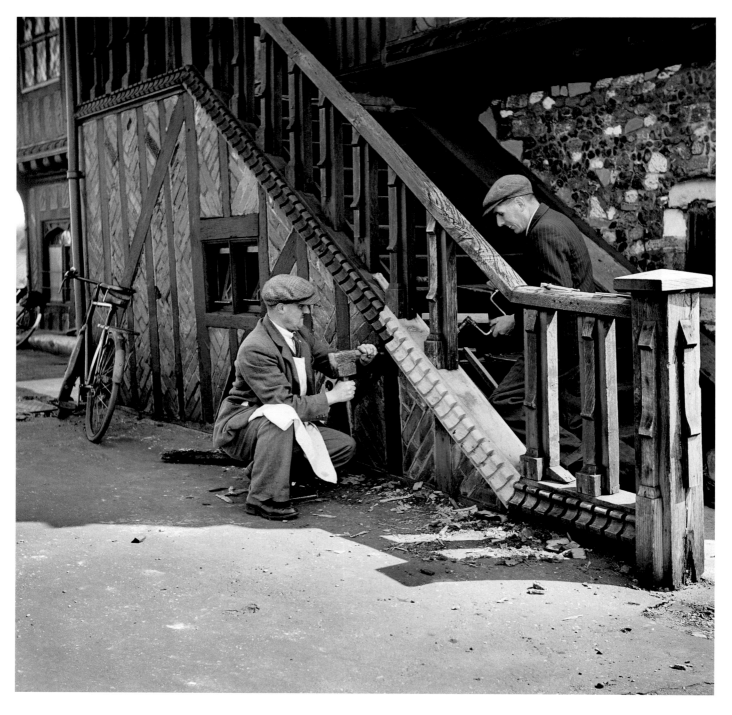

Moot Hall, Aldeburgh, Suffolk, May 1959
The Moot Hall is a picturesque timber-framed building which has long been a magnet for amateur artists. It dates from the early 16th century when Aldeburgh was a prosperous port. The ground floor was originally a colonnaded market but it has since been enclosed, while an external staircase led to a large council chamber on the first floor. These carpenters are renewing the banister of the staircase – something which must have been necessary several times during the life of the building. [AA98/14965]

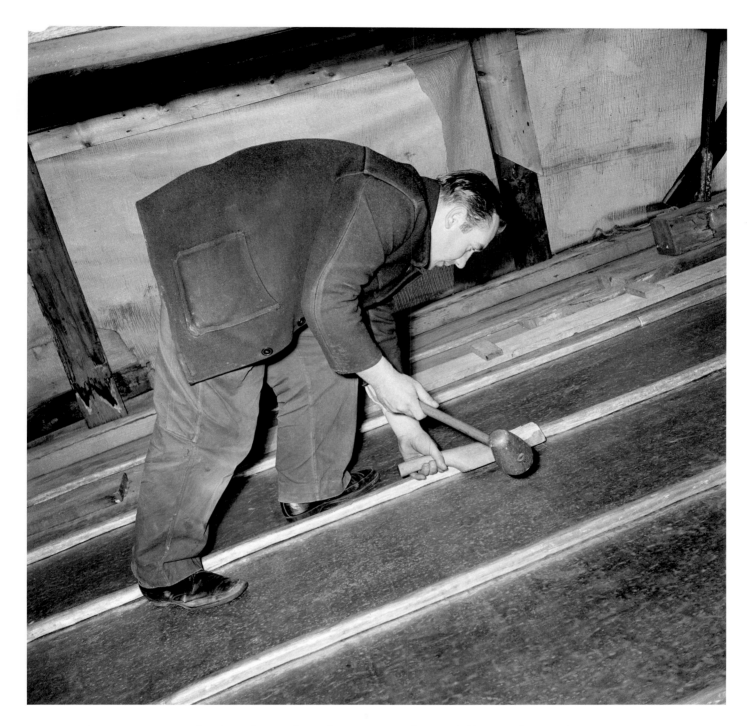

St Peter Mancroft Church, Market Place, Norwich, Norfolk, October 1963
Plumbers were originally workers in lead and one of their main tasks was roofing. Many of the greater churches and other prominent buildings were roofed in lead and the plumbers would cast lead into sheets, lay strips on the roof and join them to make watertight. During the restoration campaign in the 1960s, the roof of St Peter Mancroft was renewed using such traditional skills. [AA98/09919]

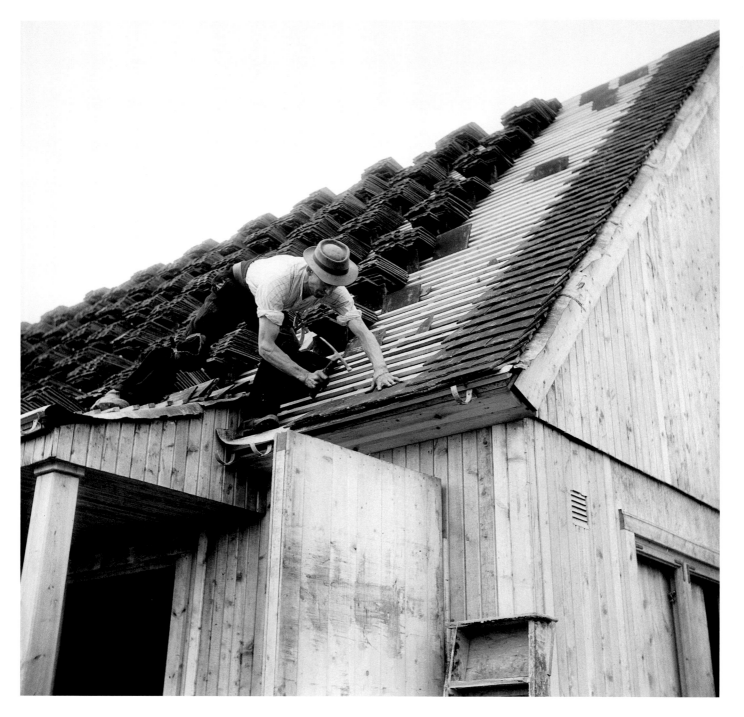

Tiling, Great Ellingham, Norfolk, July 1946
At the end of the Second World War Britain was facing a serious housing shortage. Between 1944 and 1948, 156,623 of a planned 500,000 prefabs were built under the government's Temporary Housing Programme. Several designs were trialled and, between September 1945 and March 1946, 5,000 prefabricated timber houses were imported from Sweden under this Programme. Many of the Swedish timber houses were allocated to rural areas such as Norfolk, where the revival of agriculture during the war had created an urgent need for housing for farm workers. [AA98/13002]

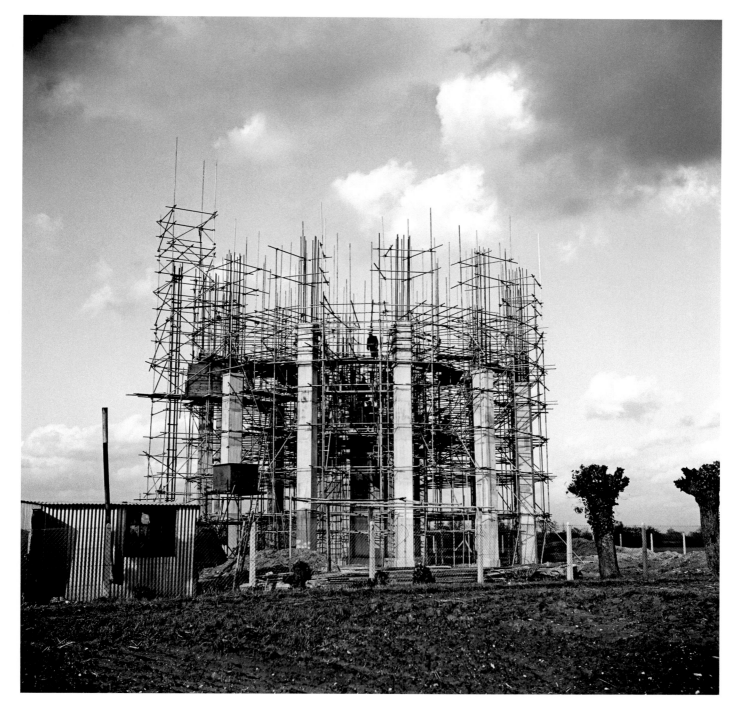

Water tower, Pulham Market, Norfolk, March 1951
New materials required new skills. This water tower is being built in reinforced concrete with a tank supported on a ring of columns and a central shaft carrying water pipes and providing access. Water towers are widespread and were an important element in the supply of domestic mains water in rural areas, which was often managed on a local scale by the Rural District Council. [AA98/07311]

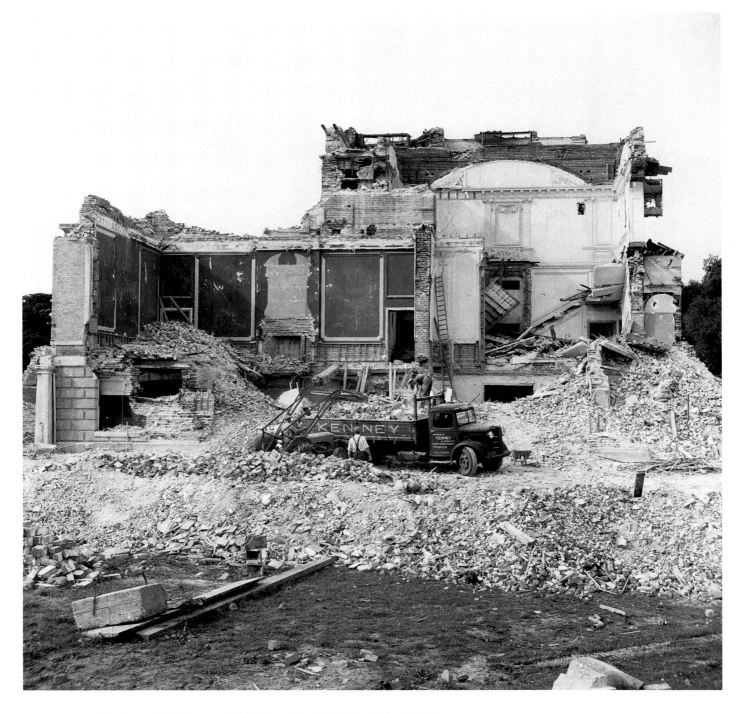

Henham Hall, near Blythburgh, Suffolk, July 1953
The 20th century saw the loss of many country houses for a variety of reasons, but just after the Second World War the financial situation exacerbated by high death duties brought about a crisis for country house owners. In the 1950s alone almost 300 country houses are recorded as having been demolished (Worsley 2002, 19), while others were converted into schools and other institutions. Henham Hall, built in the 1790s by James Wyatt, became another statistic. [AA98/13507]

~ *Thatching* ~

'Every parish had its own thatcher in the 1920s. But in the 1930s things changed' (Blythe 1969, 133). By the time Ronald Blythe was writing his book *Akenfield* in the 1960s, this most evocative of traditional crafts had passed its low point and was increasingly in demand again as incomers bought up old cottages.

A number of materials can be used for thatching. The commonest traditional material was wheat straw (known as 'long straw') which was a by-product of the cereal harvest. Roofs made of long straw typically need to be renewed every 25 to 30 years. Unfortunately, mechanical harvesting breaks up the stalks and so modern strains of wheat are too short for thatching, making long straw increasingly difficult to source. Straw is not the only material suitable for thatching – in some upland areas of England heather was used, while in other regions, including Norfolk, water reed (*Phragmites australis*) has gradually replaced wheat thatch due to its greater availability.

Thatching is largely seasonal work. Ernie Bowers, the thatcher in *Akenfield*, used the winter months to harvest his own reeds, source straw and search the woods for suitable lengths of coppiced hazel to make the essential 'broaches' (also known as 'spars') and 'liggers' (or 'rods') used to secure the roof.

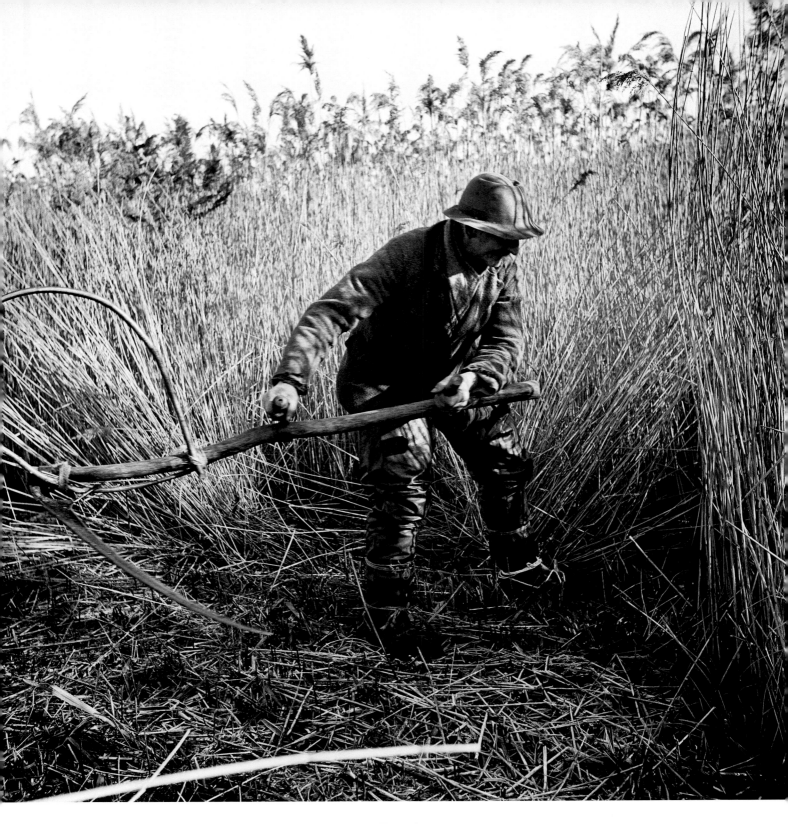

Cutting reeds, near Horning Ferry, Norfolk, February 1949
Water reed is traditionally used for thatching in much of Norfolk and Suffolk where it is in plentiful supply on the wetlands and marshes. Harvesting reeds was seasonal work for the winter months and was often carried out by the thatchers themselves. [AA98/07734]

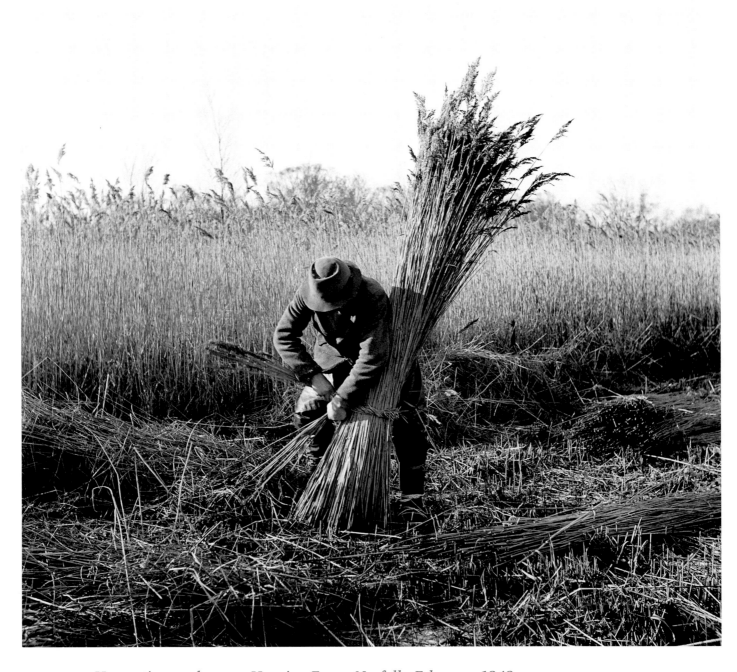

Harvesting reeds, near Horning Ferry, Norfolk, February 1949
Once cut, the reeds are tied into bundles using twisted reeds as a rope. [AA98/07731]

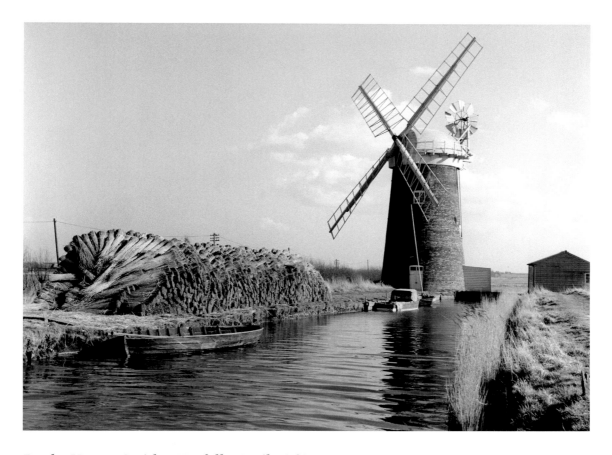

Reeds, Horsey Staithe, Norfolk, April 1963
As reeds grow in wet locations, the waterways provided a cheap and convenient means of transport. These bundles of reeds are waiting for a boat on the staithe next to Horsey drainage mill – one of the system of mills which managed the Broads. Built in 1897, it ceased operation in 1943, but was restored in 1961 (*see* p 74–75). [OP04512]

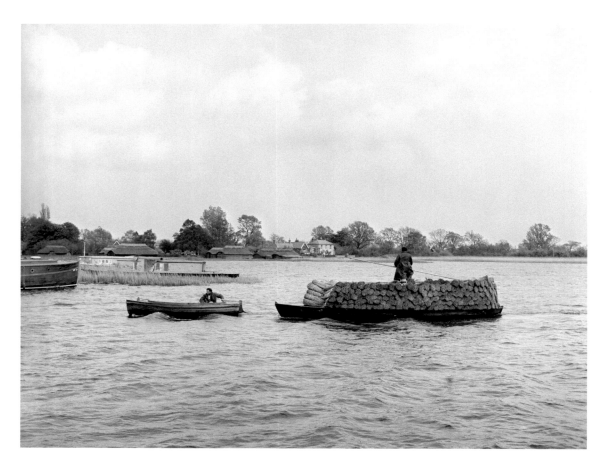

Transporting reeds on Hickling Broad, Catfield, Norfolk, May 1958
Here a boatload of reeds is being towed by a motor boat. Traditionally, the man standing on the
cargo would have punted using the pole he is holding. [AA98/15130]

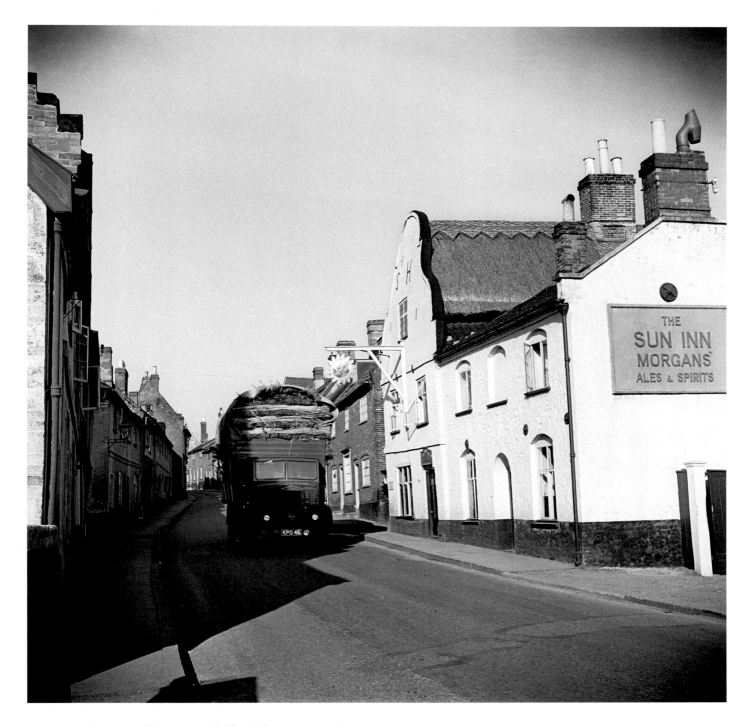

Wymondham, Norfolk, February 1949
Motor transport has often replaced water transport in the region. In this photograph a lorry stacked with reeds is passing the largely 18th-century Sun Inn in Damgate Street, which is itself thatched. [AA98/07725]

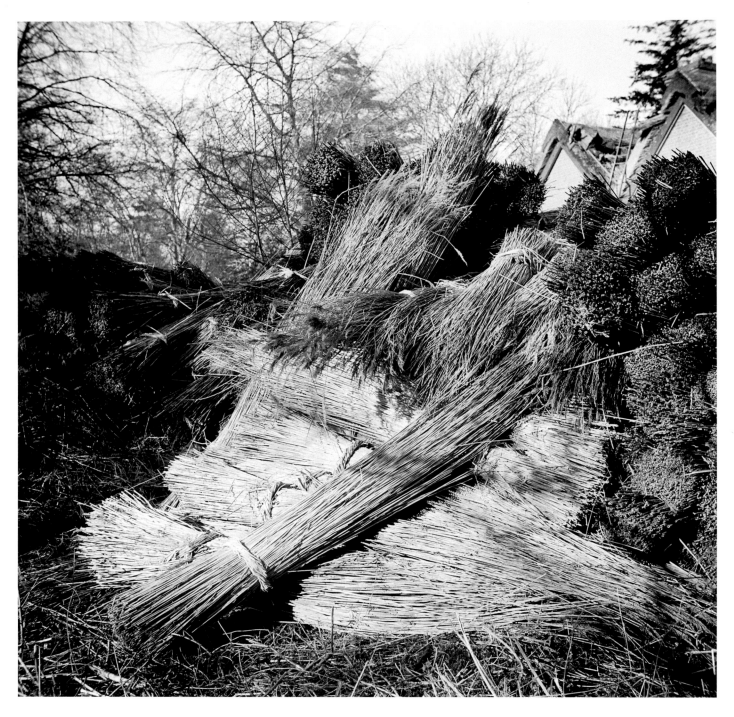

Thatching, February 1949
Bundles of reeds have been delivered to this unidentified location where a thatcher can be seen working in the background. This photograph gives some idea of the quantity of reeds required for a single roof. [AA98/07740]

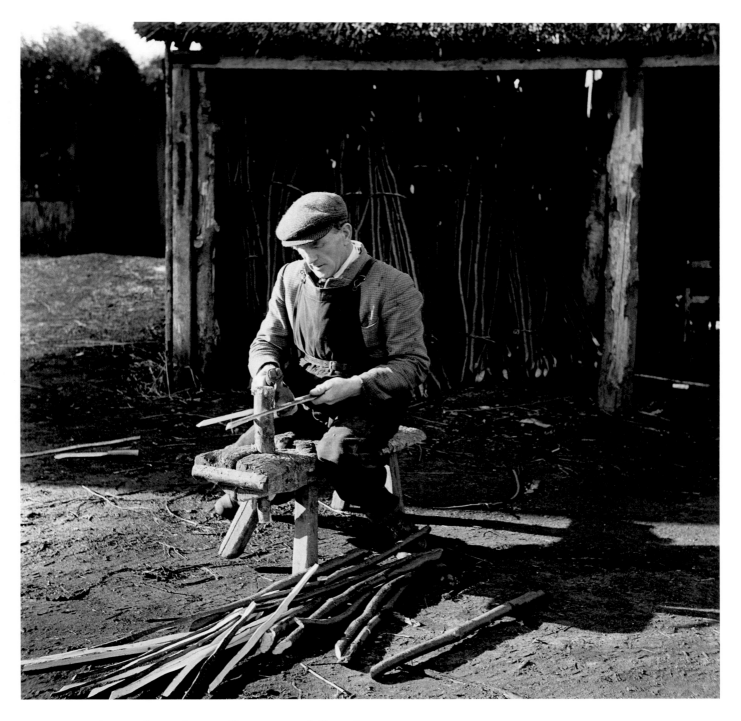

Splitting broaches, Salhouse, Norfolk, February 1949
Mr Sam Blackburn, a thatcher, splits lengths of coppiced hazel about 1in thick to make 'broaches'
or 'spars'. These are twisted into 'staple' shapes and used to secure the thatch at various stages.
They also pin down the 'liggers' or 'rods' that hold down the thatch and provide decorative fea-
tures. A modern roof requires 8–10,000 broaches as well as liggers. [AA98/07733]

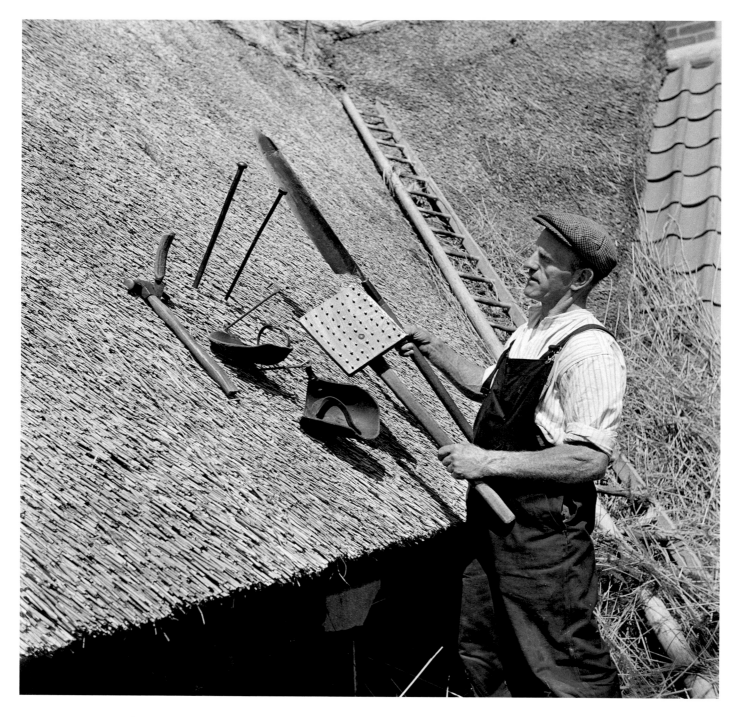

A reed thatcher and his tools, July 1948
Mr Blackburn demonstrates his tools: a hammer, a pair of knee pads, three thatching needles, a 'leggatt' (also known as a 'bat') for dressing the thatch to keep the butt ends in smooth alignment (left hand), and a long-handled knife for trimming thatch (right hand). The face of the leggatt is nailed, showing it was for use with water reed – those used with wheat reed are ridged. In addition he will have a supply of broaches and liggers. [AA98/10847]

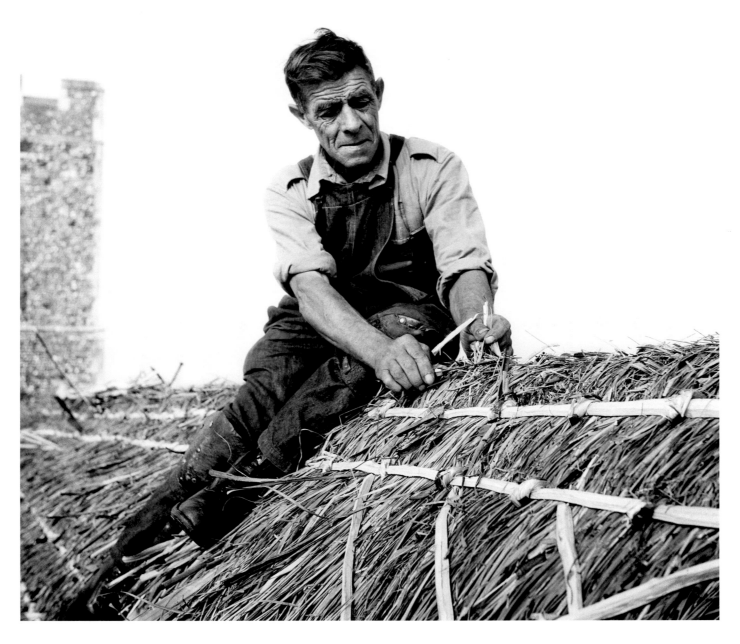

St Margaret and All Saints' Church, Pakefield, Suffolk, October 1949
Courses of reed will not bend over the ridge of a roof, so it is reinforced by an additional wrapover 'skirt', often made of sedge. This is secured by liggers and staples and may be highly decorative. Here a thatcher is working on the ridge. [AA98/07600]

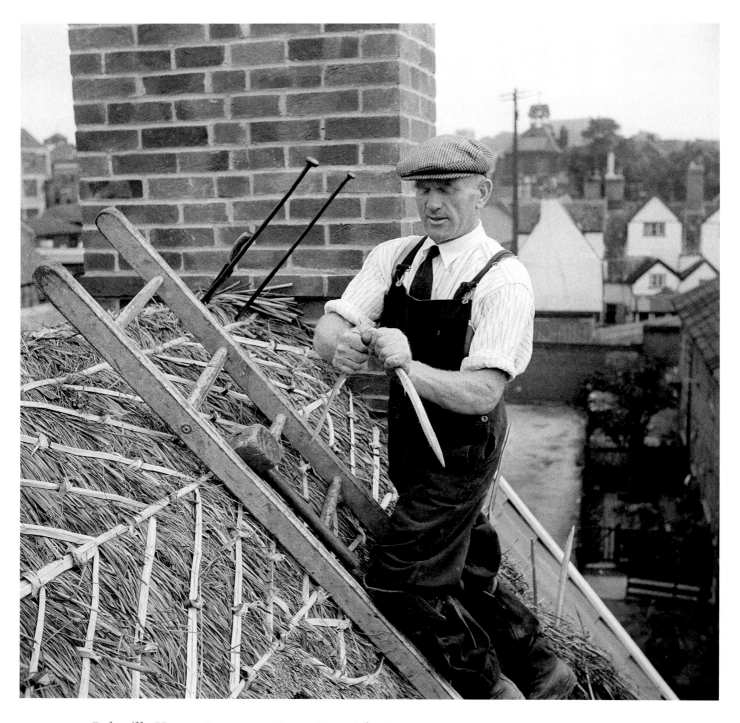

Pykerills House, Rosemary Lane, Norwich, August 1948
A thatcher twists a broach to form a staple which he will use to secure a ligger. [AA98/10833]

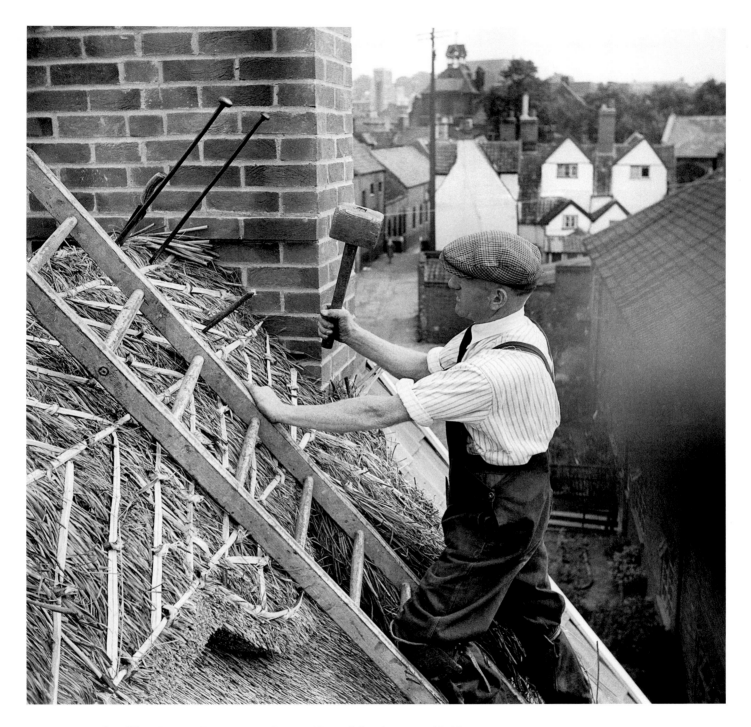

Pykerills House, Rosemary Lane, Norwich, August 1948
Thatching generally starts at the eaves and proceeds from right to left in overlapping courses. Here
a thatcher hammers home a staple over a ligger to help secure the decorated ridge – this is known
as sparring down. [AA98/10834]

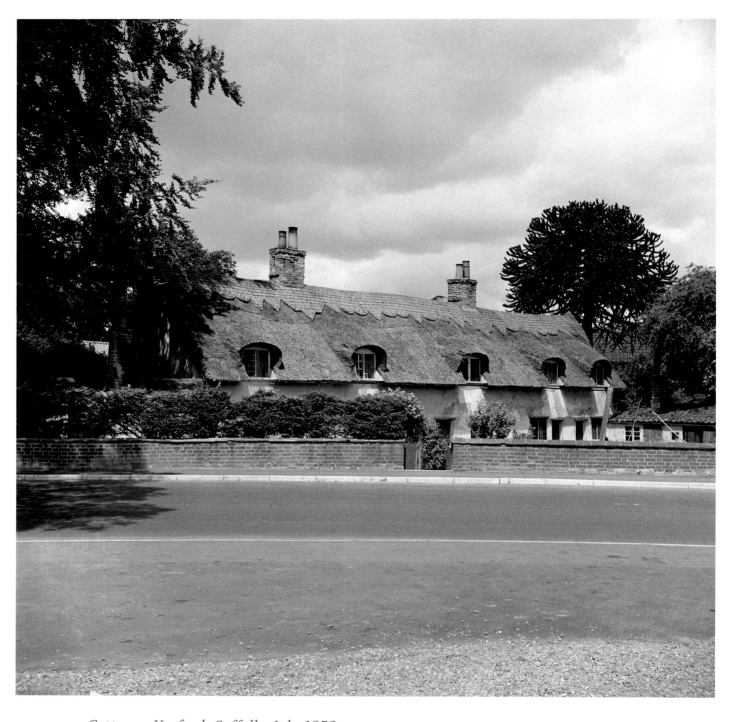

Cottages, Yoxford, Suffolk, July 1953
To many people a thatched cottage symbolises an idyllic, lost England. This recently thatched terrace of cottages has been neatly finished with a decorative skirt along the roof ridge. [AA98/13538]

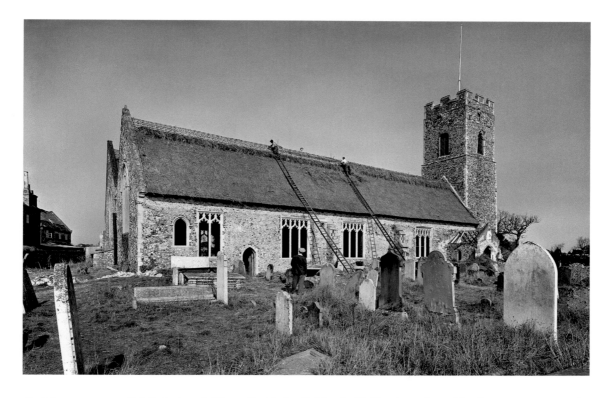

St Margaret and All Saints' Church, Pakefield, Suffolk, October 1949
Not only cottages, but barns, churches and even hayricks were often thatched. This 14th-century church was severely damaged during the war. It was restored and then re-consecrated in 1950. In this photograph thatchers are putting the final touches to the roof by attaching liggers onto the ridge – however, the windows are still unglazed. [BB98/14595]

~ *Agricultural crafts* ~

Each rural community supported its complement of craftsmen whose primary role was to serve agriculture, while providing in a smaller way for a range of community needs.

Foremost among them were the blacksmith and farrier (not always the same person). They also included the saddler and harness maker, and the carpenter. Other related crafts (dealt with in different sections of this book) include milling, thatching, and the building trades.

Gregory Gladwell, the smith at Akenfield, recalled, 'It was all agricultural work at the forge. Mostly shoeing.' (Blythe 1969, 113). In the 1930s the Gladwell family smithy shod an average of eight horses a day at a rate of one hour per horse. At the end of the Second World War he still had over 100 horses on his books, each needing to be shod at least three times a year: making 1,200 shoes a year. Things changed quickly and by the 1960s he was making ornamental ironwork for newcomers restoring cottages: he survived. 'It was all agricultural work', too, for saddlers and village carpenters. With so many horses on the farm, the saddler made and repaired saddles, horse collars and harness. A huge range of objects was made from wood – handles, tools, gates, fences, furniture and fittings for houses; the village carpenter could make most of these and other objects, and also carried out repairs. Unlike Gregory Gladwell, few smiths, saddlers or carpenters were able to cope with falling demand in the 1940s and 1950s or to adjust to new markets.

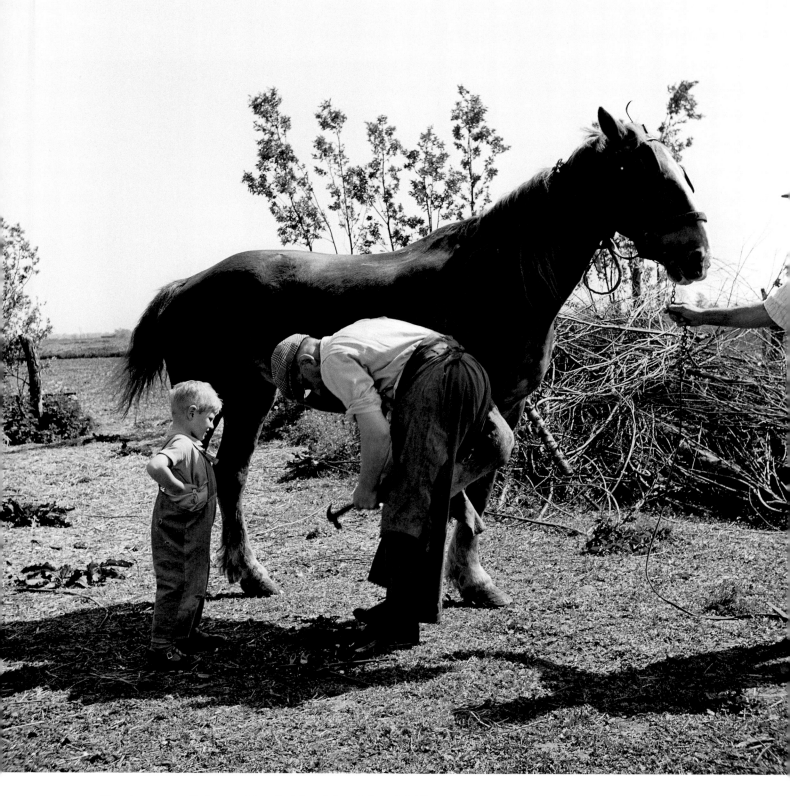

Farrier, near Soham, Cambridgeshire, May 1948
This little boy admiring a farrier at work may be dreaming of one day shoeing horses himself; but
opportunities for apprentices were fast running out in the post-war years. [AA98/10862]

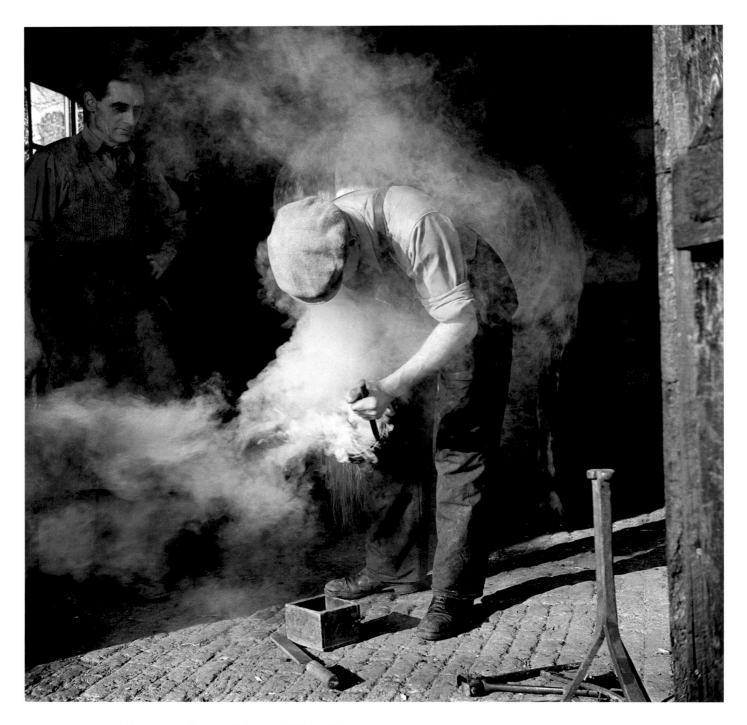

Smithy, Woodbastwick, Norfolk, February 1949
Here a hot shoe is 'seated' against a horse's hoof to check the fit. Within a few years of this photo-graph being taken, relatively few working farriers were left. [AA98/13563]

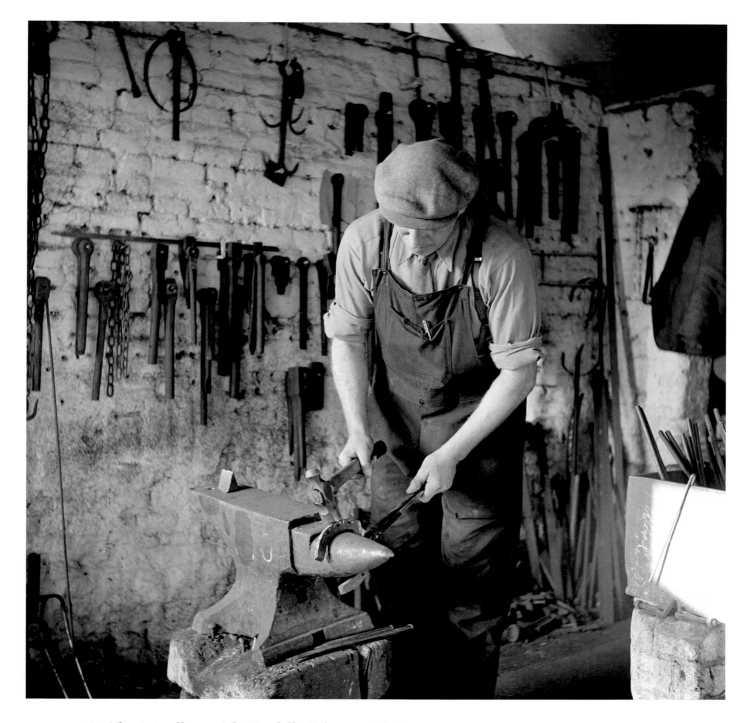

Smithy, Woodbastwick, Norfolk, February 1949
A farrier hammers a horseshoe into shape using the 'beak' or 'horn' of his anvil. [AA98/13558]

Smithy, New Buckenham, Norfolk, June 1966
Before the Second World War every village had plenty of work for one or more blacksmiths. In addition to shoeing horses, many of the simpler agricultural implements and machines were repaired or even made at the forge, and the smith was a significant partner in the making of wagons and wheels. By the late 1960s many village smiths had either gone out of business or converted to making ornamental ironwork. Mr Arthur Reeves' smithy, seen here, is built onto the rear of his house. [BB98/21798]

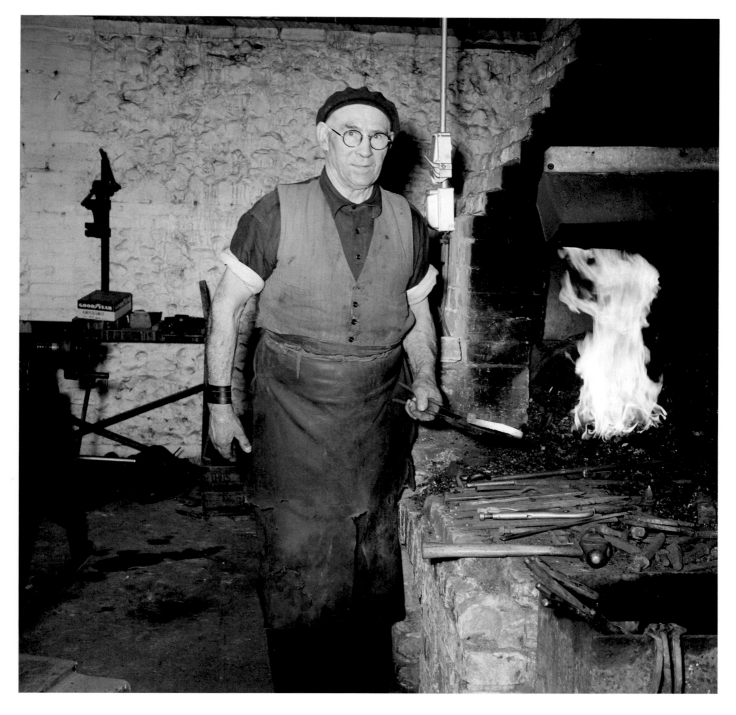

Smithy, West Lexham Farm, Norfolk, April 1960
Some large farms maintained their own smithy (like this one) to shoe horses and make running repairs to many of the iron tools used on the land. In this case, the smithy might also serve the local community. [AA98/17379]

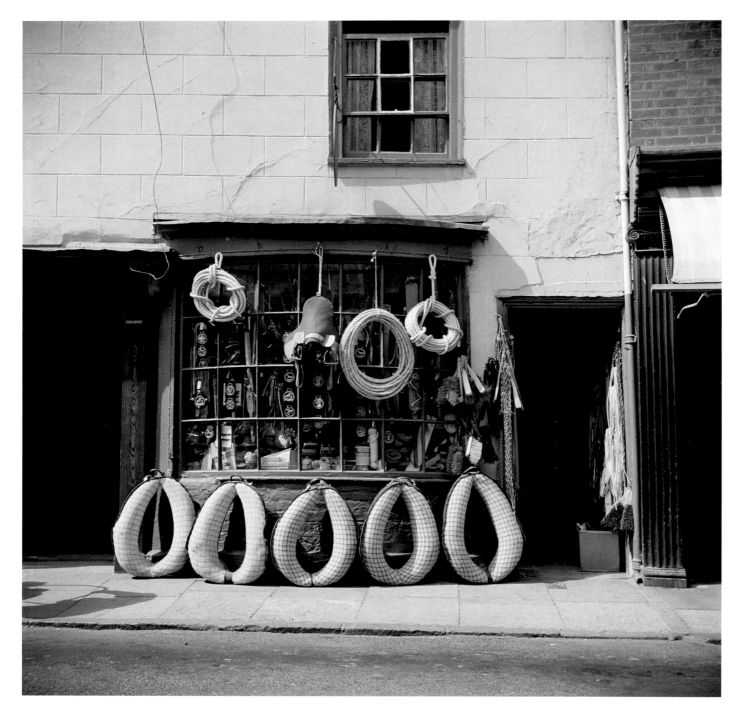

Saddler, 58 Thoroughfare, Halesworth, Suffolk, July 1949
Much of a rural saddler's trade came from the work of the heavy horses used on farms. The collar was an important element of the working horse's harness. Resting on the shoulders and breast to spread the load, the collar allowed the horse to push its full weight against it. They were stuffed with rye straw or cloth and faced in leather, with a padding of cloth against the horse's shoulders for comfort. Five collars are displayed outside this saddler's shop with their soft inner surface facing outward. [AA98/14619]

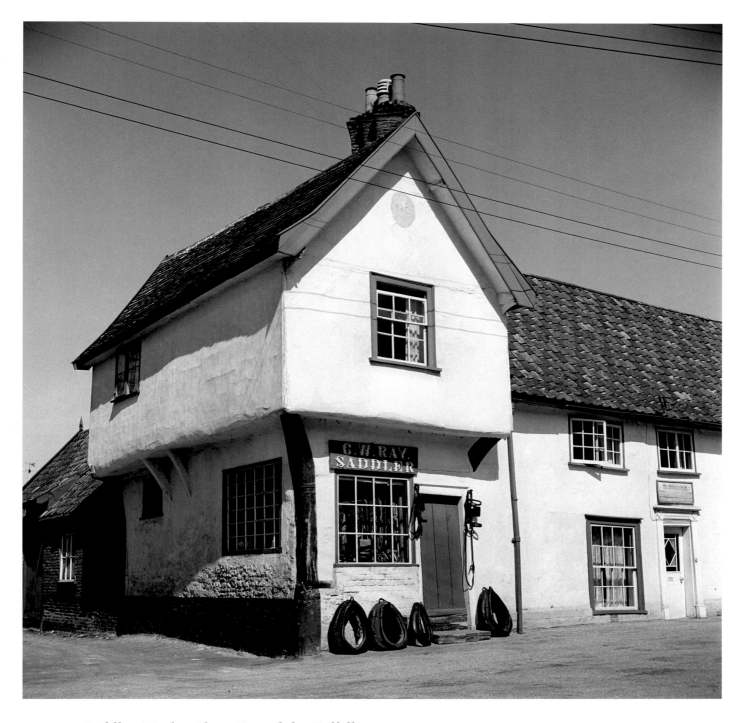

Saddler, Market Place, Botesdale, Suffolk
This late medieval hall house was remodelled in the 17th century and has the date 1637 on the gable end. By the time this photograph was taken the house had been subdivided – the jettied cross-wing has become a saddler's shop with a workshop to the rear. Here four new horse collars are displayed with the leather side out. [AA98/09419]

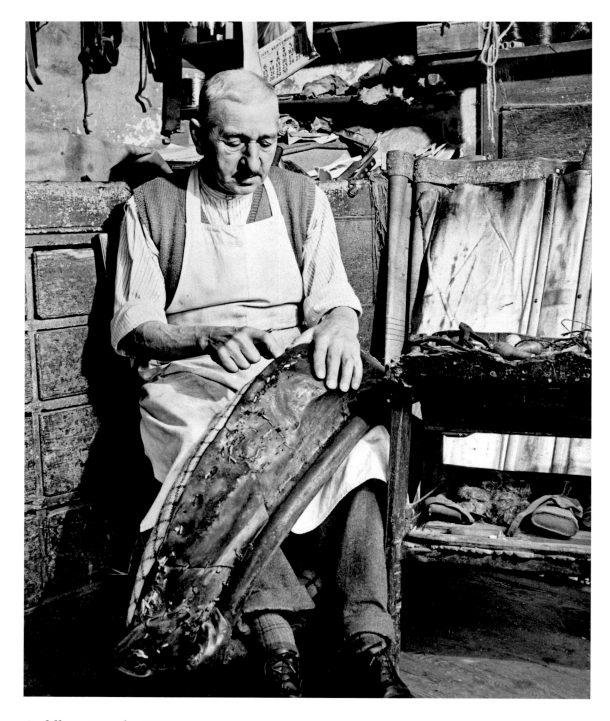

Saddler at work, 1953

This saddler is making a horse collar, though by this date demand must have been falling rapidly. The soft cloth padding on the underside can just be seen. Horry Rose, the saddler in Akenfield, remembered, 'We made plough collars for the Suffolk Punches and the great Percheron horses for 12s 6d each [in the 1930s] … I made hundreds of these collars' (Blythe 1969, 138). He recalled that all his materials were bought locally. [BB99/04216]

~ *Specialist crafts* ~

Certain crafts naturally served a wider catchment area rather than a local market, making goods which were of high value or for specialist use. In the early 19th century even many of the more humble artisans, such as the tailor and boot maker, were drawn to the growing urban centres. Among the specialists, the cooper made casks and barrels, the wheelwright made wheels and, by extension, wagons (*see* p 158–160), boat builders were located on navigable waterways, while the furniture maker may create either functional or higher quality products.

At the luxury end of the spectrum, a small number of stained glass workshops cover the whole country. Much of their work today is in the areas of repair and conservation although new commissions are still placed. In a similar class were decorative painters capable of intricate work such as murals. More unusual is the making of gun flints which were produced in a small number of places, most notably Brandon, Suffolk. In 1813 the flint masters of Brandon were contracted to supply over 1 million musket flints a month, while during the Crimean War 11 million gunflints annually were supplied to Turkey.

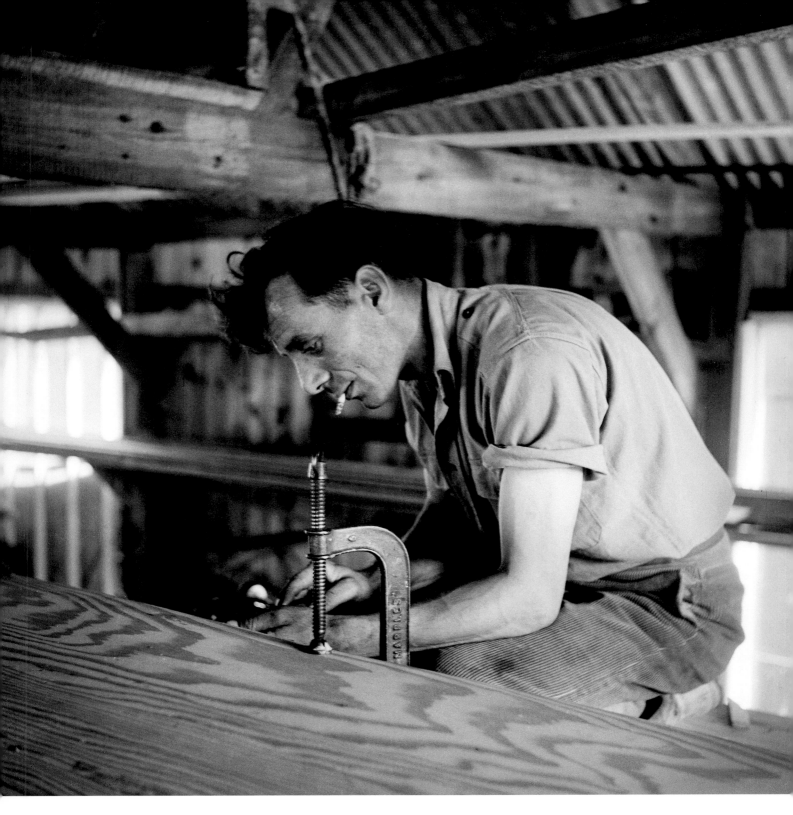

Boat builder, River Bure, near Wroxham, Norfolk, 1947
For many centuries watercraft of different types have been an essential means of transport on the rivers and inland waterways of Norfolk. More recently, pleasure craft have also become commercially important, particularly on the Broads. Here a boat builder works on a small craft. [AA99/00303]

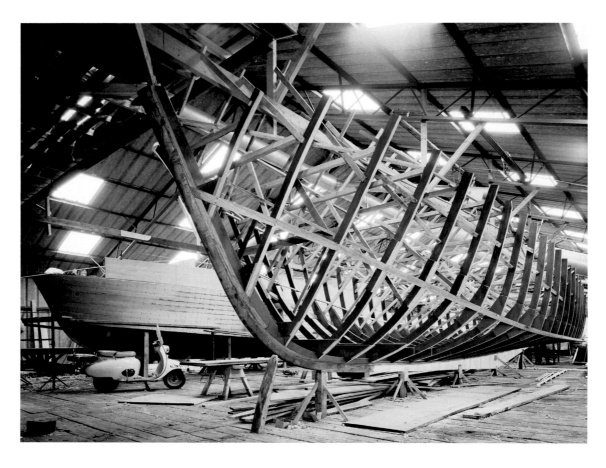

F B Wild's Boatyard, Horning, Norfolk, 1963
Cruising on the Broads has become an important source of tourist income in some areas of Norfolk. In this photograph two pleasure boats are shown at different stages of construction. [BB99/01083]

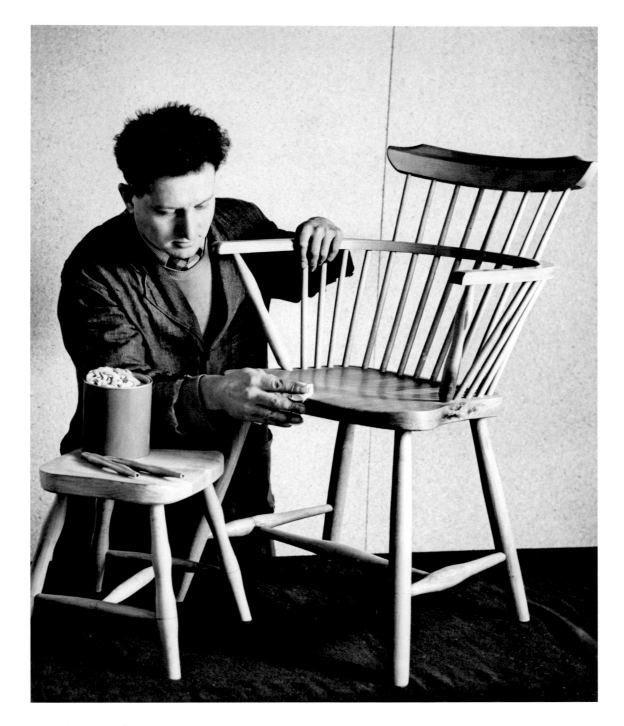

Furniture maker

The handcrafting of wooden furniture is an ancient trade. Traditional country furniture was part of the varied output of the village carpenter, though more refined items could enter the urban market. More recently it has become the preserve of the joiner (or cabinet maker in the case of fine quality pieces). Some carpenters have survived by becoming 'craft' woodworkers or by making high-quality bespoke products. [BB99/04218]

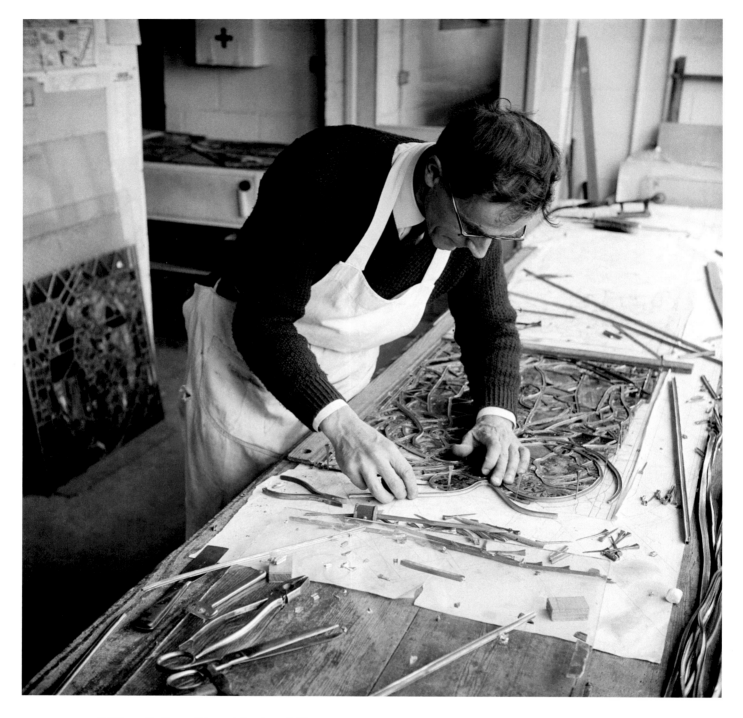

G King & Son, Norwich, Norfolk

A large quantity of stained glass survives in England from the medieval period, often in churches and cathedrals. The creation of a stained-glass window was a luxury item requiring a wealthy patron. Once the design had been agreed, the craftsman would prepare a full-size drawing or cartoon, which was then marked out on the glazing table. The glass was cut to shape and held in place by the lead strips or 'cames'. Making a stained-glass window is a skilled craft and in many respects the techniques have changed little over the centuries. [AA98/12843]

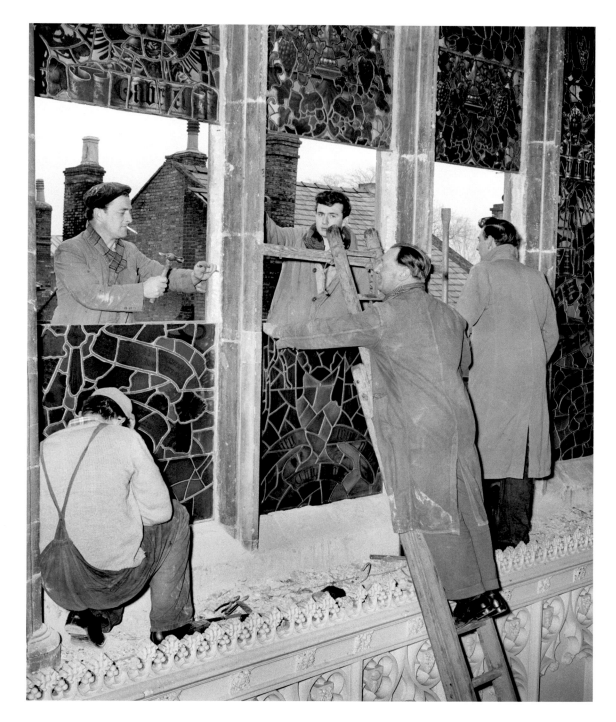

St Mary's Church, Bury St Edmunds, Suffolk, March 1964
Once a stained-glass window has been made, it must be transported to site and fitted. Several panels may be needed to fill the window space, and these are supported by horizontal iron bars known as saddle bars. Here the refurbished east window is being installed in St Mary's Church. [AA98/11897]

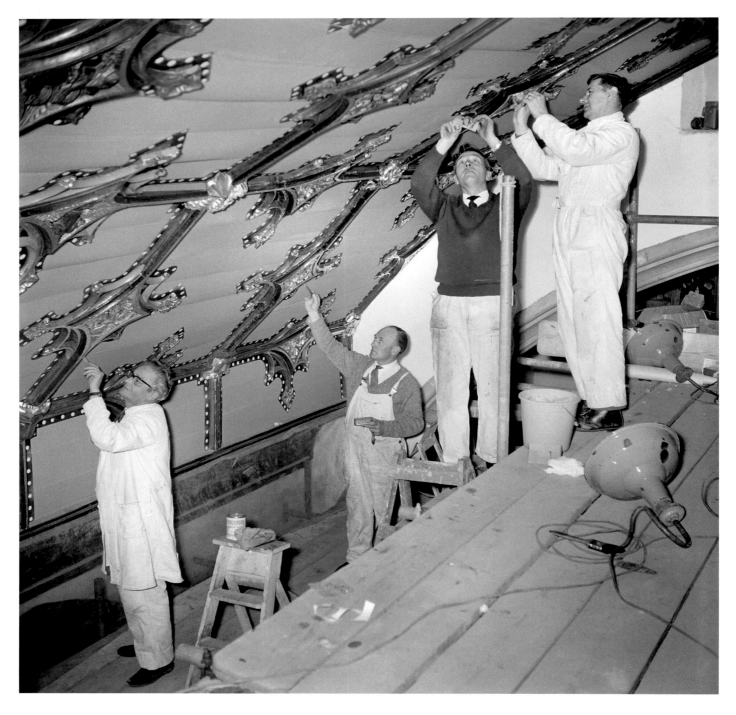

St Mary's Church, Bury St Edmunds, Suffolk, May 1968
A tradition of painting walls and ceilings in both religious and secular settings has long existed in England. Today we are used to seeing whitewashed or bare masonry walls in churches. However, in the Middle Ages they were usually brightly painted, with the walls, ceiling and woodwork all being covered with religious imagery or decorative patterns. St Mary's, on the edge of the Abbey precinct, would have been no exception. Here the ceiling of the chancel is being cleaned, restored and re-gilded. [AA98/12824]

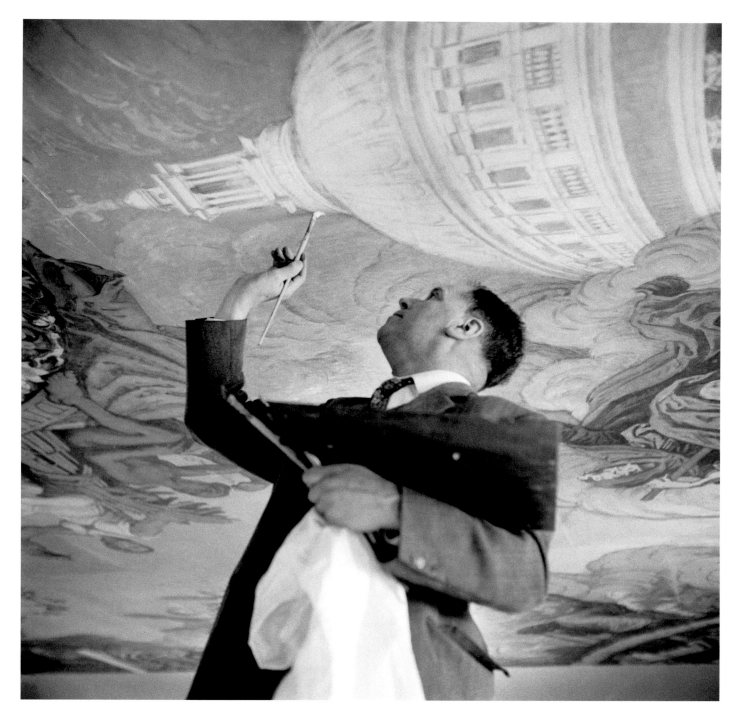

Painting, 'Templewood', Northrepps, Norfolk, February 1969
Although medieval wall paintings still survive mostly in churches, they were also common in domestic contexts, created by artist craftsmen who travelled in search of work. Styles changed, but the craft continued. 'Templewood' was built in 1938 by Seeley & Paget as a shooting box for Lord Templewood. The painted ceiling in the saloon was commissioned in the 1960s from Brian Thomas, continuing this old tradition. [AA99/02546]

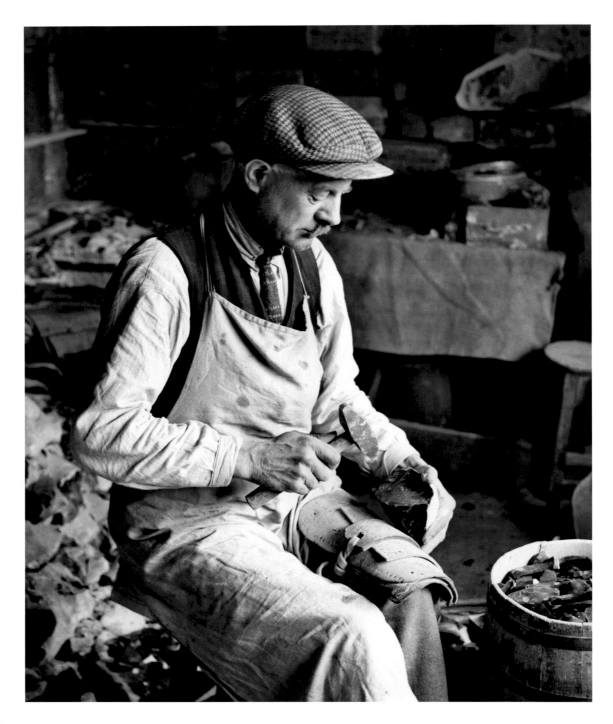

Flint knapping, Brandon, Norfolk, April 1937
Flint has been shaped for building since the Middle Ages but its use for gunflints (in flint-lock pistols and other firearms) only dates from the 17th century. Brandon was the foremost centre for this industry and its fortunes fluctuated with conditions of war and peace. The industry declined from the mid-19th century, though as late as 1950 2,000 gunflints a day were still being produced for export. With a leather pad bound to his left thigh, a knapper used a hammer to quarter flint nodules and to strike flakes from them (seen here): a skilled flaker could produce up to 10,000 a day. These were worked into gunflints using a small iron anvil. [OP00119]

~ Industry ~

Although many rural crafts continued to flourish during the 19th century, a number of traditional processes became increasingly industrial in scale and outlook in response to technological developments and changing patterns of transport and demand. Urban centres created a growing market for brick, cereal milling became linked into the regional economy, and steam was often used to supplement or even replace wind and water power. Light engineering works grew up to manufacture and repair the more complex machines which were being invented for agriculture, and they often diversified into new areas. Norfolk was also home to a very unusual industry – fairground rides were made and maintained at Savage's Works in King's Lynn.

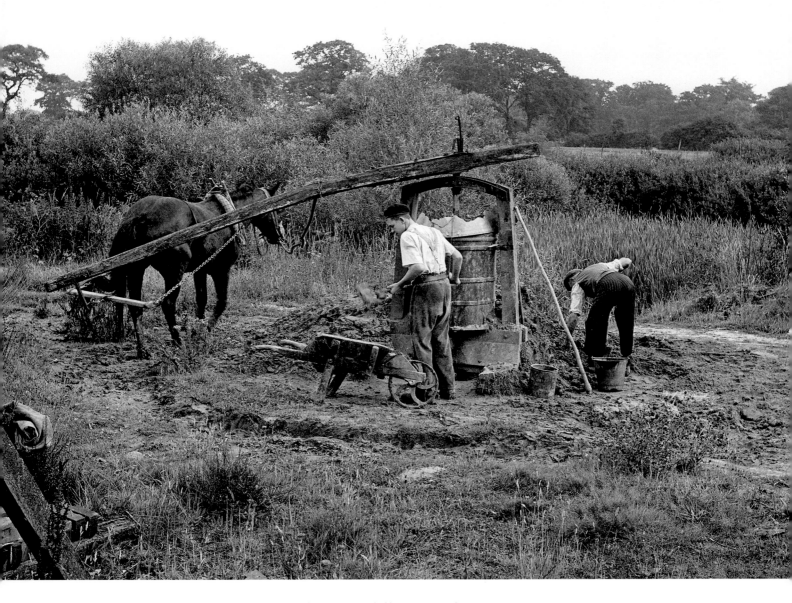

Barney Brickyard, near Fakenham, Norfolk, September 1952
Brick offered a cheap and versatile alternative to building stone and was widely used from the
16th century, though bricks tended to be produced near to their place of use until developments in
transport in the 20th century reduced this constraint. Traditionally, clay was dug in the autumn
and weathered over the winter, after which it was 'tempered' – kneaded and mixed into a suitable
consistency for moulding. Here two men at Cowling's Brick Yard, Barney, operate a horse-powered
pug mill. This simple technology was introduced in the late 17th century to speed up the temper-
ing process. [AA98/07202]

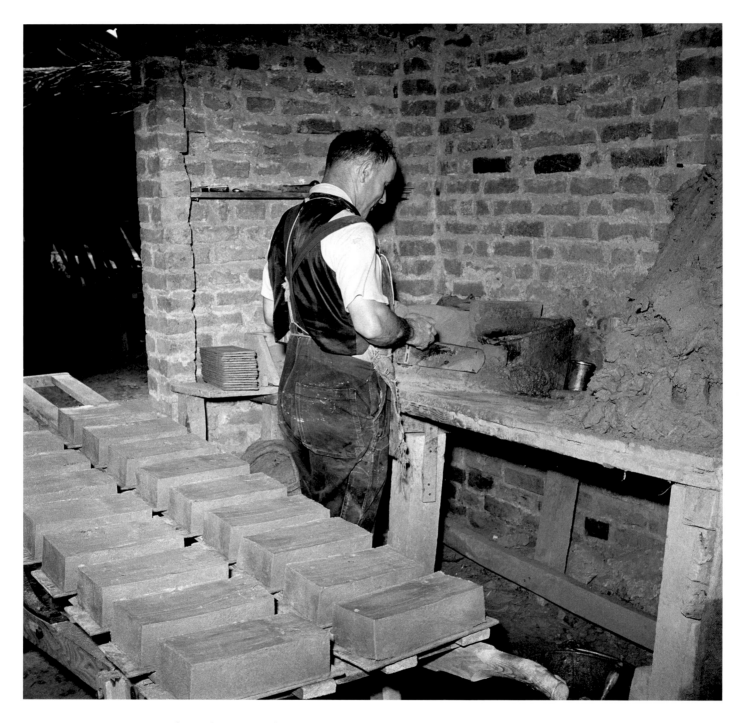

Barney Brickyard, near Fakenham, Norfolk, September 1952
Once the clay was tempered, it was moulded by hand into the brick shape using wooden moulds.
A skilled craftsman could mould 3,000–5,000 bricks a day. The bricks were then left to dry before
firing. [AA98/07198]

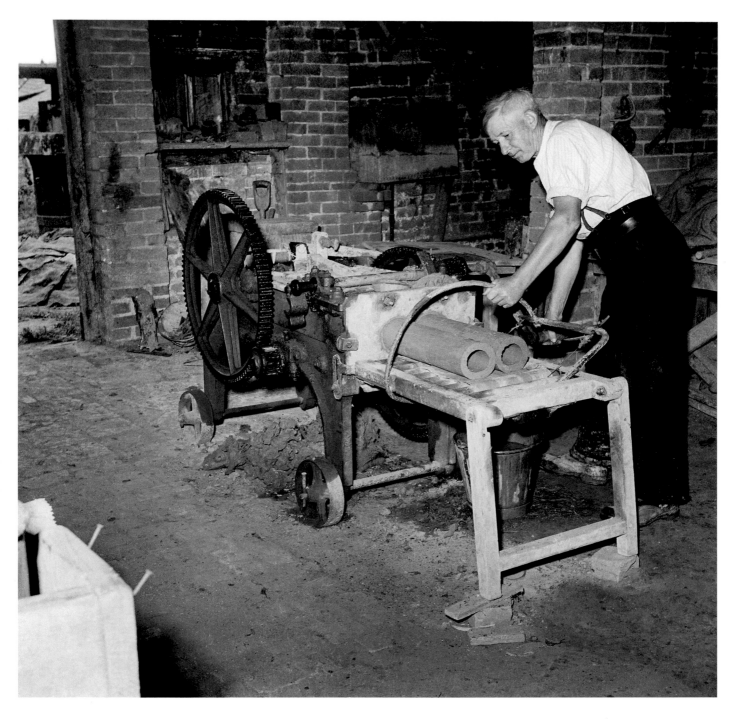

Barney Brickyard, near Fakenham, Norfolk, September 1952
Clay can be moulded into many different shapes, such as roof and floor tiles. In this picture a mould is used to extrude lengths of pipe. [AA98/07196]

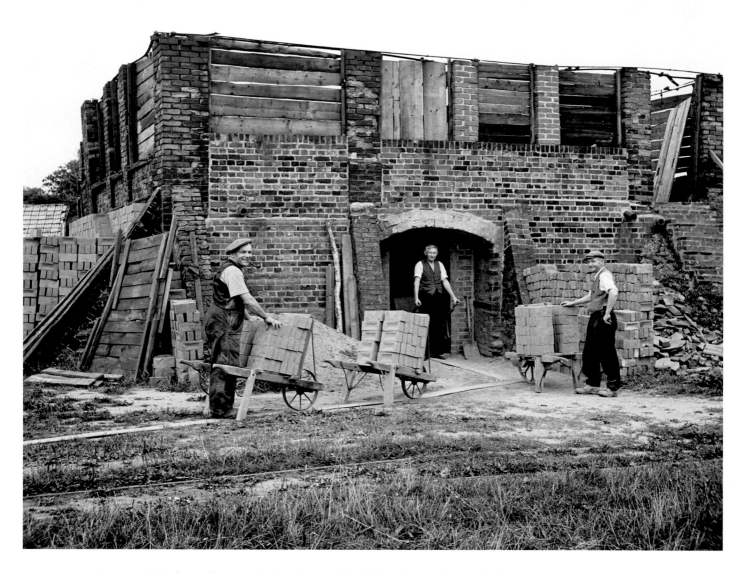

Barney Brickyard, near Fakenham, Norfolk, September 1952
Specially designed barrows are used to carry the stacks of bricks around the brickyard. These men
are posing for the camera outside the brick kiln. [AA98/07188]

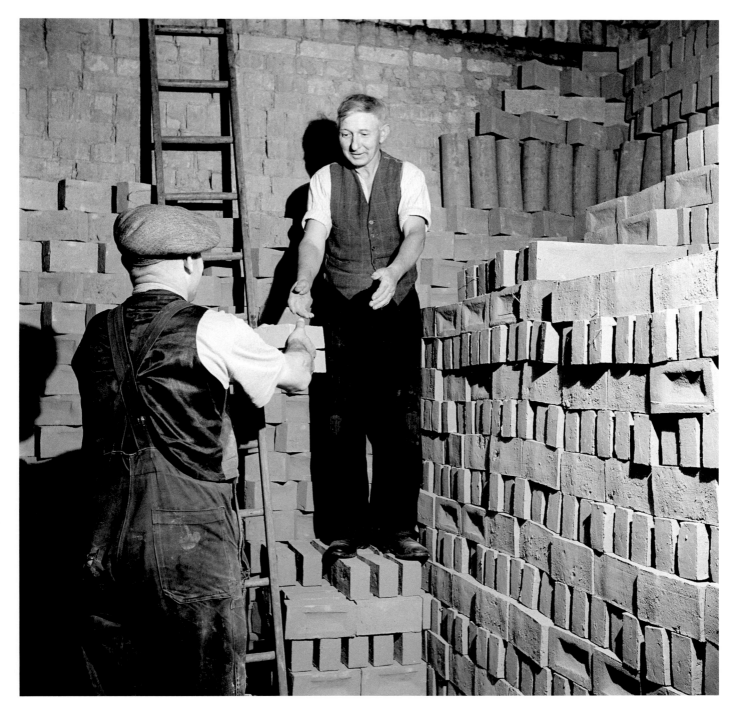

Barney Brickyard, near Fakenham, Norfolk, September 1952
The bricks are stacked in a brick kiln for firing, leaving spaces between them for the hot gases to circulate. Lengths of pipe are stacked above them. [AA98/07190]

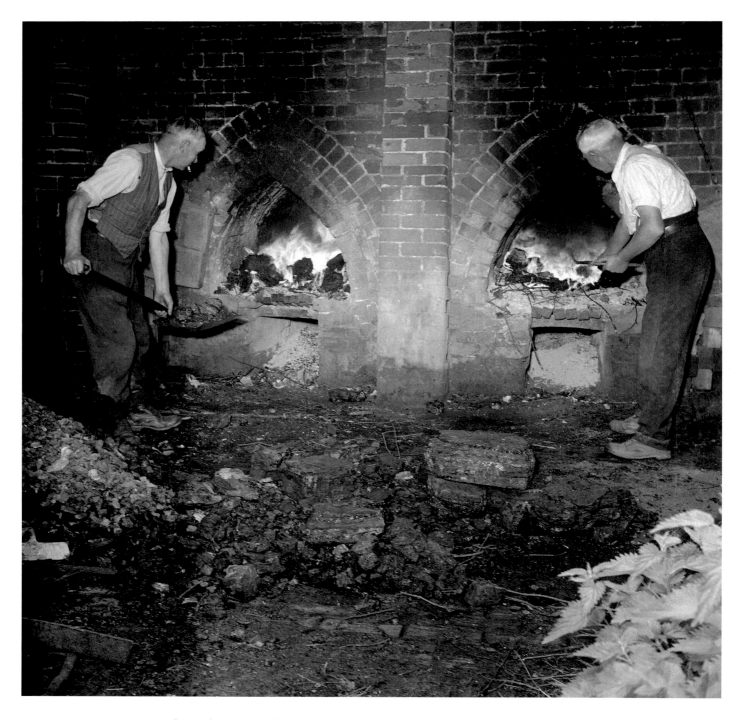

Barney Brickyard, near Fakenham, Norfolk, July 1953
Two men stoke the coal-fired furnace in order to fire the brick kiln. Firing requires a temperature of 950–1150°C and depending on the size of the kiln it may take a week – two days to reach temperature, a day at full heat and three days to cool down. [AA98/13471]

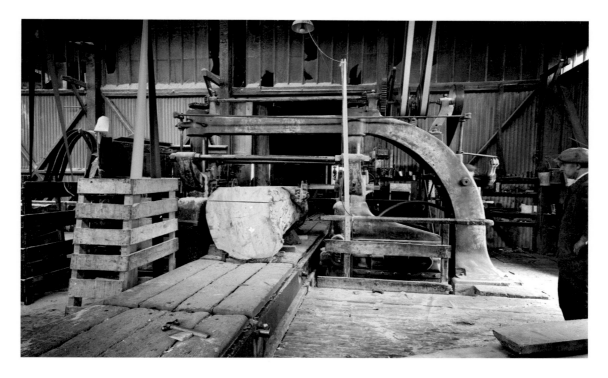

Savage's Works, King's Lynn, Norfolk, April 1954
Timber was another important building material. Tree trunks were traditionally cut by hand into planks by two sawyers working a large pit saw. The trunk was supported over a pit: the top sawyer stood over the trunk and the pitman beneath it in the pit. By the time Hallam Ashley was photographing, this long-established practice had been replaced by a mechanical saw. [BB98/30385]

Sawn planks, Wroxham, Norfolk, October 1968
A large tree trunk sawn into planks is seasoning while it awaits use at D B Sabberton's Boatyard.
[AA98/16382]

Panxworth Ironworks, near Woodbastwick, Norfolk, May 1961
In 1869 Thomas Smithdale & Sons of Norwich opened a second iron foundry and engineering works in Panxworth to be nearer to their rural market. The complex was purpose-built. Their main business appears to have been mill work and agricultural implements, though on occasion they made machinery for milling mustard and may even have entered the mustard business on their own account. [AA98/12026]

Savage's Works, King's Lynn, Norfolk, April 1954
The firm originally made agricultural equipment but by the late 19th century it had become a specialist repair shop for fairground rides. Three carousel horses wait attention to the left, while a mound of sawdust shows that this was an active carpentry shop. [AA98/17387]

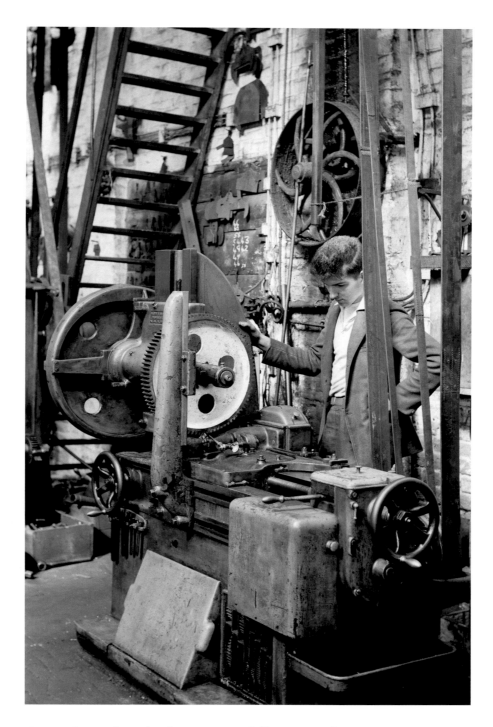

Savage's Works, King's Lynn, Norfolk, September 1957
A man operates metal-cutting machinery powered by a belt from an overhead
shaft. [BB99/05475]

~ *Retail* ~

Few people or communities have ever been truly self-sufficient, so buying and selling has been an important element in English society for centuries. In the medieval period, markets provided a rare opportunity for people in rural areas to replace everyday items not made locally or acquire exotic goods. They were also occasions for entertainment and for meeting people. While large towns might have a weekly or monthly market, a village may just have an annual fair. Otherwise, itinerant tradesmen, variously called chapmen, pedlars or hawkers, would pass through periodically.

The first shops in both towns and villages were probably opened by those involved in production or manufacture, such as bakers, butchers or carpenters. The first village shops are documented in the late 17th century, several of them in East Anglia, but it was only with improvements in communications in the late 18th and early 19th centuries that they were able to stock a range of goods.

Retailers often diversified beyond their original trade, becoming general dealers. Until the development of good public transport in the mid-20th century, and more particularly private car ownership, the village shop supplied those necessities which were not produced locally – for example cooking ingredients, soap, matches, crockery, paraffin, medicines and post office services.

A typical village shop was often little more than a converted front parlour in a cottage or house. Many shopkeepers made no structural alterations whatsoever, but the majority at least enlarged a window for display purposes. A shopfront was only the norm in towns.

Today, many village shops and post offices are struggling or have closed, while hardware shops selling 'everything you could possibly want' are virtually things of the past. Markets, on the other hand, seem to be experiencing a revival as part of the move towards low food miles and direct contact between producer and consumer.

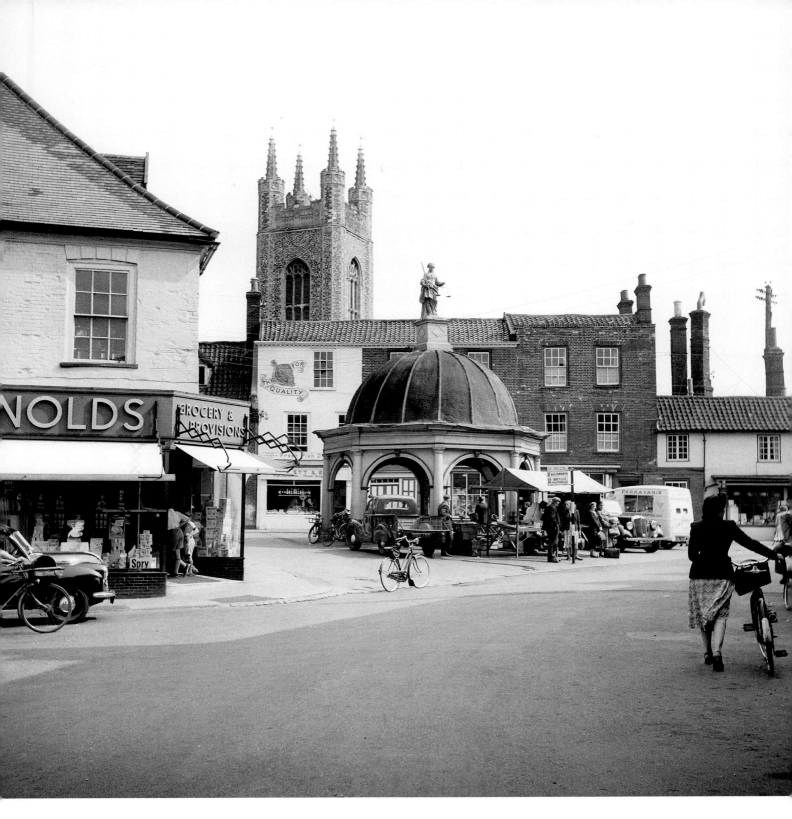

Market-place, Bungay, Suffolk, June 1954
Market day in Bungay has attracted neither shoppers nor vendors. A single stall has been set up next to the Butter Cross of 1689, and an ice-cream van hopes for trade. More bicycles than private cars are in evidence. [AA98/11616]

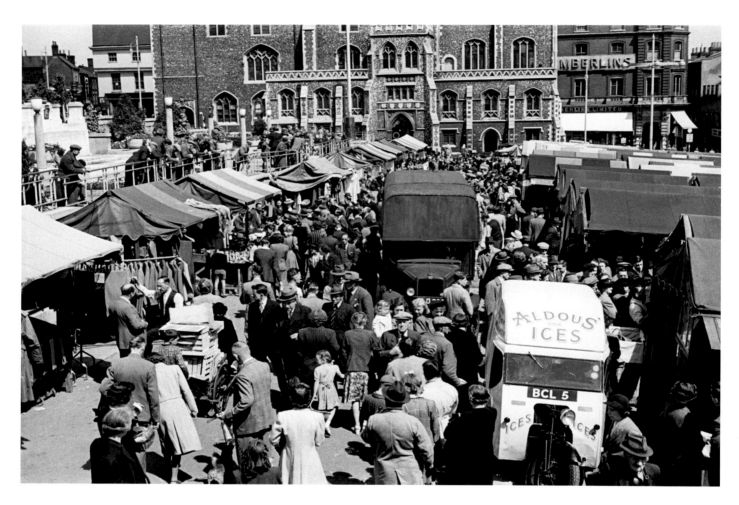

Market Place, Norwich, Norfolk, July 1948
Many towns have a market-place at the heart of the settlement and have held a weekly or monthly market since the 13th century or even earlier. In this photograph the market in Norwich seems very busy; a man on the left pushes a market barrow, while an ice-cream vendor makes the most of the crowds on a summer's day. [MF98/01664/16]

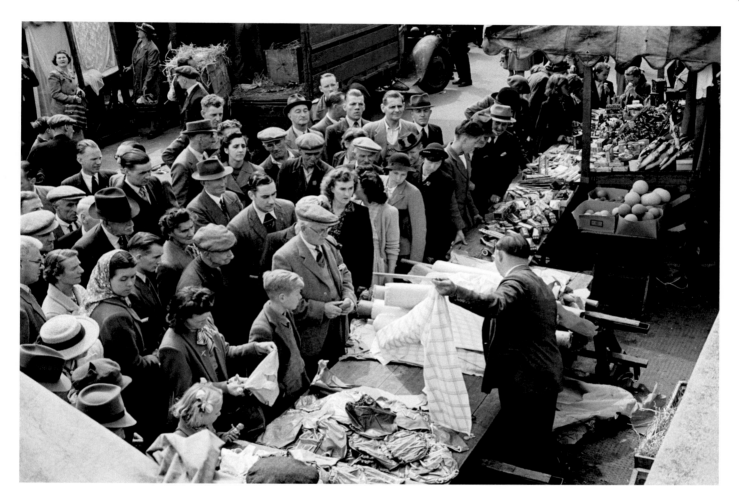

Market Place, Norwich, Norfolk, July 1948
The British people endured rationing during the war years, and post-war austerity continued into the 1950s. Perhaps this is why a market stall selling rolls of cloth has attracted so much interest. A neighbouring toy stall is also popular. [MF98/01662/09]

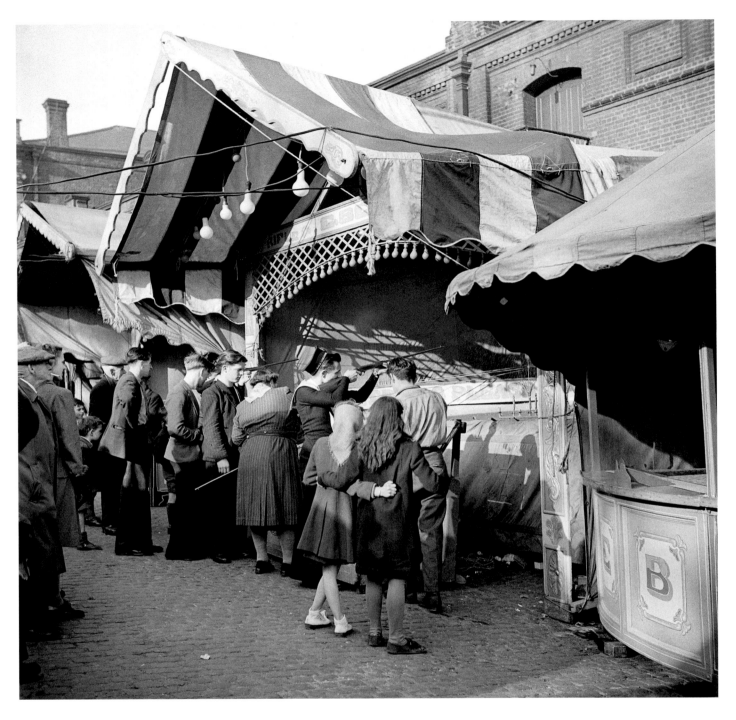

Easter Fair, Norwich, Norfolk, March 1948
In addition to its market, Norwich has two annual fairs at Christmas and Easter. In origin fairs were commercial events, but historically they have always offered entertainment – performing animals, freaks, acrobats. As the range of goods stocked in shops increased from the late 18th century, entertainment began to displace the market aspect of fairs, and a new trade of travelling showman developed on the fringes of society. The traditional showmen lived a mobile lifestyle from Easter until the late autumn, moving from fair to fair and seldom staying in one location for more than a few days. [AA98/17164]

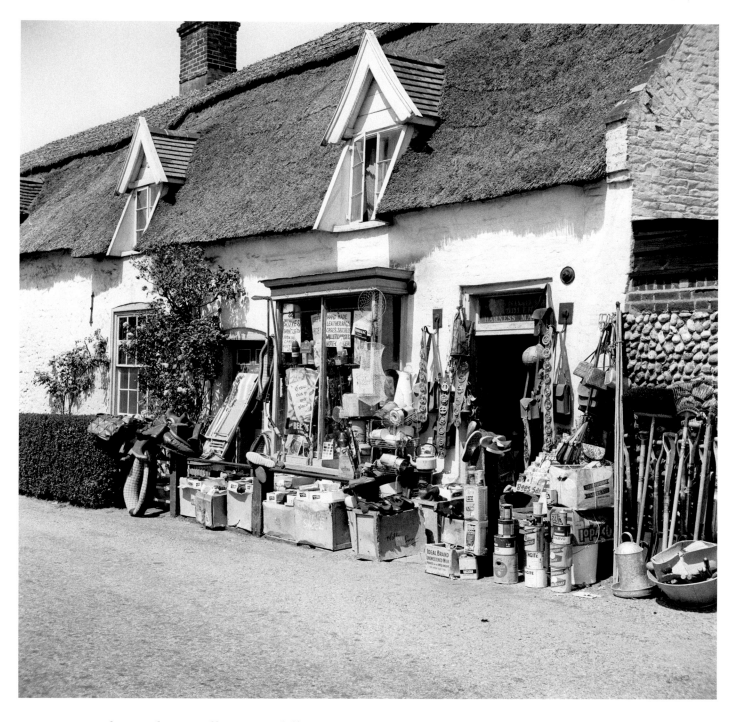

Hardware shop, Ludham, Norfolk, June 1953
Village shops had a reputation for selling everything and this hardware shop certainly seems to live up to it! [AA98/11268]

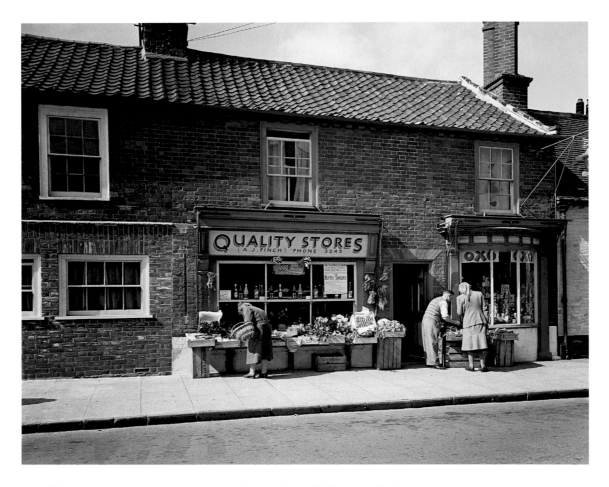

Quality Stores, High Street, Southwold, Suffolk, April 1949
A greengrocer displays his produce on the pavement in front of the shop. This would probably be both local and seasonal: perishable fruit and vegetables were seldom available out of season before refrigeration became common. The asparagus season has just begun judging from the bunches displayed round the window. [AA98/14578]

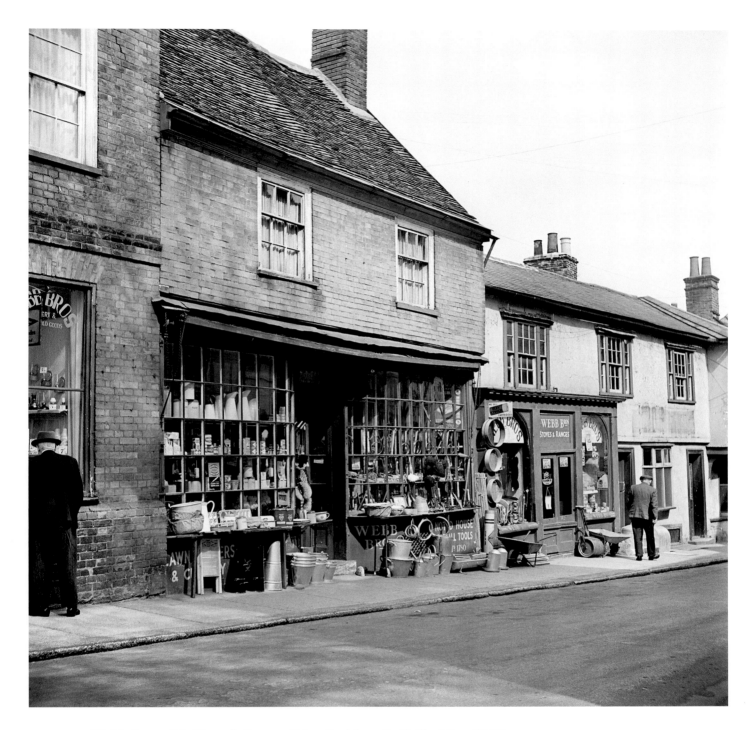

Webb Bros, 30 Church Street, Woodbridge, Suffolk, May 1950
Webb Bros advertised itself in county directories as an ironmonger but by the time this photograph was taken the firm had clearly diversified into stoves, groceries and pawnbroking and taken over premises on either side. Its stock spills onto the pavement and hangs from the shop windows. [AA98/14964]

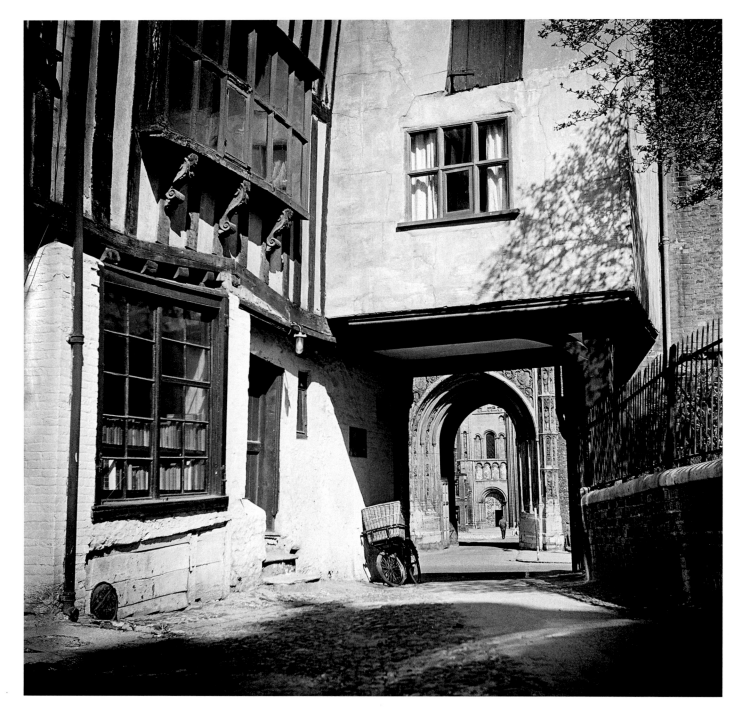

Tombland, Norwich, Norfolk, April 1947
This view looks through the archway under 14 Tombland (a mid-16th century house built for Augustine Steward, a former mayor of Norwich) and the 15th-century Erpingham Gate into the cathedral precinct and the west front of Norwich Cathedral. A delivery boy's bicycle leans against a wall – many shops provided a delivery service and shop boys with heavily laden baskets on their bikes were a common sight. [AA98/07528]

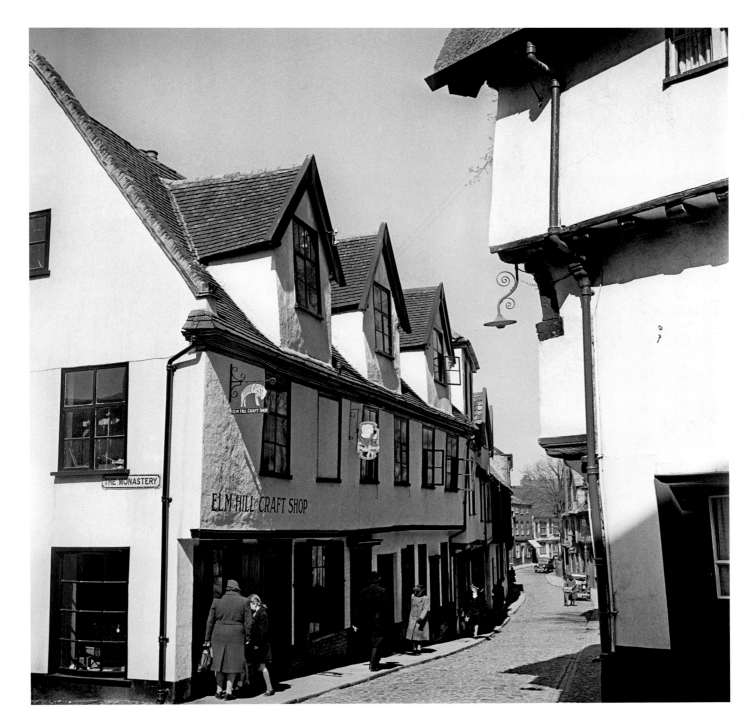

Craft shop, Elm Hill, Norwich, Norfolk, April 1947
Elm Hill is a picturesque survival of the street plan of the medieval city, though many of the houses date from the 17th and 18th centuries. Despite its traditional façade, the craft products sold in shops like this had switched from being everyday essentials to gentrified ornaments. [AA98/07531]

Mackley & Bunn, Printers, Timber Hill, Norwich, Norfolk
There was plenty of work, even in a small town, for a jobbing printer, producing the ephemeral material required by local businesses as well as social stationery. Some even published a local broadsheet. [MF98/01759/34]

~ *Transport* ~

'The village was full of wagons a hundred years old or more when I was a boy, and still perfect' (Blythe 1969, 128). So mourned Jubal Merton, wheelwright of Akenfield, of the passing of the farm wagon which had been a model of craftsmanship and the ubiquitous rural workhorse before the development of public transport. Until then the life of a country dweller was limited to the farm and the village – travel to the major centres such as Norwich or Ipswich was difficult and few made the journey even once a year. The carrier might go to the nearest market town once or twice a week, but a return trip could take all day. Even after the coming of the railways, the transport of bulky goods took advantage of rivers and other waterways wherever possible, although the canal system which was so important to the Industrial Revolution never penetrated into East Anglia. The railways probably made little difference to most members of the labouring class, though they were important for the bulk transport of goods including farm produce. It was not until the advent of the internal combustion engine, an 'annihilator of distance' as Evans (1974, 153–4) terms it, that mobility came within the common grasp. Blythe implicated it as 'the chief agent in the change' that ended the old rural community and way of life.

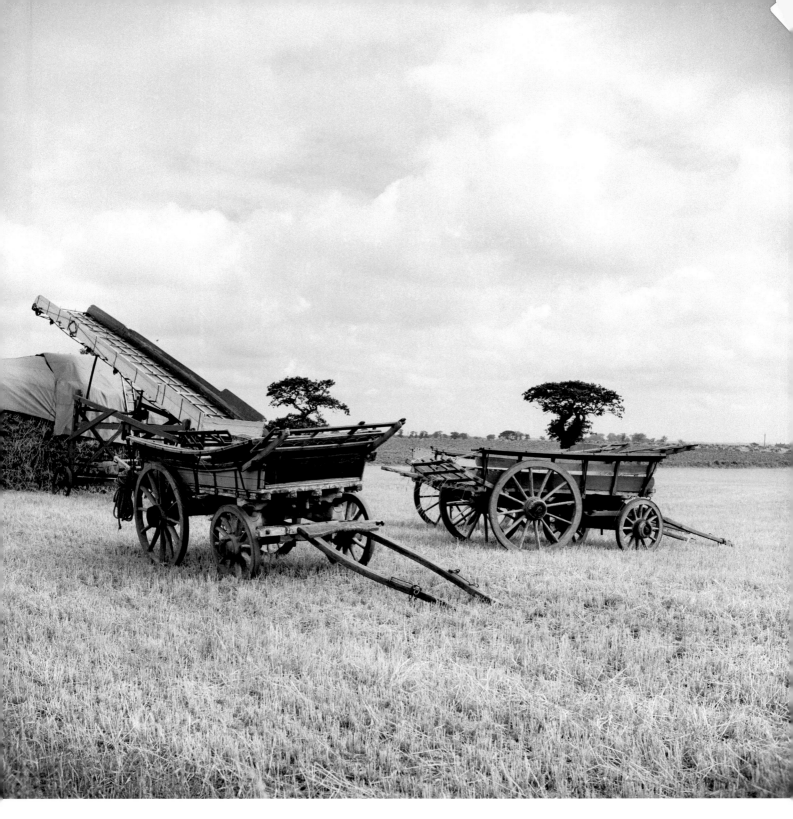

Farm wagons, Freethorpe, Norfolk, September 1959
This pair of wagons has just helped bring in the harvest, and an elevator behind them stands next to a covered haystack. Farm wagons were standard equipment on every arable farm until the mid 20th century and they were strongly regional in style. They were usually made locally by a wainwright, in co-operation with the wheelwright, who made wheels, and the blacksmith. Wheel-wrighting was a particular craft specialism, not generally practised by carpenters. [AA98/15161]

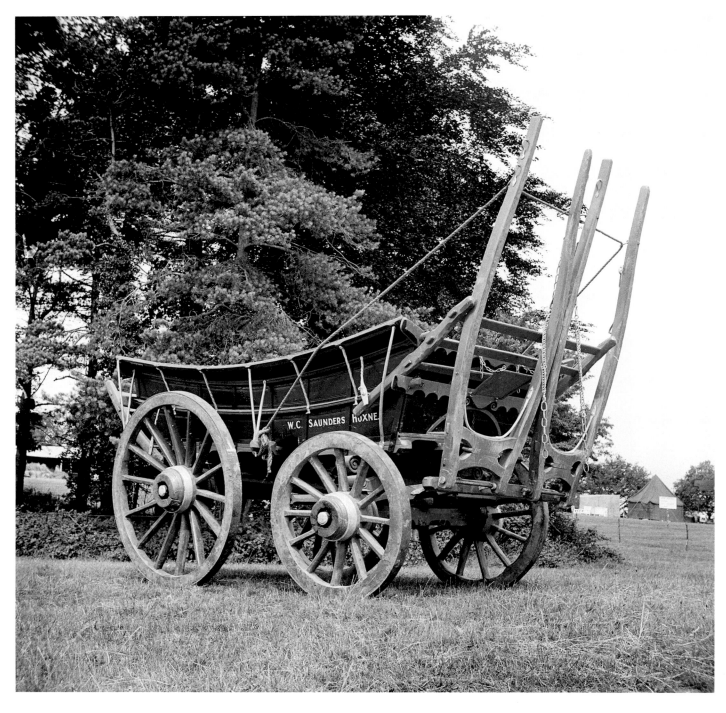

Wagon, Royal Norfolk Show, Keswick, Norfolk, June 1947
In 1947 this wagon was still a piece of working equipment, not a curiosity. It is fitted with double shafts to accommodate two horses, and is painted with the name of W C Saunders of Hoxne, farmer, of Chickering Hall and Chickering Corner Farm. [AA98/11487]

Royal Norfolk Show, Keswick, Norfolk, June 1947
A parade of carts attracts a considerable crowd in the show ring. These were working vehicles and the skills demonstrated by their drivers were used every day, though by 1947 it was probably obvious to most spectators that their days were numbered. [AA98/11521]

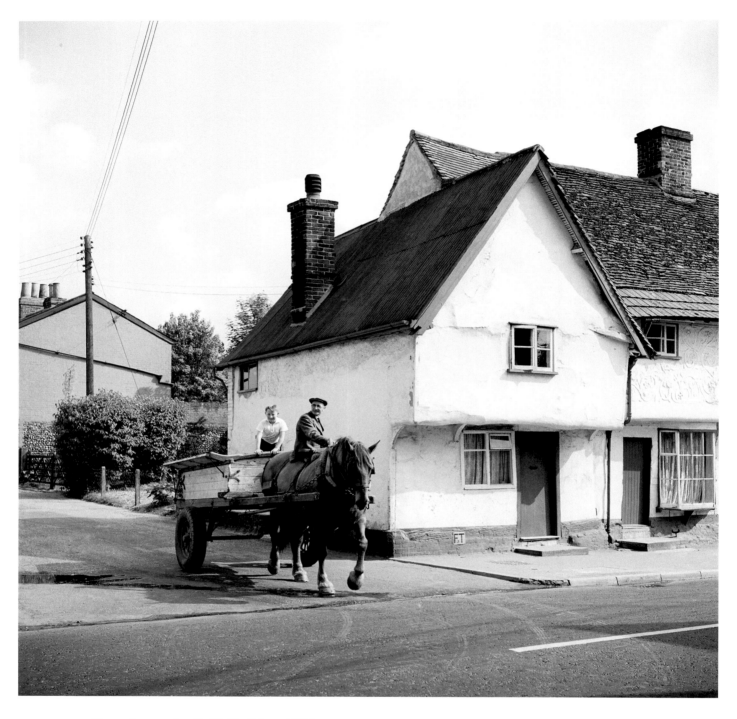

Cart, Ixworth, Suffolk, May 1959
Carts continued in use alongside motor vehicles, and were thought to be more suitable for certain tasks. This cart has been modified by the replacement of its traditional wheels by inflatable tyres. The 16th–17th-century cottage on the corner of the High Street displays an example of pargetting, traditional decorative plaster work, in this case in a foliage pattern. [AA98/07168]

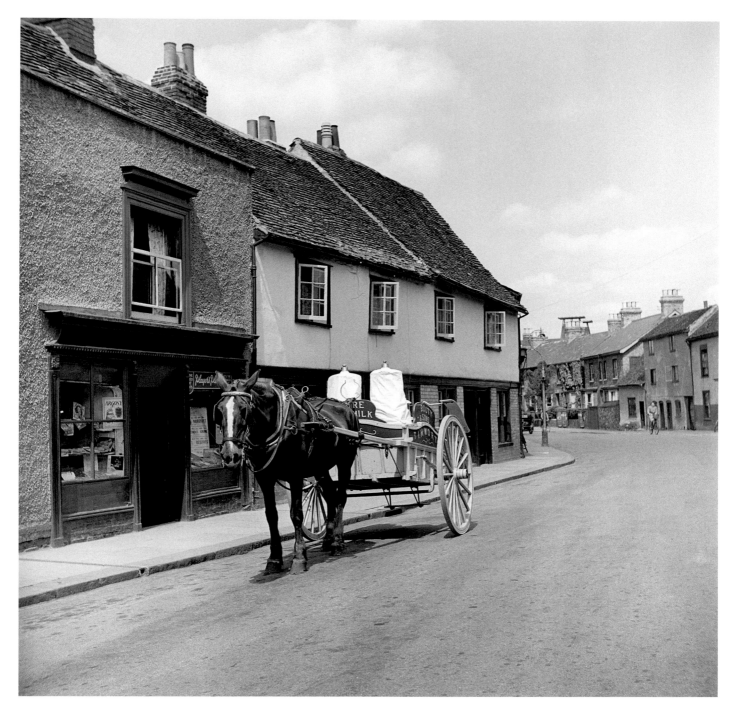

Milk float, Bury St Edmunds, Suffolk, May 1947
A milk float belonging to Booty & Sons of Timworth waits patiently outside a tobacconist and newsagent's shop. Two white-swathed churns of milk stand in the cart. The shadow suggests it is midday, but the street is almost empty. [AA98/16568]

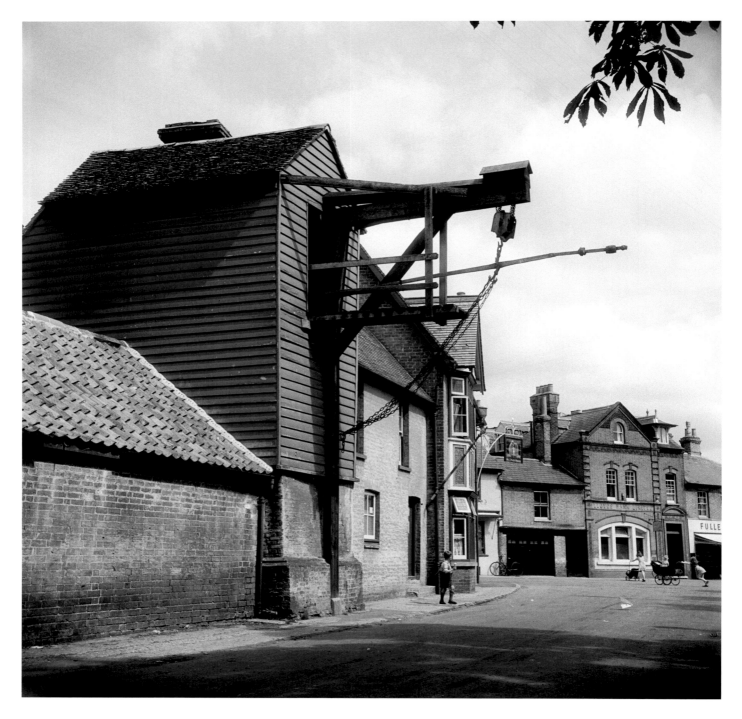

Steelyard, Soham, Cambridgeshire
A steelyard was a weighing machine used to assess tolls on heavily laden wagons or to weigh agricultural produce. This example is attached to the Fountain Hotel at the corner of Churchgate Street and High Street. Dating from c 1740, it has been restored and is still in working order. [AA98/09082]

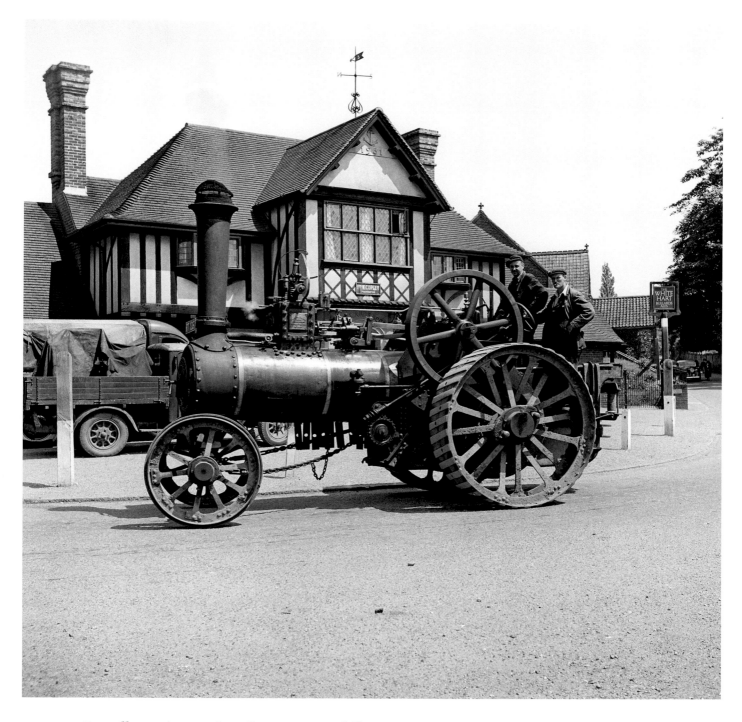

Burrell traction engine, Costessey, Norfolk, June 1951
One use of traction engines was as mobile power units. They were also used for heavy road haulage. This example, photographed outside the White Hart inn, is Burrell of Thetford No 3607, a 7 nhp (nominal horse power) traction engine supplied in August 1914 to W Last of Church Farm, Occold, Suffolk. *Kelly's Directory* of Suffolk for 1916 describes Mr Last as a farmer and threshing machine owner. Due to the cost of investment, traction engines tended to be owned by contractors who hired their machines from farm to farm. [AA98/07109]

Scrapped traction engines, Great Massingham, Norfolk
The age of steam on the farm lasted for over a century. In the early 19th century steam engines started to be used to provide power around the farmstead. Steam ploughs began to appear in the 1850s and were still widely used in the 1920s, though by the 1950s the internal combustion engine had gained total dominance. These engines, made by the firms of Allchin, Green, Burrell and Aveling, belonged to R E P Palmer, haulage contractor, of Great Massingham. They were dumped on Massingham Common in 1940 when his yard was requisitioned for an airfield and were being scrapped in 1946. [AA98/07546]

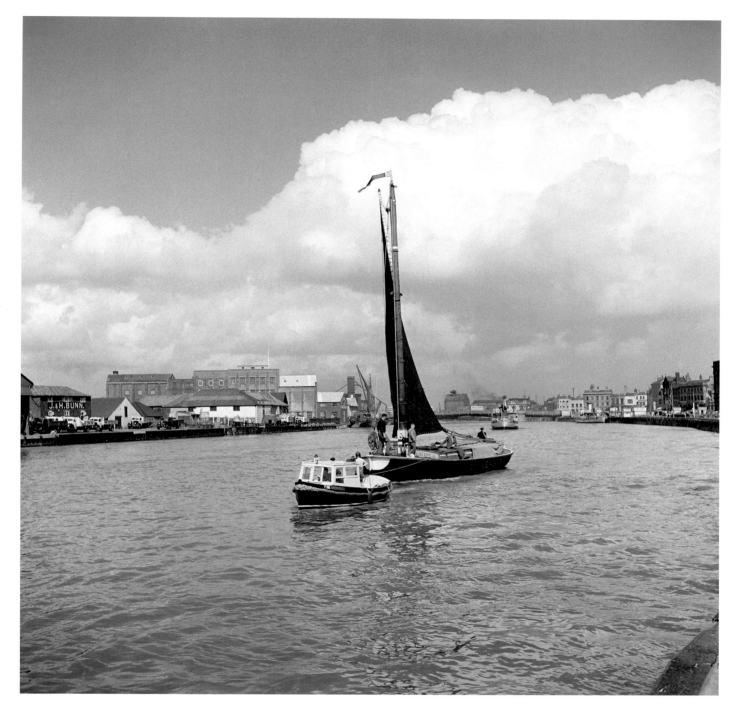

Wherry, Great Yarmouth, Norfolk
In much of East Anglia waterways offered a ready means of transport for bulk goods. The traditional working boat, called a 'wherry', carried grain and other goods to and from the coastal harbours. Wherries were powered by sails, though this example on the River Yare at Great Yarmouth is being towed to its berth by a motor launch. AA98/09263

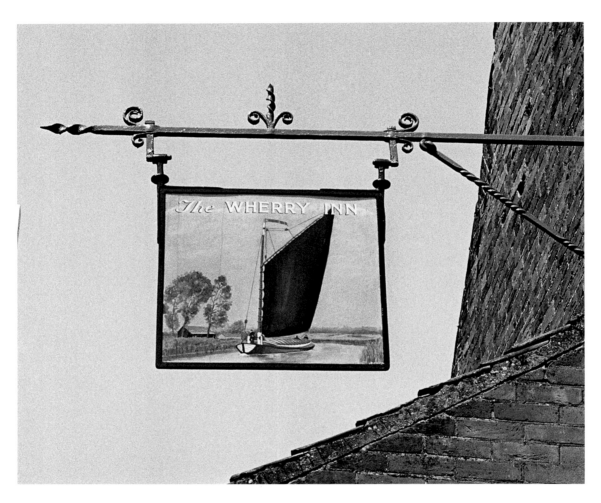

The Wherry Inn, Geldeston, Norfolk
Wherries were analogous to the Thames barges which served London or to canal barges elsewhere in England. A number of inns near navigable rivers took their names from this important means of transport. [AA98/09407]

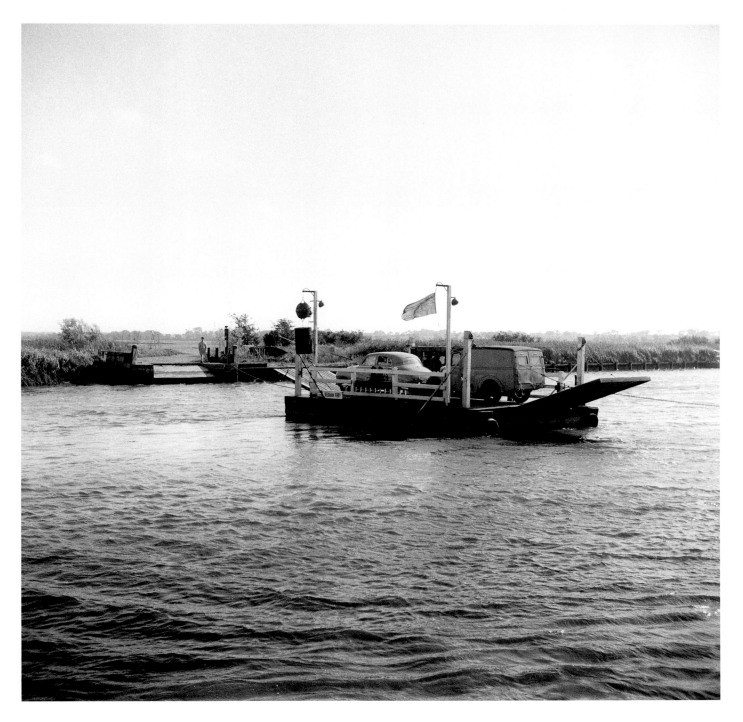

Ferry, Reedham, Norfolk, September 1954
Much of East Anglia is watery, and many rivers could only be crossed by ferry before road bridges were built in the later 20th century. This chain ferry is still the only vehicle crossing on the River Yare between Great Yarmouth and Norwich. When photographed, it was only big enough to carry two vehicles. [AA98/09928]

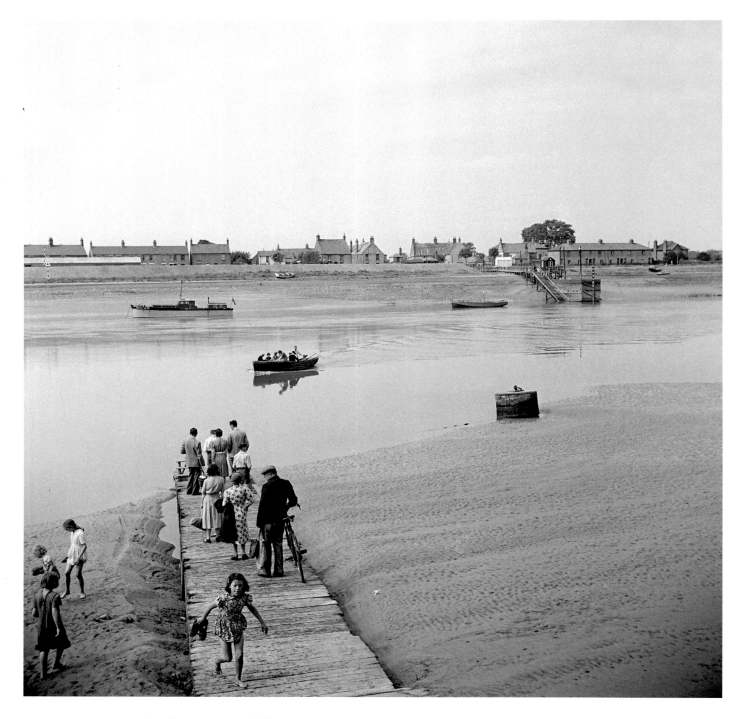

Ferry, King's Lynn, Norfolk
This foot ferry on the River Great Ouse at King's Lynn was only a rowing boat with an outboard motor attached. Presumably it operated in all weathers with no protection from the elements. Passengers queue on the jetty, including a man with his bicycle. Was this the daily commute to work or trip to the shops? [AA98/07615]

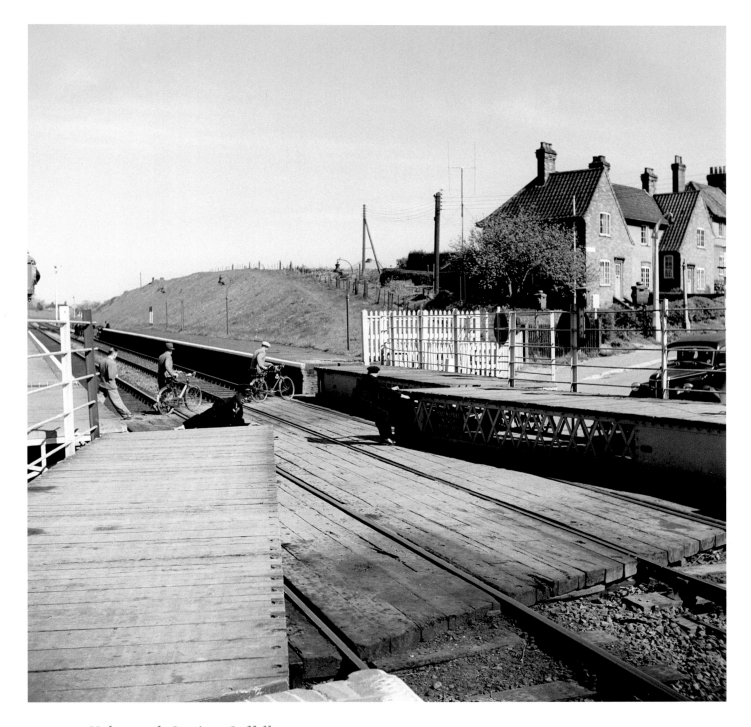

Halesworth Station, Suffolk
The arrival of the railways in the 19th century was an important step in the gradual breakdown of the traditional rural community – people could now travel easily and bulk goods be moved cheaply. At Halesworth the level-crossing gates were operated by hand and incorporated an extension to the platform. The train has passed, and men wheel their bicycles across the tracks while a private car waits for the gates to open fully. [AA98/09329]

~ Sources consulted ~

Biographical

Anon, 1862. *General and Commercial Directory and Topography of the Borough of Sheffield, with all the Towns, Parishes, Villages, and Hamlets within a Circuit of Twenty Miles.* Francis White & Co: Sheffield

Anon, 1956, *East Anglian Buildings: an exhibition at the Castle Museum, Norwich, May 26–August 26, 1956.* Norwich Museums Committee: Norwich

Ashley, H 1936. 'Windmill photography', *British Journal of Photography*, 28 August 1936, 544–6

— 1946. '*Cheirotherium* [sic] footprint found at Scrabo Hill, Co. Down', *The Irish Naturalists' Journal*, VIII (9), 332 and pl XII

— [1951], *The Beauty of Norfolk*. Norwich: Jarrold & Sons

Davidson, K 1999. 'The life and work of Hallam Ashley, FRPS, 1900–1987', *SPAB Mill News*, 80 (July 1999), 4–5

Harrison, N K 1964 . '35 years of archaeological recording [Review of an exhibition of Hallam Ashley's photography]', *British Journal of Photography*, 25 September 1964, 779–83

Society for the Protection of Ancient Buildings, 1951, *Report of the Committee for the Seventy-First – Seventy-Third Year and an Account of the General Meeting with the Address by the Rt Hon Lord MacMillan, GCVO, October, 1951*

Correspondence files held at the NMR

Social history

Blythe, R 1969. *Akenfield*. London: Allen Lane

Evans, G E 1958. *Ask the Fellows Who Cut the Hay*. Newton Abbot: The Country Book Club (first pub 1956)

— 1974. *The Farm and the Village*. London: Faber (first pub 1969)

— 1985. *The Strength of the Hills: An autobiography*. London: Faber (first pub 1983)

Taylor, C 2006. *Return to Akenfield: Portrait of an English village in the 21st century*. London: Granta Publications

S Wade Martins & T Williamson, 2008, *The Countryside of East Anglia: changing landscapes, 1870–1950*. Woodbridge: Boydell Press

Crafts and industries
Arnold, J 1968. *The Shell Book of Country Crafts*. London: John Baker

Bensley, L 2008. *The Village Shop*. Oxford: Shire Publications

Brown, J 1991. *The Horse in Husbandry*. Ipswich: Farming Press

Clark, R H 1975. *A Traction Engine Miscellany*. Cambridge: Goose & Son

Clarke, R 1935. 'The flint-knapping industry at Brandon', *Antiquity*, IX, 38–56

Cobbett, W 1826. *Cottage Economy* (new edn) (the author: London)

Cox, J & Letts, J 2000. *Thatch: thatching in England 1940–1994*, English Heritage Research Transactions: Research and Case Studies in Architectural Conservation, 6. London: James & James

Crewe, S 1987. *Stained Glass in England 1180–1540*. London: HMSO

Fearn, J 2004. *Thatch and Thatching*. Princes Risborough: Shire Publications

Gourvish, T R & Wilson, R G 1994. *The British Brewing Industry 1830–1980*. Cambridge: Cambridge University Press

Harris, A P 1990. 'Building stone in Norfolk', in Parsons, D (ed) *Stone: quarrying and building in England* AD 43–525, 207–16. Chichester: Phillimore

Morrison, K A 2003. *English Shops and Shopping: An architectural history*. London: Yale University Press

Stanier, P 1995. *Quarries of England and Wales: A historic photographic record*. Truro: Twelveheads Press

Wade Martins, S 1995. *Farms and Fields*. London: Batsford

Watts, M 2006. *Watermills*. Princes Risborough: Shire Publications

Watts, M 2006. *Windmills*. Princes Risborough: Shire Publications

Worsley, G 2002. *England's Lost Houses: From the archives of* Country Life. London: Aurum Press

Wright, N R 1975. *Spalding: an industrial history*, 2 edn. Lincoln: Society for Lincolnshire History and Archaeology

Yardy, A 2008. 'Broadland millwrights: Englands of Ludham', *Friends of Norfolk Mills Newsletter*, 22 (August 2008), 3

General reference
Countryside Agency, 1999. *Countryside Character: Volume 6: East of England*. Cheltenham: The Countryside Agency

Finberg, H P R & Thirsk, J (gen eds), 1967–2000. *The Agrarian History of England and Wales* (8 volumes). Cambridge: Cambridge University Press

Miller, E 1969. *The Abbey and Bishopric of Ely: The social history of an ecclesiastical estate from the tenth century to the early fourteenth century*. London: Cambridge University Press (first pub 1951)

Morris, J (gen ed) & Rumble, A (ed), 1981. *Domesday Book: Cambridgeshire*. Chichester: Phillimore

Pevsner, N & Radcliffe, E 1965. *Buildings of England: Essex*, rev edn. Harmonsdworth: Penguin Books

— 1974. *Buildings of England: Suffolk*, rev edn. London: Penguin Books

Pevsner, N & Wilson, B 1997. *Buildings of England: Norfolk 1: Norwich and North-East*, rev edn. London: Penguin Books

— 1999. *Buildings of England: Norfolk 2: North-West and South*, rev edn. London: Penguin Books

Websites
Historyshelf *www.historyshelf.org* (on the history of Scottish fisheries, including the herring)

Norfolk Mills Index *www.norfolkmills.co.uk/mills*

~ Index of places illustrated ~

~ Index of places illustrated ~